Co-op:
the people's
business

ROCHDALE PIONEERS
150 YEARS

Presented by the
Co-operative Union Ltd, UK
to celebrate 150 years
of Co-operative Enterprise
in Europe

This project has been partly
funded by the European Community

of whole heart
cometh hope.

Co-op:
the people's business

JOHNSTON BIRCHALL

Picture research by Bernard Howcroft

Manchester University Press
Manchester and New York

Distributed exclusively in the USA and Canada by St. Martin's Press

Published by Manchester University Press
Oxford Road, Manchester M13 9NR, UK
and Room 400, 175 Fifth Avenue, New York, NY 10010, USA

British Library cataloguing in publication data
A catalogue record for this book is available from the British Library

Library of Congress Cataloging in Publication Data
Birchall, Johnston.
 Co-op: the people's business / Johnston Birchall.
 p. cm.
 ISBN 0–7190–4421–9 (hard). — ISBN 0–7190–3861–8 (pbk.)
 1. Cooperation—History. 2. Cooperation—Great Britain—History.
3. Rochdale system—History. 4. International cooperation—History.
I. Title
HD2956.B49 1994
334'.0941—dc20 93–45569

ISBN 0 7190 4421 9 *hardback*
 0 7190 3861 8 *paperback*

Designed by David Rodgers MCSD

Printed in Great Britain
by BPC Books and Journals, Wheatons Ltd, Exeter

Contents

To the unnamed wives of the Rochdale Pioneers

Preface

At first sight, 'co-operation' is a very odd subject for a book. It means simply 'working together for the same end', and it is something with which we are all so familiar that it seems too mundane a subject to write about. Co-operation is as old as the human species. Without it, there would probably not be a human species, since in the harsh conditions of the Stone Age even the fittest individuals could only survive if they learned to hunt together, to build their homes and defend their territory *together*. Even in this age of competition and individualism, we all know that the urge to compete and to stand out from the crowd are only possible because our basic needs are taken care of by the underlying, taken-for-granted co-operation of countless others who together make our human world possible.

In fact, co-operation (with a small 'c') is much older even than the human species. When we set out to study evolution we find that other animals have also learned to survive through mutual aid. Darwin, who is popularly thought to have preached a stern 'struggle for existence' between individuals, pointed out how (in the words of Peter Kropotkin):

> In numberless animal societies, the struggle between separate individuals for the means of existence disappears, how struggle is replaced by co-operation, and how that substitution results in the development of intellectual and moral faculties which secure to the species the best conditions for survival.[1]

We need not think here just of those obviously co-operative species, the bees or ants, but of birds who flock together for mutual protection, of herd animals who roam in their thousands over vast distances in search of food, of baboons who hunt together using sophisticated teamwork, and of gorillas who seem simply to enjoy each other's company. In fact, Kropotkin observed that 'as we ascend the scale of evolution, we see association growing more and more conscious'[2], so that in the higher apes and in humans we observe a growing love of sociability for its own sake, coupled with an ability to think logically about our needs, and to combine together in more and more complex ways.

Until about two hundred years ago, such co-operation seems to have been taken for granted; most humans lived in village communities, tribes, clans or large extended families, and even in cities there were 'urban villages' in which people felt at home, both as citizens and as members of different trades organised in guilds. But something fundamental happened during what we call the industrial revolution, which happened

first in Britain, and then spread to encompass the world. This was the progressive development of a market society in which more and more products from human labour were turned into commodities to be bought and sold rather than produced for oneself. Even labour became a commodity, to be bought and sold at whatever price the market would bear, and more and more people became dependent on selling their labour just to survive. The old forms of co-operation (with a small 'c') were weakened or destroyed. Yet for those who were the losers in this new market society, new forms had to be thought up to take their place. These new forms were, unlike the old ones, not just a product of custom and habit. Like the factory-made commodities which were beginning to flood the market, they had to be designed and manufactured from scratch; some of them worked, others did not, and the penalty for failure was renewed poverty and despair. Those that survived became part of a movement for 'Co-operation' (with a large 'C'). Suddenly, people were part of a conscious and deliberate 'Co-operative Movement'; they had learned to become 'co-operators'.

This book is a celebration of this conscious attempt to rebuild the bonds of social solidarity, to invent new forms of mutual aid among people in need. It focuses on the British experience because Co-operation is essentially a product of the industrial revolution, and this started in Britain earlier than anywhere else. This does not mean that self-conscious attempts to form co-operatives would not have happened elsewhere, because they certainly would have done – in Russia for instance, where there were very deep roots in earlier, customary forms of mutual aid based on the village commune. What it does mean is that other countries were able to learn from the British experience, specifically from the Consumer Co-operative Movement based on the 'Rochdale system', which in the latter half of the nineteenth century attracted great interest in Europe and then in this century spread throughout the world.

The book does not, however, begin with the founding of the Rochdale Pioneers' Society in 1844, though it is their 150th anniversary which we are celebrating in 1994. Chapter One begins two decades earlier, with a 'prefigurative' movement which flourished and then died before the first really successful model was established at Rochdale. Of course, Rochdale was not the first co-op, nor was it even the first to be founded in Rochdale! Nor was it the only one in existence in 1844. But it was the first really successful one, and so is rightly considered the model and the starting point for a worldwide movement – it is this which justifies the title '150 years of Co-operation'.

Notes

[1] Kropotkin, P. (1972) p. 2
[2] *Ibid* p. 53

Acknowledgements

The production of this book was particularly enjoyable because it was a team effort. Bernard Howcroft, our picture editor, having retired from his post as Manager of the Library and Information Unit at the Co-operative Wholesale Society, has spent much of his time tracking down old photographs and illustrations. He has built up a formidable collection from which we jointly chose what we thought were the best pictures, and those most illustrative of the storyline. Over weeks of painstaking work, he showed unfailing good humour, expert knowledge and, in the face of my sometimes impossible demands, not a little patience. Iain Williamson, Chief Information Officer of the Co-operative Union, conceived and managed the whole project, providing some incisive direction when it was needed and also arranging much of the illustrative material for the last two chapters on the International Movement. Roy Garratt, Librarian at the Co-operative Union, also provided good advice and some shrewd comments on the text, while Gillian Lonergan generously provided the index. Brian Rose who, as reviser of the 1970 edition of Bonner's history is one of the leading experts in the field, also provided an invaluable commentary on the text. I am fortunate in having as a colleague at Brunel University a distinguished social historian – Professor John Burnett. He read and checked the accuracy of the first few chapters, and gave some welcome advice and encouragement.

Finally, I have high praise for Francis Brooke, publisher at Manchester University Press, his assistant Anne Burbage, and the production team who have had the difficult job of laying out the text and illustrations. In my experience, if other publishers were even half as good, the job of being an author would be much easier.

Johnston Birchall

Illustration sources

Grateful acknowledgement is made to the following individuals and organisations who generously opened up their picture resources so that the best of them could be used in this book of celebration:

ROCHDALE PIONEERS 1844–1994

Beamish – The North of England Open Air Museum; Johnston Birchall; Brighton District Museums Service; Glasgow Museums Service; International Co-operative Alliance, Geneva; Co-op Kobe, Japan; Peter Pedley, Glossop; Rochdale Metropolitan Borough, Art Gallery and Museums; David Thompson, Davis, California. The Robert Broomfield paintings were originally commissioned by the BBC for their programme 'Blue Peter'

Co-operative Bank plc; Co-operative Insurance Society Ltd; Co-operative Press Ltd; Co-operative Union Ltd – Information and Publications (Manchester), and Member Education Department, Loughborough; Co-operative Wholesale Society Ltd, Library and Information Unit, and Photographic Department; CWS – Belfast Retail Branch, Cumbrian Retail Branch, Greater Nottingham Retail Branch, North Eastern Region, Scottish Retail Group, South-East Retail Group, South Midlands Retail Branch

Retail Co-operative Societies Brighton; Central Midlands; Chelmsford Star; Colchester and East Essex; Co-operative Retail Services; Ipswich and Norwich; Leeds; Leicestershire; Oxford, Swindon and Gloucester; Penrith; Portsea Island Mutual; Scottish Midland; United Norwest Co-operatives; Yorkshire Co-operatives

CHAPTER ONE

The origins of Co-operation

In the present form of society, the workmen are entirely in the power of the capitalists, who are incessantly playing at what is called *profit and loss* – and the workmen are the counters, which are pitched backwards and forwards with this unfortunate difference – that the counters do not eat and drink as workmen do, and therefore don't mind being thrown aside at the end of the game. (William King)

Suppose you could choose where and when you were to be born. Suppose also that you could not guarantee to be born into a wealthy family. What would you decide? One thing is for sure – you would almost certainly not want to be born in Britain around the year 1800. For the poor – and by our standards they were then in the majority – it was the worst of all possible times. The world's first industrial revolution was under way and vast wealth was beginning to be accumulated, but for every person who rose into the ranks of the new industrialists, there were many more who were falling into grim poverty. What would life have been like?

The agricultural workers

The odds are that you would have been born the child of an agricultural worker. Despite the spectacular growth of the new industrial cities, in 1800 around four-fifths of people were still living in the countryside, and rural labourers were the single biggest occupational group. A rural idyll it was not. Since 1760, powerful landowners had been using private acts of parliament to enable them to enclose common land which had belonged to everyone. Consequently, you would no longer have the customary rights to gather firewood, graze animals, hunt game or build your house on the common. Unless you were lucky enough to live in the north of England (where the old ways were still followed, and farmers provided land for a potato patch or grazing for a cow), you would be totally dependent on daily wages for your living. William King, the great advocate of Co-operation, put it this way: the workman's 'little perquisites, his right of common, his cow, his little piece of ground, fell off one by one: he was reduced to his mere wages, summer and winter'.[1] Whereas your parents might have lived in with the farmer as valued workers, you would most probably live out in a rented cottage, and be hired daily as and when the farmers needed you; so in the winter you would starve. Because the population had begun to grow very quickly, you would be part of a 'baby boom' generation who were all seeking work. But after

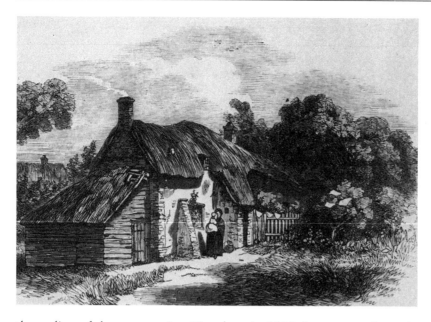

Engraving of the exterior of a labourer's cottage near Blandford, Dorset, in 1846.

the ending of the wars against Napoleon in 1815 there was a slump in demand for produce which lasted twenty years, and wages fell so low you would have needed to claim parish poor relief (a local form of income support) even when in work.

This is how one historian of the time described it:

> The standard of life from 1800 to 1834 sank to the lowest possible scale; in the south and west, wages paid by employers fell to three to four shillings, augmented by parochial relief from the pockets of those who had no need of labour; and insufficient food has left its mark in the physical degeneration of the peasantry. Herded together in cottages which, by their imperfect arrangements violated every sanitary law, generated all kinds of disease, and rendered modesty an unimaginable thing ... compelled by insufficient wages to expose their wives to the degeneration of field labour, and to send their children to work as soon as they could crawl.[2]

Surrounded by the food you yourself had laboured to grow, you would be subsisting on a diet of weak tea, root vegetables, potatoes and

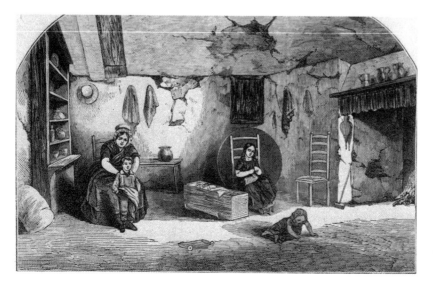

Interior of Blandford labourer's cottage showing the poverty and squalor.

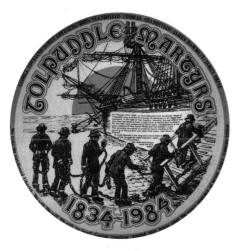

Tolpuddle Martyrs – commemorative plate issued by the Trades Union Congress on the 150th anniversary, February 1984.

white bread (which would be costly, because of the Corn Laws of 1815, designed to keep the cost of bread artificially high). Only northerners still ate the much more nutritious brown bread and oatcakes. Again, unless you lived in the north (where traditions died hard and fuel was still available), you would have lost the art of making your own bread and brewing your own beer, which means you would be dependent on the local farmer or shop. John Burnett describes how farmers had become reluctant to sell milk to local people, preferring to send it to market, and they had become extraordinarily insensitive to any claims of fair play; they would prevent you from keeping a pig and even claim the produce of your apple trees or of the vine covering your house.[3] So you would be dependent on the shop, and would soon run up a debt which would tie you to it even though the quality was poor and the prices invariably high.

So what could you have done about it? You would have been unable to read, without a vote, unable to move in search of work because dependent on local poor relief in the parish in which you were born. You would be at risk of injury in 'man-traps' set by game-keepers if you poached on the land that had once belonged to the entire village, and (after 1816) you would risk a sentence of transportation. If you tried to join together with others to form a trade union to press for higher wages, you could be prosecuted under the Combination Acts. Even ten years after these had been repealed, a group of labourers (the Tolpuddle Martyrs) were sentenced to transportation for taking illegal oaths; that is, for having the temerity to form a trade union. In such circumstances it is not surprising that Co-operation did not begin with the agricultural workers. One small co-op society was formed as early as 1794 at Mongewell, a small village in Oxfordshire. It was set up by a bishop who, finding that the villagers could not afford to buy at the local shopkeeper's prices, conceived the idea of a cost-price shop at which goods bought in the wholesale market could be sold. Though it contained one important element of Co-operation – the elimination of profit – it was really what we call a 'patronage store' relying on the backing of a rich philanthropist and, as Holyoake says, 'it did nothing to teach the customers the principle of … self-management'.[4]

Other occupational groups – urban day labourers, semi-skilled factory workers, and that vast army of domestic servants (nearly a million of them, a seventh of the workforce in the census of 1841) – were equally vulnerable, unable to defend themselves through co-operation. They would come into the Co-operative societies at a later stage and benefit from them, but at this point they simply had too much to do trying to survive.

The artisans

Suppose you had been born into a family of artisans, skilled craftsmen who could put you into an apprenticeship. You might still be living in a rural area, because at this time industry was widely dispersed, and many workers were self-employed and living in industrial villages, as weavers, coopers, blacksmiths, masons or builders. You would be proud of your craft, working at your own pace to your own standard of quality. Or you might have lived in a small town, working as a 'journeyman' for a 'master', but without the social gulf that this word was later to signify; you would aspire to become a master yourself some day. You might be working in an industrial village in one of the new cotton mills as a skilled

overlooker or mechanic, but in all cases you would be more likely to identify with the masters than with the labouring classes, who were a long way below you in status.

Because entry to your trade was restricted, and wages were determined by custom more than by the market, you would at first have been quite well off: part-educated, a member of an established trade union, and protected from illness and accident by that earliest form of 'Co-operation with a big-C', the friendly society.[5] This was a kind of mutual insurance club which was formed by members who subscribed weekly to a common fund, out of which those who fell ill would be paid an agreed rate of sickness benefit. It relied on members having a wage which was above basic subsistence, enough foresight to provide for themselves and enough education and self-discipline to be able to keep the books and make sure the society was run on sound lines.

It is not surprising, then, that the first recorded consumer co-operative societies were formed by that elite among skilled artisans, the shipwrights of Woolwich and Chatham dockyards. As early as 1760 they had set up flour mills and (at Chatham and possibly at Woolwich) a bakery. Nor is it surprising (in the light of the subsequent history of the Co-op) that the impetus for co-operation was a local monopoly of millers and bakers who had conspired to supply that most basic of commodities, bread, at very high prices.[6] If you had been one of these shipwrights, you would have been incensed at being held to ransom by suppliers who knew how to 'co-operate' to fix the market, at a time when transport was still poor, and it was simply not practical to attempt to buy bread elsewhere. You would have agreed readily to the idea of a weekly subscription to build a new mill under your control, and you would have reaped the benefits in good quality, low cost bread.

But how do we know that these early examples of Co-operation were successful? Because they provoked serious opposition – the Woolwich mill was burned down, and the local bakers were accused of arson. And because the idea spread, by 1797, with the rise in the price of bread caused by the French wars, societies were being formed at Hull, Whitby and other ports. The Hull mill was so successful that the local millers tried to indict it as a nuisance, but the jury at the trial found in the

Left Co-operative flour mill established at Woolwich around 1760.

Below The Hull Co-operative Anti-Mill.

Arrival of the factory system – workers outside a Rochdale cotton mill (from a painting by Robert Broomfield).

co-operators' favour, finding (as Beatrice Potter puts it) 'poverty a still greater nuisance'. Further south, skilled artisans rebelled against millers who were adulterating flour with china clay, and formed a baking society at Sheerness (1815) and another corn-mill at Devonport.[7] These developments led to a natural extension of the idea into retailing; for instance, in 1816 the Sheerness Economical Society, having set up their bakery, then branched out into running a store.

Not all skilled artisans were so well off though. Burnett divides them into three types. There was an elite of skilled trades unaffected by the industrial revolution: printers, tailors, carpenters, shipwrights, bricklayers and masons. Then there were the new skills associated with the factory system: cotton spinners, miners, railway workers, skilled metal workers and so on.[8] But if you were unlucky enough to be a handloom

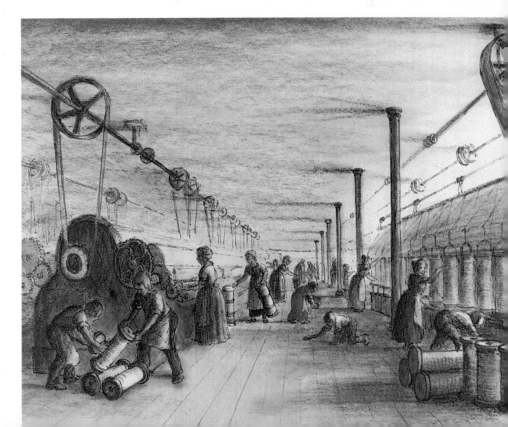

The deskilling of labour – interior of a Rochdale cotton mill (from a painting by Robert Broomfield).

weaver, silk worker, nail-maker, framework knitter or shoemaker, your prospects were grim. It was these trades that were hit by competition from the factories, which reduced them from independent self-employed craftsmen to outworkers for large capitalists. If you were a handloom weaver, for instance (still the biggest occupational group in 1830) your parents would have been earning up to thirty shillings per week at the turn of the century, but your wages would be falling gradually to a starvation wage of a penny an hour.

What had happened was that manufacturers were finding it cheaper to dispense with skilled men and replace them with unskilled, even, in some trades, with women and children. They achieved what has more recently come to be called the 'deskilling' of labour. This was achieved partly through the use of machines, but, at this stage, more through the splitting up of skilled work into its constituent parts, and 'sweating' of the workforce – through paying wages by piecework and either enforcing the strict discipline of the factory or giving out work to people in their own homes. Outwork was very important; according to E. P. Thompson, 'Large-scale sweated outwork was as intrinsic to this revolution as was factory production and steam.'[9] Gradually, traditional trades were debased. You would have found yourself in an organised workshop of skilled men being surrounded by scores of dishonourable workshops employing workers who had never had a proper apprenticeship. If you had been a shoemaker, you would have been the first to feel the effects, if a tailor, you would have been able to resist this pressure for a while longer. But each recession in trade would have made your situation weaker. E. P. Thompson sums up the first half of the century as

> a period of chronic under-employment, in which skilled trades are like islands threatened on every side by technological innovation and by the rush of unskilled or juvenile labour.[10]

The Saltaire mill near Bradford, West Yorkshire, in its day the longest building in Europe.

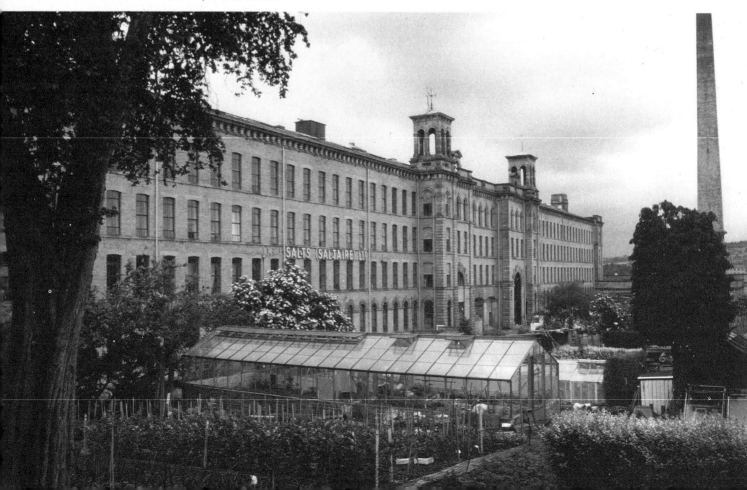

William King.

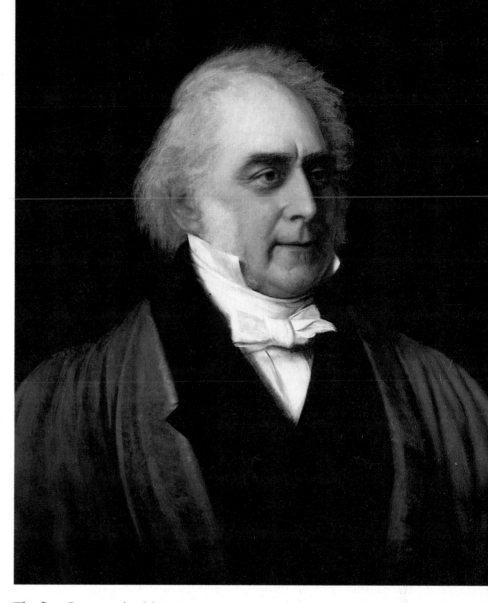

The first Co-operative Movement

It was from these depressed trades that you might have emerged as a leader of one of the many new working-class organisations; trade unions, friendly societies, co-operatives. Not only would you have been better educated than other workers, you would have seen the rise of a new master class of men who felt no traditional obligations of loyalty or authority. You would have seen your wages go down year by year, and experienced more and more short-time working and layoffs, as the new system had begun to flood the market with cheap goods which could not be sold. You would have lost control over the conditions of work and become reduced to a mere instrument of production. This is how William King, the main advocate of 'practical Co-operation', described it:

> There are persons who think that ... the labourer can never be anything but a marketable commodity, to be bought and sold by capitalists, like a log of wood, a hat or a pig. . . they infer that hats and workmen should be manufactured upon the same principle. When hats and workmen are plentiful, the manufactures should be closed for a few years or so; when scarce, they should be opened again.[11]

In the first of a series of monthly pamphlets which King wrote advocating the formation of co-operative societies, he puts the situation in all its stark simplicity:

> The rate of wages has been gradually diminishing for some hundred years, so that now it is not above one third of what it used to be ... the same causes, continuing to act, the wages must go on diminishing till a workman will not be able to maintain a family; and by the same rule, he will at last not be able to maintain himself. This conclusion it is frightful to think of, but whether we think of it or not, it will march on in its own silent way, till it unexpectedly overwhelms us like a flood.[12]

He goes on to describe how the reliance of agricultural labourers on parish relief was spreading to the skilled workers, and how, even though many would not take it out of pride, they would eventually have to turn either to charity or to crime. But it gets worse; little did he know that six years after writing, the New Poor Law would come into play, forcing those who were really destitute to enter into purpose-built workhouses where they would lose all their human rights, and leaving the rest to starve or to beg for private charity in order to survive. On the other hand, little did he know, either, that the lot of the skilled worker would gradually get better as the century wore on, as improved transport and the extension of markets helped stabilise the economy and allow some of its fruits to percolate downwards. But this could not be foreseen, and if it had it would have been cold comfort to those living day by day through the terrible 1820s, '30s and '40s.

If you were a skilled worker faced with this deteriorating prospect, what on earth could you do about it? Whatever you decided, it had to be done carefully, because the authorities, who were still frightened by the spectre of the French revolution, might react swiftly and without mercy, sometimes with sheer naked aggression, as in the Peterloo massacre, more often picking off the ringleaders and transporting them to the colonies for the crime of 'combination'. On the other hand, you would have seen the masters combine legally and successfully among themselves whenever you and other workers had tried to force up wages or resist a

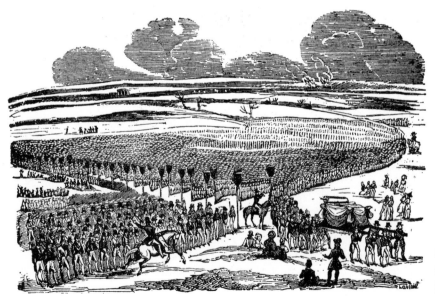

Robert Owen leading a mass procession of trade unionists to protest against the transportation of the Tolpuddle Martyrs.

wage cut, and you would have begun to feel that your only hope was to oppose this ruthless, cut-throat competitive system with one based on its exact opposite – mutual co-operation. Dr King's message was a hopeful one: 'These evils may be cured: and the remedy is in our own hands. The remedy is CO-OPERATION.'[13] I shall explain later what King had in mind, but by 1828 he could point to several working examples of Co-operative societies which appeared to offer a radical alternative. There was the London Co-operative and Economical Society, founded by George Mudie, editor of the *Sun* newspaper (it was a very different paper from its modern namesake) and some London printers. This society, influenced by the ideas of Robert Owen, the so-called 'father of Co-operation' (of whom also, more below), attempted to put into practice a plan for a self-supporting community of 250 households, and they set up the first co-operative newspaper, the *Economist*. They began with bulk-buying of produce for their own needs, estimating that such 'communal trading' would immediately cut their living expenses from £20,000 a year to £13,000.

A second London society was founded in 1824 as a centre for Owenite propaganda. There were attempts at founding co-operative communities at Orbiston in Scotland, and New Harmony in the USA, on plans laid down by Owen. But most important of all, from the practical point of view, there was the Brighton Co-operative Trading Association, formed in 1827 by Dr King and William Bryan, and used by King as the model on which he based his co-operative propaganda.

We might be surprised to find that it is that elegant and slightly decadent playground, Brighton, which emerges as the centre for radical Co-operation. But at this time, in the 1820s, it was much less fashionable, a fast-growing town which still had only two main streets (East St and West St) and, as a centre for those older trades which were being hit so hard by the new capitalism, a town hit hard by unemployment. It was the cabinet-makers, shoemakers, tailors and printers who led the way. The local trades were already organised in societies such as the Boot and Shoe Makers Society, the Society of Tailors, the Hearts of Oak Society of Carpenters and so on.[14] In 1825 they elected William Bryan, a cabinet-

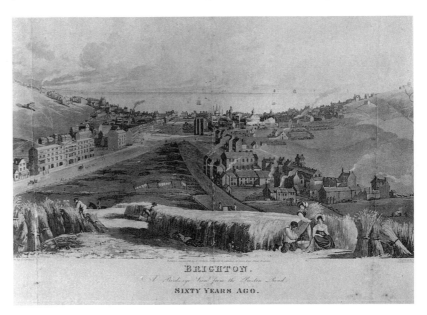

BRIGHTON.
A Picturesque View from the Preston Road
SIXTY YEARS AGO.

Elegant and slightly decadent – Brighton in the 1820s.

maker, as chair of a Committee of Brighton Trades, and after the slump in trade of 1826 they embarked on their groundbreaking experiment in Co-operation.

It will not surprise you to learn that they began with shopkeeping. They aimed eventually to make enough of a profit to invest in workshops which would provide work for their members, and then to buy some land with which to put to work unemployed members growing food. They succeeded in both these aims. But the centre of the scheme, around which it all revolved, was the store. One reason for this is plain enough; in a time of predominantly small shopkeepers, locally based and with only one or two shops each, it was not difficult for people with only a little capital to enter into the trade. Nor was it very difficult to stock up, since working-class people could only afford basic foods (bread, bacon, potatoes were the mainstays), and so a narrow range of goods would suffice. Bookkeeping skills were needed, but the Brighton co-operators already

Shopkeepers in West Street, Brighton, in the early 19th century.

Isolated 19th century industrial village housing in Styal, Cheshire.

had these, from their experience of running friendly societies (in fact, the Brighton Society was at first called by the cumbersome title 'The Brighton Co-operative Benevolent Fund Association'). Another reason, which they were very clear about, was the need for a store from which to sell products made by the members themselves; it was to be an outlet for *worker co-operation*.

Yet another reason for starting with a store was the very real need to provide cheap, wholesome provisions for members, what we now call *consumer co-operation*. In the fast-growing urban areas, workers were becoming more and more dependent on food retailers: they were no longer able to 'grow their own', many women worked full-time, sub-standard dwellings often did not have cooking facilities, and transport (before the coming of the railways in the 1840s) was still very primitive. In such restrictive circumstances, shopkeepers were in a powerful position. The most powerful of all were those employers who also owned shops, and operated the detested 'truck' system, whereby workers were forced to shop at one shop owned by their employer or by a works

The mill owners gained power over the workers by owning both the housing and the shop – luckily Samuel Gregg at Styal, Cheshire, was benevolent and his workers eventually took over the 'truck' shop as a Co-op.

manager. The worst abuses were in isolated industrial villages, where there was only one shop and no choice but to use it. Even where there was competition, the millowner could pay the workers in tickets which could only be used at one shop (this may be the origin of an old northern joke in which mean employers are said to 'pay their workers in washers'). The result was that the real wages of the workers were effectively reduced still further, because they were paying more for their food than they ought to have done. William King gives one example from the Staffordshire potteries:

> Workmen who are earning eight shillings a week have, in many cases, five shillings worth of truck, i. e. goods in kind, at thirty or fifty per cent dearer than the market price.[15]

THE NEW LANARK
Ticket for Wages.
FIVE SHILLINGS.

The shop at New Lanark, the industrial community founded in Scotland by Robert Owen, where the workers exchanged their 'tickets' (see above) for food and clothing. They were luckier than most in that Owen sold at fair prices and put the profits to use in providing schooling for the workers' children.

VILLAGE STORE
Robert Owen · 1813

The truck system was banned by Act of Parliament in 1831, but it survived in some industries such as mining, iron working and railway building until 1871.[16]

Even where the truck system did not operate, shoppers could be tied to one shop by indebtedness; when there were layoffs or short-time working, the shopkeeper would lend goods which then had to be paid for. In a study of Dukinfield cotton workers in 1841 (quoted by Burnett), six out of seven were in debt to local shopkeepers. This had at least three consequences. First, prices were higher for everyone than they would have been: William King quotes evidence that London tradesmen were charging 14–15 per cent higher prices 'to indemnify themselves against the effect of bad debts'.[17] Second, because customers were tied to the shop by their debts, and there was little real competition, profits were reckoned to be very high. Third, food was almost always adulterated.

Before the late eighteenth century there was very little evidence of food adulteration; it is a phenomenon of an urban life, in which the producer and the consumer are separated by both physical and social distance. A study by Accum in 1820 showed that almost all food and drink was more or less heavily adulterated. The most harmless examples were watered milk, the whitening of flour with alum, the adding of potatoes, beans or peas to bulk out the flour. But dangerous poisons were used in beer to bring back the flavour after it had been watered down, and hedgerow leaves and used tea-leaves were used to bulk out tea. By 1830, ground limestone was being found in flour, opium in beer, white arsenic in gin, and (it was alleged) burnt bones in bread. It was both a direct threat to health and an indirect one, in that it also made the poor poorer.[18] William King struck a chord in the hearts of his readers, when, in trying to persuade them to start their own Co-operative shops, he commented:

> It is quite notorious that every article capable of being adulterated is adulterated. There are persons who live by carrying on trades expressly for the purpose. The generality of people cannot possibly distinguish genuine articles from counterfeits. Whoever buys the counterfeit for the genuine cheats himself out of so much health and strength.[19]

This last point is crucial, because during this period only the best paid of the workers had an adequate diet. The result was restricted physical growth and rickets in children, tuberculosis and anaemia in women, and frequent deadly epidemics. As wages were reduced, bread replaced meat, then even weak tea became unaffordable. Almost half the children born in towns died before the age of five, and a high proportion of those who survived were damaged. And of course, the genetic damage was long-term: by the time of the Boer War towards the end of the century, only a third of recruits were found fit for service.

To make matters even worse, the governments of the time were also keeping the price of food artificially high. Apart from the notorious Corn Law of 1815, which kept up the price of bread and discouraged imports, they chose to raise much of their revenue from taxes on food and drink rather than through income tax (which was not reintroduced until 1842). A witness before a Select Committee investigating the plight of the handloom weavers in 1834 states that of an estimated annual wage of £22, a weaver paid over £9 in tax.[20] Not only were 'luxuries' such as beer, spirits and tobacco taxed, but imported foods such as tea, sugar,

coffee, wheat and meat were subject to tariffs. E. P. Thompson lists soap, bricks, vinegar, windows, paper, dogs, tallow for candles, and even oranges as subject to tax, and he observes: 'We sometimes forget the crazy, exploitative basis of taxation after the Wars, as well as its redistributive function – from the poor to the rich'.[21]

So the Brighton co-operators began with their store. Starting with only £5 in capital, during the first year they raised their weekly sales to £40, soon accumulating enough capital to lease a 28–acre plot on which unemployed members were put to work. They provided the practical examples, and Dr King provided the publicity for the first genuine co-operative movement which in an action-packed three years produced 300 co-operative societies all over the length and breadth of Britain and Ireland. There were societies as far apart as Dublin, Belfast and Aberdeen, in every industrial area outside Wales (which for some reason was practically untouched), and in nearly every large town.[22] It was a fantastic outpouring of hope and energy which, unlike the earliest co-operative societies, sprung up as a fully self-conscious movement, aiming to replace the uncertainties of a capitalist market with the mutual support networks of a co-operative economy. It soon attracted influential friends, who in 1829 formed the British Association for the Promotion of Co-operative Knowledge, to help spread the word. From 1831 twice-yearly co-operative congresses were established to give the movement a national focus.

Unfortunately, it was a movement which withered almost as quickly as it had grown: it continued to grow until one report estimated there were 500 societies by 1832.[23] Yet by 1834 it had almost collapsed, with only a few tenacious societies in the north of England and Scotland hanging on to see better days and to be rediscovered by the pioneers of the second Co-operative Movement.

We shall have to find out what happened to it, so that we can understand the kinds of lessons learned by the Rochdale Pioneers which made their later movement so outstandingly successful. But before we do this, we ought to find out more about the dominant ideas of the time, and the formidable task which faced co-operative philosophers in creating a coherent economic and social philosophy.

When the Co-operative Wholesale Society began its own production in 1873, purity and quality were foremost among its objectives. These advertisements show some of the early products that were manufactured.

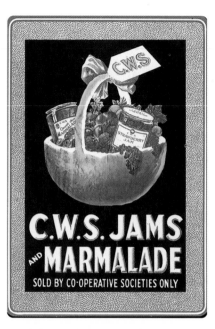

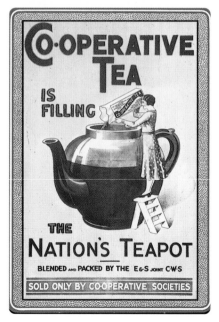

Notes

1. Mercer, T. W. (1947) p. 99
2. Rowland Prothero, quoted in Burnett, J. (1989) p. 21
3. See Burnett, J. (1989)
4. Holyoake, G. J. (1912) p. 17
5. See Thompson, E. P. (1968)
6. See Cole, G. D. H (1944)
7. See Potter, B. (1899)
8. Burnett, J. (1989)
9. Thompson, E. P (1968), p. 289
10. *Ibid* p. 269
11. Mercer, T. W. (1947) p. 119
12. *Ibid* p. 51
13. *Ibid* p. 52
14. See Andy Durr 'William King of Brighton: Co-operation's prophet?' in Yeo, S. (ed.) (1988)
15. Mercer, T. W. (1947) p. 56

[16] Burnett, J. (1989)
[17] Mercer, T. W. (1947) p. 136
[18] See Burnett, J. (1989)
[19] Mercer, T. W. (1947) p. 89
[20] Burnett, J. (1989) p. 13
[21] Thompson, E. P. (1968) p. 336
[22] Cole, G. D. H. (1944)
[23] Potter, B. (1899) p. 51

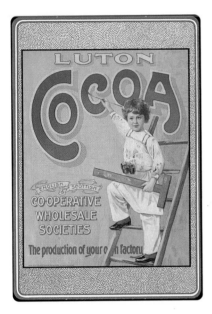

CHAPTER TWO

The philosophy of Co-operation

The remedy which we propose ... is Co-operation: not the immediate and general adoption of a new order of things, foreign to the ideas and habits of a race of beings, the very law of whose existence is HABIT; but the slow and gradual formation of small societies of the more intelligent workmen, laying aside their antipathies and animosities, and uniting their labour for a common good, attainable by union alone. (William King)

Co-operation needed practical examples in order to survive and grow, and this it got in abundance during the late 1820s and early '30s. But it also needed a coherent philosophy in order to counter the dominant ideas of the time. E. P. Thompson puts it this way: 'Alternative and irreconcilable views of human order – one based on mutuality, the other on competition – confronted each other between 1815 and 1850.'[1] That the competitive view (which was that of those holding almost all the economic and political power) should be confronted at all by a co-operative philosophy is a real achievement, and it is mainly due to two men: Robert Owen and William King.[2]

The dominant ideas of the time

Consider the arguments they had to fight against. Firstly, there was an all-pervasive religious feeling at the time, which emphasised the sinfulness of human nature, and the responsibility of the individual to seek for personal salvation. Such individualism slips easily into the complacent view that we do not have any obligation towards others, that we must seek our own salvation through work, and that the riches which result from this work are a sign of God's grace. The other side of the coin is the view that the poor are also morally responsible, that it is more important to save their souls than their bodies, and that their poverty is a sign of (and a punishment for) sinfulness and therefore not something we should do anything about.

Almost universally, the upper classes preferred to blame the victim, mistaking effects for causes: people were poor not because they had no work but because they were idle; they were ignorant not because they had had no education but because they were naturally inferior; they were addicted to vices such as drunkenness, not because they sought to alleviate their suffering but because they were naturally depraved. We will hear later of a change of heart among some prominent clergymen who gave the Co-operative Movement valuable help (the 'Christian

Socialists'), but at this time even the church leaders were in tune with what one historian sums up as 'a general attitude, which appeared at times to consign to collective perdition almost the whole of the wage-earning population'.[3]

This moral order was underpinned by an economic philosophy which was equally complacent. Before the beginning of the nineteenth century, Adam Smith had already described the main features of a capitalist economy in his book *The Wealth of Nations*, and in doing so had taken for granted the new market economy in which human relationships were reduced to the buying and selling of labour. He had been far from complacent about the prospects for the labouring classes, showing how they depended on the demand for their labour which did not guarantee them a right to exist. He had shown, in comparing Britain with America, that it was 'not the actual greatness of wealth, but its continual increase, which occasions a rise in the wages of labour'.[4] In other words, though Britain was much richer the wealth was not being shared out, while in America the demand for labour was continually growing and so the workers got a much larger share. He had also shown how the capitalists, being fewer in number than the workers and therefore better able to combine together, being able to live off their capital in the event of a strike, and being able to call on all the power of the state to help them, could almost always win an industrial dispute.

But he had also, in one famous saying, provided the 'masters' with a most potent idea justifying their new capitalist society. Smith had observed that in dealing in the market, a person is 'led by an invisible hand to promote an end which was no part of his intention'[5]; this was interpreted to mean that, through the impersonal mechanism of the market, self-interest would automatically lead to the public good; selfishness had become a public duty. He also criticised state intervention in the market as causing more harm than good: as Sydney Elliott puts it, he believed that 'the best regulated state was one which made no regulation at all'.[6] And so Adam Smith, the greatest economist of the time, seemed to be suggesting that there was no way the workers could ever do anything to better their lot, either through industrial or political action.

As if this were not pessimistic enough, along came the Rev. Thomas Malthus with a mathematical theory of population which seemed to suggest that all attempts to help the poor would only make matters worse. His theory goes like this. The human population grows geometrically (that is, by multiplying), and in the most favourable circumstances (such as the USA in Malthus' day), would double every twenty-five years or so. Even in Britain, he calculated the population was going to double during the first half of the nineteenth century (correctly, as it turned out). But the amount of food available grows only arithmetically; it might be possible to double or treble it, but eventually the rate of increase falls as the land is used up. The result is that the human population will tend periodically to crash. Either people will voluntarily limit their families by marrying late, or they will die from illness or starvation. The problem is that, in the long run, there is not much we can do about it. If we succeed in growing more food now, the crash will only come later.

Malthus did not foresee that the problem of feeding the British population would soon be solved through a combination of greater yields from agriculture and imports of food from the colonies. Nor did he realise what we now know, that it is only as people become more secure in

their living standards that they begin to limit the size of their families. His conclusion was firstly that poor relief should only be given if we can be certain that it does not encourage the poor to breed; they have to convince us that they are worthy of help. Secondly, since there is 'a natural tendency of the labouring classes to increase beyond the demand for their labour, or the means of their adequate support', we should be pessimistic about our ability 'of permanently improving their condition'.[7]

These were the ruling ideas of the time, against which co-operators had to argue.

Robert Owen

The first great breach in the walls of this individualist philosophy was made by a Welshman, Robert Owen, who had made his fortune in the cotton trade, and at New Lanark in Scotland had become one of the most enlightened employers of his day. Owen had one basic idea, that human character was not formed by people as they wrestled with 'original sin' but was formed *for* people, out of the environment in which they had to

Opposite above General view of New Lanark, the industrial village where Robert Owen tested out his ideas on human nature and the environment.

Opposite below The buildings which Owen built at New Lanark to house his workers.

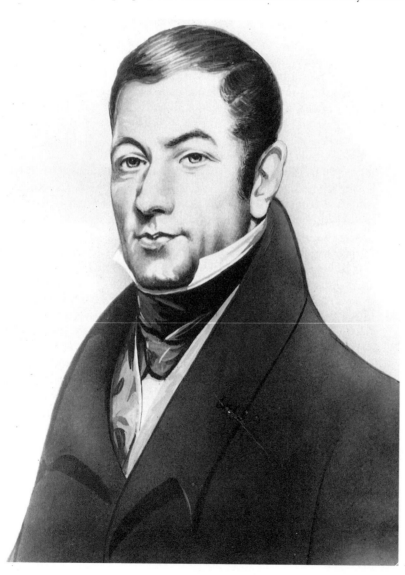

Robert Owen

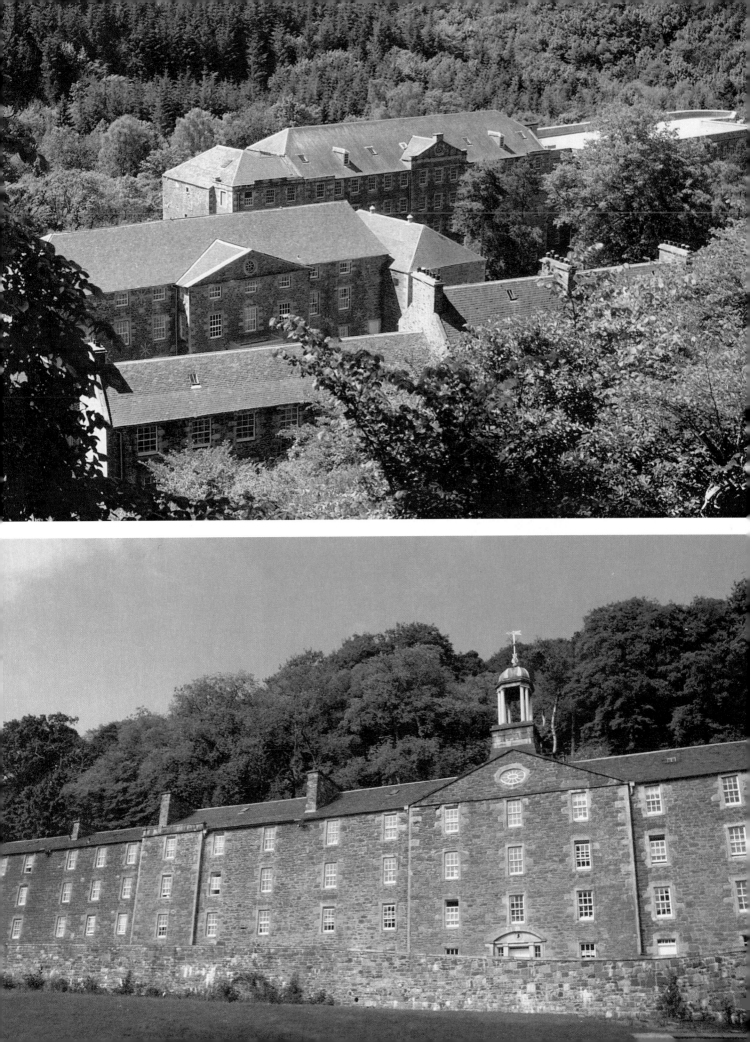

The New Lanark counting house, where Owen paid his workers in company 'tickets'.

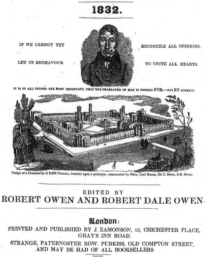

Title page of Robert Owen's periodical *The Crisis*. The engraving shows one of his model communities.

live. Put the working classes in a good environment, teach them good habits through education (preferably as early as possible in primary school, but also through adult education), and watch them change into responsible citizens. This was his message, and at New Lanark he proved its worth, building an Institute for the Formation of Character, containing school rooms, public halls, community rooms and, what is most remarkable for the times, a nursery school.[8] What followed from this main idea was a conviction that, given the right environment, people could form co-operative communities, 'villages of co-operation' just like New Lanark, which would solve the problem of poverty by allowing working-class people to opt out of capitalist society into a 'New Moral World' in which they would grow their own food, make their own clothes and eventually (under Mr Owen's careful guidance) become self-governing. Unfortunately, though he argued vehemently against religion (which

made him unpopular even with some co-operators), he retained from evangelical Christianity a naive faith that the 'millennium', an age of peace and plenty, was just around the corner.

Owen felt he had the key to unlock the secret of history, and that he only had to tell people the truth for them immediately to start creating his new world. Yet the solution to the problem of how to go about building his co-operative communities evaded him. First he turned to the aristocracy and the wealthy mill owners, who listened to him only for as long as they felt he might have a way of putting the poor to work, and so cutting down their poor law contributions. Nothing much came of this. Then he tried to work through Parliament, but was disillusioned by the ineffectiveness of the first of the Factory Acts, and soon lost interest in conventional political reform. Then with some wealthy supporters he began to form communities himself, at Orbiston in Scotland and New Harmony, in the USA; after a few years both of these failed, both

The Owenite community at New Harmony in the United States of America.

Harmony Hall, Queenwood, USA, where Robert Owen tried to establish a community in the 1820s.

through lack of capital and through lack of careful selection of community members.[9] Eventually he turned to the working classes. In 1833 he appeared at the Co-operative Congress and for a brief time became a leader of the trade union movement, forming a 'Grand National Moral Union of the Productive Classes' which he hoped would take over the entire industry of the country. Needless to say, the masters struck back, with mass discharges of workers, long strikes and lockouts. The inability of the Union to stop the transportation of the Tolpuddle Martyrs 'brought a grandiose effort to an ignominious end'.[10]

Owen had no interest in the early Co-operative Movement; William Lovett (then secretary of the British Association for Promoting Co-operative Knowledge) reported him as saying that 'their mere buying and selling formed no part of his grand Co-operative scheme'.[11] As Margaret Cole, Owen's biographer, rather scathingly comments

> A man who had just offered to run the entire territory of Texas was not likely to be impressed with the coral-insect activities of small trading and producing societies of the working classes.[12]

But he did go into trading himself, opening a National Equitable Labour Exchange in London, which was designed to enable working people to exchange goods using labour notes, which valued goods according to the time taken to produce them, and eliminated capitalist profits. The exchange idea caught on but also fell in the general crash of 1834, and Owen retreated into a kind of co-operative religion of his own making, inventing impressive titles such as the Society of Rational Religionists and sending out missionaries to preach the word to the unconverted. He was still hoping to form complete communities, and twice was persuaded to become governor of the Queenwood community, founded in 1839, but after being accused of extravagance he was forced to resign and the community collapsed. In 1837 on one of his epic lecture tours he visited Carlisle and found to his surprise that there were six or seven Co-ops still in existence. He was still adamant that 'joint stock retailing is not the Social System which we contemplate ... and will not form any part of the arrangements in the New Moral World'.[13] So why do co-operators the world over still venerate Owen as the 'father of Co-operation'?

There are two good reasons. Firstly, if he was often wrong, he was wrong in the right way; that is, while his schemes were often impractical

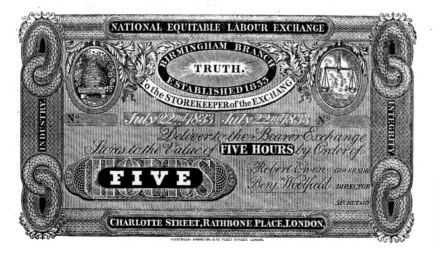

The Labour Note issued in Robert Owen's National Equitable Labour Exchange as payment for goods valued according to the amount of work put into making them.

and he was difficult to work with, he nevertheless communicated some profound underlying values. Sidney Pollard believes that what was new and revolutionary in Owen was simply this, that unlike other contemporary thinkers he believed that 'the right to a full humanity was to be available to all, even to the humble peasant and cotton spinner and street sweeper'.[14] He communicated deep values, summed up by Margaret Cole as 'kindliness, toleration, co-operation, respect for youth, the creation of a non-competitive environment in which civilised behaviour would grow up naturally,'[15] and it was this that made his working-class followers remain loyal. Secondly, his philosophy of Co-operation caught the imagination of more practical people who *were* prepared to give the co-op shops a chance, people 'who were inspired by, but did not copy, Owen'.[16] Among these were G. J. Holyoake, an Owenite missionary who became a life-long supporter of the Consumer Co-operative Movement based on Rochdale, and Dr William King. It was King who worked out, over three years from 1827 to 1830, a complete, down to earth social and economic philosophy of Co-operation.

William King

Dr William King is generally recognised as a publiciser of Owen's ideas but, as we shall see, he was much more than this. Like Owen, he believed in the ultimate aim of a co-operative community living in its own homes, on its own land, and employing its own members in productive work. Unlike Owen (who had said that while a community might build a store, a store could never build a community), King thought that it was better to begin small than not to begin at all. He also recognised that the working classes would have to do it for themselves, and set about instructing them; he started a monthly periodical called *The Co-operator*, which sold at a penny each and which (according to the poet Southey) reached a circulation of 12,000 copies.

The Co-operator was 'unquestionably the best and most influential propaganda journal ever placed at the service of the early Co-operative Movement'.[17] It was a systematic exposition of the Co-operative philosophy, combined with some shrewd advice about how to run a shop, and in 28 editions published over nearly three years it never once mentioned Robert Owen. Or rather, when it did mention him it was not by name, but to contrast 'Practical Co-operation' with 'that absurd theoretic Co-operation which has been talked of so long and to so little purpose'.[18] Nor did it fill up its pages with attacks on religion or prophecies that the millennium was just around the corner. With its mixture of practical wisdom and Christian piety it was an instant hit: it seems that in every town the paper reached, a co-operative society was formed.

William King was born in 1786 in Ipswich, the son of a Yorkshireman who was a country vicar, and in his photograph (see p. 7), taken when he was old and white-haired but obviously still full of energy, you can see the direct, shrewd gaze of a man whose judgement is worth waiting for. You feel that he is a kindly man, but one who does not suffer fools for long. Lady Byron, his friend and supporter, called him 'at once the curious combination of the Christian and the cynic – of reverence for MAN and contempt for MEN'.[19] Unlike Owen, who was mainly self-taught, King distinguished himself as an academic (studying political economy, moral philosophy and modern history at Cambridge), and then became a

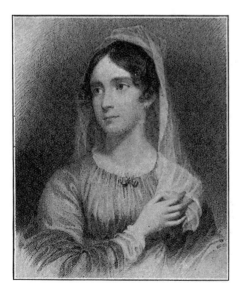

Lady Byron, friend and supporter of Dr. William King.

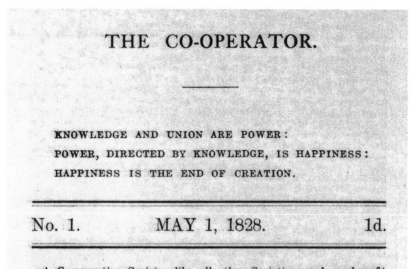

THE CO-OPERATOR.

KNOWLEDGE AND UNION ARE POWER:
POWER, DIRECTED BY KNOWLEDGE, IS HAPPINESS:
HAPPINESS IS THE END OF CREATION.

No. 1. MAY 1, 1828. 1d.

A Co-operative Society, like all other Societies, such as benefit Clubs, Trade Societies, Savings' Banks, is for the purpose of avoiding some evils, which men are exposed to when they act singly, and of obtaining some advantages which they must otherwise be deprived of.

The evils which CO-OPERATION is intended to combat, are some of the greatest to which men are liable, viz. the great and increasing difficulties of providing for our families, and the proportionate danger of our falling into PAUPERISM and CRIME.

Let us consider these more at length.

The rate of wages has been gradually diminishing for some hundred years, so that now it is not above one-third of what it used to be—but this is not all, for the same causes continuing to act, the wages must go on diminishing till a workman will not be able to maintain a family; and by the same rule, he will at last not be able to maintain himself. This conclusion it is frightful to think of, but whether we think of it or not, it will march on in its own silent way, till it unexpectedly overwhelms us like a flood.

But are we certain that this is true?—are we really approaching any thing like starvation, in spite of any labor and industry we may exert? I am afraid that this is certainly true; and I will give you other reasons for thinking so.

PAUPERISM.

Why do people become paupers?—because they must either go to the parish, or starve. And this necessity has operated so widely, that the independent day laborer has almost ceased to exist. The country laborer who can, in many respects, live cheaper than we can in a town; who can have his garden, and raise his own potatoes, &c. can now very seldom live without the parish aid: and it is a common rule to make an allowance for each child, above a certain number. The same situation has begun to beset the mechanic. He is frequently obliged to go without work a day or two in the week, or to have his wages lowered. If this goes on, he must also come to the parish.

1

C

Front page of the first issue of Dr. William King's periodical *The Co-operator*.

doctor and Fellow of the Royal College of Physicians. He settled at Brighton, where he could have made a rich living, but chose instead to become 'the poor man's doctor'.

He gained valuable experience as a visitor to the poor, but soon moved on from conventional charity work to help form a friendly society, the Provident Institution, which he hoped would eventually be able to do without charity and allow the poor to meet their own needs through mutual insurance. He helped set up a Mechanics' Institute whose aim was to educate the skilled artisans, and he gave regular

lectures. Meeting William Allen and other working-class leaders who were setting up the Brighton Co-operative Society, he learned that the friendly society approach was not enough; the working classes had to use their capital not just to insure themselves against trouble, they had to trade their way out of it. He was already forty-two when he started *The Co-operator*, a mature commentator on practical affairs, with a good grasp of political economy, who could explain Co-operative principles in language people could understand. T. W. Mercer says:

> Those who had written on the subject prior to the publication of *The Co-operator* had somehow so contrived to hide the principles of voluntary association in metaphysical fogs and foolish speculations that plain men could hardly understand what was meant by 'mutual co-operation'.[20]

His magazine, eagerly awaited by co-operators all over the country, became a kind of textbook to the new movement.

He begins by criticising the dominant ideas of the time. He starts from the same point as Adam Smith, that in the 'original state of things ... the whole produce of labour belongs to the labourer. He has neither landlord nor master to share with him.'[21] Yet unlike Smith he does not accept that the growth of landlords and masters is inevitable, that in the market society the worker will only get a fraction of the value from his or her work. King sees it as ironic that the worker, who produces 'all the wealth of the world that ever did exist, or ever will exist' has to take whatever wages the capitalist is prepared to pay,[22] wages that are determined not by the value of the product but by ruthless competition between masters, who have no choice but to compete. Trapped by the logic of the market, workers become mere hands working a machine, which, by overproducing goods, eventually puts them out of work.

How can the worker break out of this trap? We must recognise that without labour, capital is nothing; it is really only stored labour and cannot begin to work until the worker makes use of it. Why then cannot the worker take all the value from the product? Because while he or she is working to make the goods, the worker must live, and so the capitalist advances capital in order to keep the worker alive. But supposing the worker has enough capital to do this, then the product would all go to the worker. The key is to store up enough capital to get control over our own labour, and then, possessing both labour and capital, we will be able to do without the capitalist altogether. But individual workers cannot do this on their own; there is too much risk, the process of accumulating enough capital takes too long, and if we become ill or grow old there is nothing to fall back on. But together, if we learn to co-operate, we can do it.

Three decades later, Karl Marx was to see the capitalist system as about to be transformed into a higher stage of society, which he called communism. The means by which this would happen would be bloody revolution. William King also saw capitalism as about to give way to a higher stage, Co-operation, but the means was much more peaceful and constructive; the workers, once they had got hold of capital, would simply buy out the capitalists gradually until a Co-operative economy would result. There would still be competition in such a society, but it would be friendly competition to see who could run the best, most efficient co-op.

King has some sympathy with Adam Smith's argument, and he sees inequality and individual self-seeking as necessary steps on the road to

The Co-operative Commonwealth – engraving by Walter Crane.

the Co-operative society. Yet, against the pessimistic theory of Malthus that nothing can be done because of overpopulation, he really loses his temper. King argues that 'what is now called overpopulation is merely a misapplication and abuse of words', and is 'one of the most absurd and unprovable cries ever was raised'.[23] In his view, real overpopulation does not exist. What happens is that the working population produces, with the aid of modern machinery, more goods than can be sold. This overproduction then leads to unemployment, and suddenly, those who have produced all the wealth are no longer needed. Because the workers may be needed again (when the market clears and profits can again be made), they have to be kept alive on poor relief. The non-working population, who resent paying out for this, cry 'overpopulation' and wish the workers would have more restraint and not raise such big families.

King sees it as bitterly ironic that 'As soon as they have made the food, clothing or houses, or beat the enemy, then they are of no farther use – and the state is *over-peopled*.'[24] He neatly reverses Malthus' argument, conceding that:

It is possible there may be an over-population of servants, managing

A Brighter Day – engraving from the *Co-operative News*, 1914.

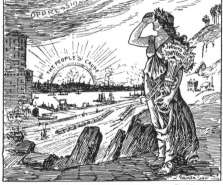

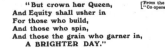

"But crown her Queen,
And Equity shall usher in
For those who build,
And those who spin,
And those the grain who garner in,
A BRIGHTER DAY."

people, head men, stewards, bailiffs, double and triple establishments – but of producers, of working-men, there cannot, in the nature of things, be an over-population for ages to come.[25]

His point is that those who produce the food, the clothes, the homes, and produce far more than they themselves can consume, cannot be unnecessary. The solution, again, is for the workers to get control of the production process, and produce for themselves. Instead of working sixteen hours per day and overproducing, they can work, say, eight hours, using the new machinery sensibly, gearing production to their needs, and having time for leisure and education.

The method by which they will achieve this, or the remedy (the good doctor's prescription) is co-operation. Capital must be accumulated, partly through weekly subscriptions (as in the friendly society), partly through the surplus from trading. Then work can be found for members

Owen may have despised the humble Co-op store, but it spread even to his birthplace, Newtown in mid-Wales.

After several false starts, by 1888 Brighton Co-operators had vindicated King's faith in Co-operative storekeeping.

until all are employed. Then the co-op can afford to pay sickness benefits, it can purchase land to live on and keep unemployed members in work growing food. Eventually, pensions and education for the children can be afforded, and a whole new society-within-society will emerge, independent of both capitalists and state welfare. This is the old Owenite dream of a community, but King is too shrewd to leave it there. He suggests an alternative, that if members wish to remain in the town they can get the same advantages, but without cutting themselves off from the wider society; this is, of course, exactly what the Rochdale Pioneers found, as they gave up the community ideal and settled for a stake in existing society. In either case, King advised, they should start with a shop, because 'We must go to a shop every day to buy food and necessaries – why then should we not go to our own shop?' Even before setting up shop, people can buy goods in bulk and divide them, and they can exchange the 'domestic articles' that they themselves make. So King's achievement (which so many social philosophers aim at but rarely succeed in), is to provide a vision of the future and a means of doing something constructive today. We are told what we are aiming at, *and* where to begin. What do we need to make it work? At a superficial level, we need rules: do not give credit, appoint three people as trustees, do a weekly audit of the accounts, only allow as members people who you can trust (and not over 35 years of age, because after this they will be worn out), and meet in a room but not in a pub, because members will be tempted to drink the surpluses before they are made. At a deeper level, members need to bring with them the right values and attitudes. Firstly, we need commitment to the idea of voluntary association; there is no short-cut and, while the state will be needed to provide a co-operative law, it cannot be relied on to help Co-operation to flourish:

> Co-operation is a voluntary act, and all the power in the world cannot make it compulsory; nor is it desirable that it should depend on any power but its own. For if Co-operation (as seems likely) be the form which the greater part of the world is destined to assume, the interference of governments would only cramp its energies and misdirect them.[26]

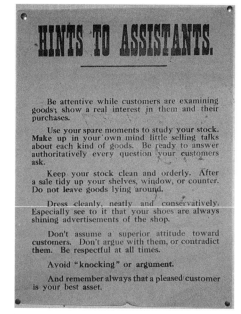

'Hints to Assistants' poster in an early Ipswich Society store.

'The Shop for the People' – a Co-op store in South London established in 1890.

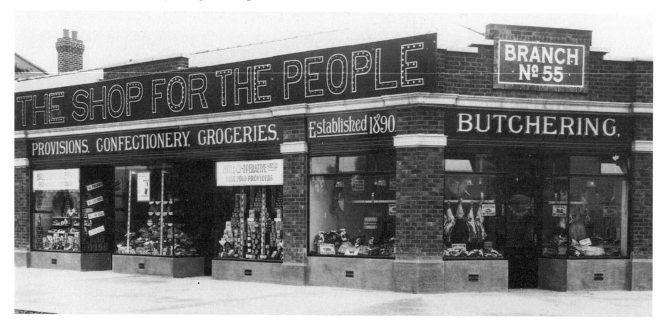

A Brotherhood of Co-operation – early
Co-op store in the London area.

Secondly, we need to be educated both generally and in the principles
and practices which King is discovering; the greatest obstacle he can see
to the extension of Co-operation is ignorance. This is why on the one
hand he puts so much stress on providing adult education through lec-
tures, meeting rooms and news rooms, and on providing a school for
members' children. And on the other hand, he is concerned with the de-
tailed knowledge required to run a business, buying and selling wisely,
keeping accurate accounts; the failure of co-ops, King observes, may be
traced more often than not to 'want of a rigid system of accounting'.
Thirdly, we need to have a fellow-feeling for other members, a desire to
put common needs before self-interest; 'Mutual regard, friendship and
affection become then as binding upon a member as the duties of com-
mon honesty and sobriety.'[27]

Does this mean that only saints can become co-operators? In a sense,
yes, because as King flatly declares 'No man but a real Christian is fit for
such a Community.'[28] But this overlooks the beneficial effects of actually
being in a society which, by its very structure, binds people together: 'In
a community, our own interest is much better secured in that of the com-
munity than we could possibly secure to ourselves; therefore interest and
duty would go hand in hand.'[29]

We will see in the next chapter that this did indeed happen (though
only after two more fundamental principles were discovered, of open
membership and the regular provision of dividends on purchases): that
Co-operation leads to lasting friendship and mutual esteem has been a
common experience of co-operators ever since. It is strengthened by yet
another social process which many academic sociologists writing since
King have missed, but which he, to his great credit, clearly identifies – the
force of *habit*.[30] This propensity to do habitually what you have become
used to doing is the great conservative force in the world. It can prevent
change, and no doubt makes the initial commitment to co-operate
harder. But once we have learned to co-operate, we begin to do it natu-
rally; as King puts it 'The workman ... has acquired all the elements of
Co-operation and wants only to be habituated to the practice of it.'[31] So

there we have it, a complete Co-operative philosophy, containing an understanding of the dynamics of competitive and co-operative economies, of the factors which make for success or failure, and of the underlying social processes which make people work together for the common good. All that William King needed now was for the Co-operative Movement to prove him right.

So what happened to that first Co-operative Movement?

There are two types of explanation for the rapid decline of the first Co-operative Movement, one based on outside events, the other on internal weaknesses. The external explanation focuses on the fact that, being disappointed by the 1832 Reform Act which did not give them the vote, and being bitterly opposed to the New Poor Law of the same year, many working-class people turned to political agitation through the Chartist movement, abandoning the Co-op shops as being less important than the quest for political power. Beatrice Potter says that leading working men who had acted as secretaries and managers to the Co-op shops 'were now sedulously occupied in preparing the People's Charter, and carrying out a vigorous political campaign in all parts of the country'.[32] At the same time, national-level trade union organisations were being formed to fight the 'masters' through the more impatient method of the strike. Robert Owen also seemed to offer an alternative to the shops in his labour exchanges, in which workers could exchange their products for 'labour notes' based on the time it had taken them to make the goods; although these exchanges eventually collapsed, they too may have been a distraction. In fact, Owen may, during these years, have been doing more harm than good. Arnold Bonner says 'It may well be that if Owen had remained in America, the early Co-operative Movement would have grown and fulfilled its early promise.'[33]

On the other hand, supposing some co-operators had continued to run the shop as well as agitating for political change through Chartism (after all, as we shall see, some of the Rochdale Pioneers were also Chartists).

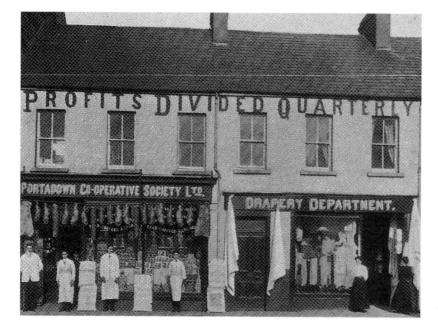

Early Co-operative store in Portadown, Northern Ireland, which highlights the Rochdale principle of returning profits to the members.

The explanation then becomes that in the general crash of working-class hopes when, in 1834 the state began to turn to outright repression, the co-ops also fell apart.[34]

But the internal weaknesses were probably much more important. To begin with, the co-ops had no legal status: there was no remedy against fraud, the societies could not rent or own property in their own right but had to do it through individuals, and the capital of the society belonged legally to no-one. However, the Rochdale movement started under the same conditions, and only got legal status when the first Industrial and Provident Societies Act was passed in 1852. This weakness would account for a few failures, but not for the majority. Secondly, there was sometimes a lack of loyalty to the store; one witness, William Lovett says 'The wives of members preferred to deal with private traders, who provided more choice and granted longer credit.'[35] Thirdly, since William King stresses the need for accurate weekly bookkeeping, we can assume that some societies suffered from a lack of commercial experience. Fourthly, Beatrice Potter suggests that those who did eventually employ their own members had then to try to sell their products through the shop, and they may have become overburdened with goods they could not sell.[36] Fifthly, they may also have built up cash-flow problems through not insisting on cash payment: Holyoake cites this as the main weakness, that the societies had been 'stranded by credit'.[37]

But the most important reason for failure may be found in the history of the Brighton Society. Lady Byron was in no doubt that this had 'entirely failed, owing to its violation of some of the fundamental principles of Co-operation'.[38] What were the principles and how had it violated them? The story goes that after a few years the society became so successful that some members wanted to cash in their shares in order to build themselves a fishing boat (which they did, realising a profit of £4 per week from an investment of £140). Now this would not have been a problem, except that these early societies had a limited membership and had not found a way of distributing their trading surpluses; they expected to go on accumulating capital until they could employ all the members in manufacturing goods which would then sell through the shop. So the main reason for the disappearance of the societies was probably this, that some members would have got impatient, either because they were experiencing hard times in their trade or because they were just plain greedy, and would have broken the society up or turned it into a private company, in order to get at their profits.

So it was a failure in the *structure* of the co-ops which was crucial: the inability to distribute some of the fruits of co-operative trading to the members, so that they would remain loyal. We shall see in the next chapter how the Rochdale Pioneers solved the problem by admitting unlimited numbers of members and distributing surpluses as a dividend on purchases. This was all it took to make the whole enterprise once again viable. It is a pity that we cannot travel back in time to, say, 1826 and tell these early co-operators what would go wrong. They may not have listened in any case, because their leaders were still committed to the idea of eventually setting up a self-sufficient co-operative community, which necessitated both rules: limited membership and the accumulation of common capital. In any case, William King was not too worried about failure. As he reached the end of his series of *The Co-operator*, he

declared:

> These Societies constitute a new and grand experiment, the results of which cannot but be interesting and instructive, whether they prove or disprove the practicability of the system.[39]

King died in 1865, having lived to see the Rochdale system triumph even though his own movement had failed. He was not involved much with the 'Co-op' after 1830, but at the very end of his series of monthly pamphlets he had already, unwittingly, written his own epitaph to this, the first Co-operative Movement:

> Time and experience are as necessary for Co-operation as for other institutions: many mistakes may be expected to be made – some failures may happen from ignorance and inexperience: but even these will be productive of good, and great teachers of true principles.[40]

Just how great a teacher of 'true principles' this movement was will become evident in the next chapter.

Notes

[1] Thompson, E. P. (1968), p. 226
[2] William Thompson, a disciple of Owen, is not mentioned here, but he is also said to have had an influence, particularly in his argument for the 'labour theory of value' – see Hall, F. and Watkins, W. (1937)
[3] Tawney, R. H. (1938) pp. 265–6
[4] Smith, A. (1982) p. 172
[5] Smith, A. (1970), p. 339
[6] Elliott, S. (1937) p. 24
[7] Malthus, T. (1982) p. 270
[8] See Cole, M. (1953)
[9] For a full account, see Garnett, R. G. (1972)
[10] Elliott, S. (1937) p. 30
[11] Cole, M. (1953) p. 177
[12] *Ibid* p. 177
[13] *Ibid* p. 212
[14] Pollard, S. and Salt, J. (1971) p. x
[15] Cole, M. (1953) p. 244
[16] Butt, J. (ed) (1971) p. 9
[17] Mercer, T. W. (1936) p. 13
[18] Mercer, T. W. (1947) p. 134
[19] *Ibid* p. 4
[20] *Ibid* p. 14
[21] Smith, A. (1982) p. 167
[22] Mercer, T. W. (1947) p. 60
[23] *Ibid* p. 115–6
[24] *Ibid* p. 115
[25] *Ibid* p. 116
[26] *Ibid* p. 125
[27] *Ibid* p. 77
[28] *Ibid* p. 54
[29] *Ibid* p. 54
[30] See Birchall, J. (1989)
[31] Mercer, T. W. (1947) p. 126

Co-operative values expressed in the slogans on Women's Guild banners.

[32] Potter, B. (1899) p. 56
[33] Bonner, A. (1970) p. 40
[34] See Cole, G. D. H. (1944)
[35] Potter, B. (1899) p. 53
[36] *Ibid* p. 54
[37] Holyoake, G. J. (1857)
[38] Mercer, T. W. (1947) p. 29
[39] *Ibid* p. 162
[40] *Ibid* p. 126

CHAPTER THREE

The Rochdale Pioneers

The advantages, therefore, of the working classes having shops of their own are no longer matters of speculation and conjecture, but of successful experiment. (William King)

If you could choose where and when to be born, you would not have chosen to be born into a weaver's family in and around Rochdale in the early 1840s. Rochdale was at this time a small town of around 25,000 inhabitants, with another 40,000 people living in satellite villages and hamlets dotted around the moors. The people had for centuries past been mainly dependent on the textile industry, spinning and weaving wool and cotton; Rochdale was famous for its flannels. You might have been a coalminer, because there were many small mines in the area, especially now that steam power had arrived (the new mills had a terrible hunger for coal). Or you might have been a small farmer, since there were more family-owned farms here than anywhere else in Britain, and you could mix sheep-farming or dairying with weaving to make a reasonable living.[1] But the chances are you would have been one of the handloom weavers who at that time were still the largest single occupational group, and who were fighting a losing battle to maintain themselves against the new factories with their steam-powered looms which were slowly putting them out of business.

The plight of the Rochdale weavers

Here is what one Poor Law commissioner found in the hamlet of Milkstone, in 1841, just two years before a group of Rochdale weavers decided to start their own Co-op. Edmund Butterworth had had no money for five weeks to support his family, and was in 'extreme destitution'. John Kershaw, father of four children, had a cottage with just two beds, one with no blanket. John Binns, head of a family of six, had straw for bedding and no beds, blankets or sheets. The worst case was Thomas Blomley's family of six; with a weekly income of two shillings, he was paying one in rent, and the family were literally starving. Hundreds of weavers around Rochdale were in a similar condition,[2] and so were thousands in other northern towns such as Bradford, Halifax, Huddersfield, Todmorden and Bolton. From all around came reports of weavers clothed in rags, who had sold all their furniture, who worked 16 hours a day yet lived on a diet of oatmeal, potatoes, onion porridge and treacle.[3]

To make matters worse, those who lived in the towns also suffered

Print of Rochdale in the 1780s.

Photograph of Rochdale in the 1890s. Compare Rochdale in 1780 and 1890 – the industrial revolution had done its work.

Squalid conditions in a Rochdale courtyard.

from dangerously insanitary conditions. A local historian describes it like this: 'surrounded by hills and open moorland, Rochdale was by the 1830s choking on smoke and squalor'.[4] Half the streets had no sewers or drains, and they were clogged with filth which was never cleaned away. The worst houses had no toilets, and those which had often shared them with up to ten other houses. In the worst area 45 out of every 1000 people died each year. In 1848 (when the Rochdale Pioneers' shop was just beginning to establish itself), the life expectancy was 21 years, worse than almost any Third World country today, and six years lower than that for England as a whole. An average Rochdale boy of 13 was found to be about the same height, but over two pounds lighter than a public school boy of 11.

But this did not mean that those in hamlets such as Milkstone were much better off, since in their weakened state diseases would have reached them as well. A surgeon investigating an epidemic of typhus in a hamlet near Heptonstall declared 'How they contrive to exist at all. . . confounds the very faculty of eyes and ears.'[5] And there was a dreadful irony in all this. He reported that women were having to give birth standing up, their arms round two other women, because they had no change

35

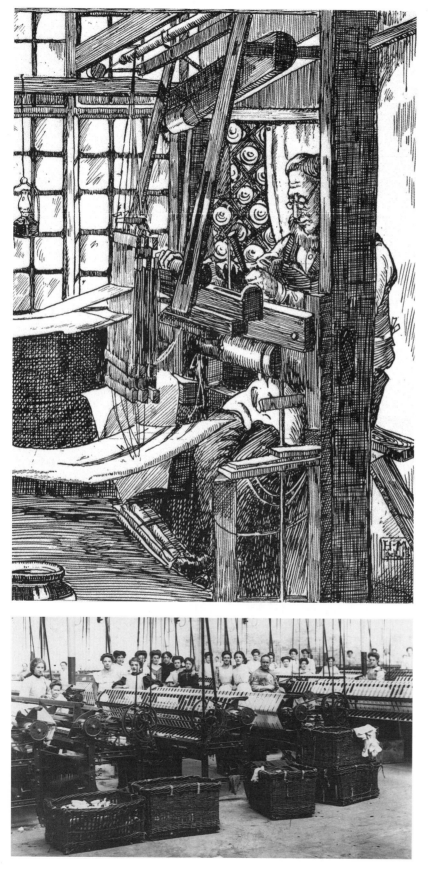

The transition within a few years from the male handloom weaver, self-employed and working from home (above), to the wage-earning and mainly female mill worker (left).

Owen's idea of co-operative communities appealed to some – drawing of the Charterville estate from the *Illustrated London News*, 1848.

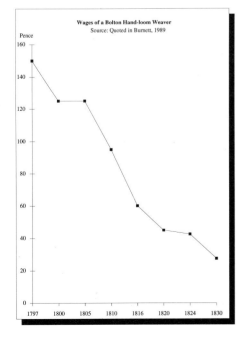

Wages of a Bolton Hand-loom Weaver
Source: Quoted in Burnett, 1989

Pence

of bedclothing; the very people who had spent their lives weaving clothes and blankets for the world had come down to this, rags on their backs and no blankets on their beds.

To make matters worse, the weavers were (as one eminent historian put it) 'haunted by the legend of better days',[6] and the memories were strongest in Lancashire and Yorkshire, where they also lingered longest. Take a look at any weaver's cottage of the eighteenth century, as far apart as Lancashire or the Cotswolds, and you will find it well designed and solidly built; it is a symbol of the 'golden age' of the weaver, when a whole family could be well employed on a mixture of self-employed weaving and small farming, with spinning for the children, and harvest work to provide variety in the autumn. What had happened to reduce them to such destitution in the course of only two generations? The most obvious culprit was mechanisation, the invention and eventual spread of power-spinning and weaving machines, and the growth of the factory system. But before that there had been an even more important loss, of independence. In the woollen industry, a whole host of small 'masters' who had been able to buy and sell in a free market had become reliant on large merchants, mill agents or middlemen, who had 'cornered the market' in cloth and were able to use their power gradually to force the earnings of the weavers down (see graph left).

In the cotton industry, there had been an amazing expansion of weaving throughout south-east Lancashire, but the boom disguised a fundamental loss of status among the workers; once they had become dependent on the spinning mill and its 'putter-out' of weaving, weavers were exposed to round after round of wage reductions. The old apprenticeship system had collapsed, overwhelmed by newcomers such as agricultural workers, demobilised soldiers and Irish immigrants who, with a rented loom in a cellar dwelling, were prepared to undercut the traditional 'journeymen weavers'. Isolated in their rural hamlets, unable easily to find out what others were being paid, often in debt to the 'putter-out' from the last period of 'short-time' working, the weavers had to take what wages they were offered.

Even in the good times, when output rose, wages still tended to

decline, since good employers who wanted to pay a living wage were undercut by unscrupulous ones who could always find someone to work for less. So in a trade depression times were especially hard, since people were laid off altogether; that of the early 1840s was 'almost certainly the worst of the whole century'.[7] Two years before the Rochdale Pioneers opened their shop, in Bolton 60 per cent of workers were found to be unemployed. In Rochdale, the local MP reported that 136 people were living on six pence per week, 200 on ten pence, 508 on one shilling and six pence, and 1500 on not more than one shilling and ten pence (less than 10p today). Five out of every six had hardly any blankets left to keep out the winter cold.[8] There was a procession of 2,000 women and girls through the streets of Rochdale; John Bright, the factory reformer, described the scene thus:

> They are dreadfully hungry – a loaf is devoured with greediness indescribable, and if the bread is nearly covered with mud it is eagerly devoured.[9]

A strategy for survival

What could the Rochdale weavers do about their situation? There were among them many self-educated people who were quite capable of working out a strategy; they belonged to communities with a continuous history of three or four hundred years, each of which 'had its weaver-poets, biologists, mathematicians, musicians, geologists, botanists' and so on. They had been taught by their parents and with some easier kinds of weaving had been able to teach themselves with a book propped up on the loom.[10] They had been brought up on a deep sense of social equality, and placed a high value on independence, but the solutions they sought

One of the Charterville cottages where two of the Pioneers tried out the rural 'utopia' – after two years they gave up and returned to Rochdale.

to their plight were communal ones, not those of self-help for a few individuals:

> It was as a whole community that they demanded betterment, and utopian notions of redesigning society anew at a stroke – Owenite communities, the universal general strike, the Chartist Land Plan – swept through them like fire on the common.[11]

There were in fact several alternatives. Firstly, they could try to *opt out of modern society* by forming their own communities. Owen's idea of co-operative communities appealed to some of them; a small but dedicated band of 'Owenite socialists' set up a 'Social Institute' in Yorkshire Street, Rochdale, and five of the Pioneers put money into the last of the Owenite communities, Queenwood. But by the early 1840s it had become clear that only a privileged few would get to live in a community, and that success was not guaranteed; Queenwood was in trouble, with extravagant building plans, dissension between the upper class supporters who had hired manual labourers to do the work and the working class Owenites who wanted genuine equality of labour.[12] Yet the attractions of opting out remained, and when Feargus O'Connor visited Rochdale in 1843, many weavers and other Rochdale workers invested in his 'Land Colonies' idea. In this scheme, shareholders were offered a chance to win a cottage and a few acres of land in a lottery, and huge sums were invested; in fact, Holyoake tells us that the Pioneers Society had, for the first few years, to compete with O'Connor's bizarre scheme for funds, and he believed that 'much of the zeal and enthusiasm necessary to the success of a new society were lost to the Co-operative cause'.[13] Samuel and Miles Ashworth, two of the original 28 Pioneers who were (respectively) its first salesman and president, won a two acre plot at Charterville in Oxfordshire, and for two years left Rochdale to try their hand at the 'rural idyll', before returning home disillusioned.[14] They never gained proper title to their land, because O'Connor's legal and financial affairs were in a terrible tangle, and they must have found that two acres were hardly enough to live on.

Second, the weavers could take *political action*, lobbying Parliament to try to get a minimum wage set by a wages board, to limit the hours of

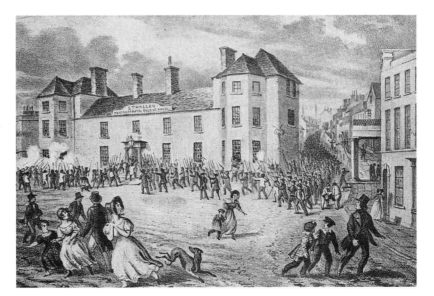

A Chartist riot in 1839 at Newport, Monmouthshire.

work in factories so that work could be shared out more fairly, and to protect the wages of men against undercutting by women and child labour. Unfortunately, though they had friends in Parliament (Richard Oastler and John Fielden), these were not enough to counter the political dominance of the free marketeers, and bills to bring these measures in during the 1830s all failed. A Royal Commission was set up to investigate their plight, but it was staffed by ideologues of *laissez faire*, who believed from the beginning that any interference in trade would make matters worse. The result was that the weavers were propelled into militant Chartism, the movement which during the late 1830s swept through Britain in a wave of mass actions designed to force the government to give working class people the vote. Several of the Rochdale Pioneers were Chartists, but by 1842 the movement was beginning to collapse, its leaders jailed or transported, its supporters demoralised.

Third, the weavers could take *moral action*, either by taking refuge in religion or by teetotalism. There was a bewildering variety of non-conformist sects to choose from in the Rochdale of the time. Some of the Pioneers were Unitarian Methodists who had seceded from a local sect of 'Cookites' who had in turn seceded from Methodism. In fact it was very difficult at that time not to have a religious attitude to life based on Christian non-conformism of one type or another. The Owenites themselves, though as 'rationalists' they claimed to offer a secular alternative to religion, were organised along the lines of a religious denomination, and were often engaged in heated controversy over whether they were deists or atheists. An easier alternative was teetotalism, which offered the moral high ground and, because it saved wages from drink, some tangible economic benefits; several of the Pioneers must have been teetotallers, because one of their objects was the opening of a temperance hotel. However, as Holyoake points out, neither religion nor moral reformism could alter the brute fact that even for the virtuous there was not enough work available and no guarantee of a living wage.[15]

Fourth, the weavers could take *economic action*, through trade union activity. This took the form of strikes and riots, of which there were several, in 1808, 1827, 1829 and 1830, when the weavers would go from house to house collecting the shuttles from the looms and locking them away to prevent people from working. By the 1842 strike, G. D. H. Cole tells us, mechanisation had advanced so far that this practice was replaced with the pulling of plugs from the factory boilers. Then in 1844 the Weavers' Union agreed a wage scale with the more enlightened employers, and then targeted those who would not agree with selective strikes. As the strike proceeded, it became more and more difficult to support those who were 'out' with the pitiful two pence a week subscribed by those still in work, and the strike collapsed. The weavers began to ask if there was a better way of improving their situation. They approached the small band of Owenites in the town, to ask about the possibility of opening a co-operative store.

This was not such a radical new idea as we might think. The Owenites in Rochdale were much more pragmatic than Owen himself, and had long supported the idea of shopkeeping. In fact, there had already been one attempt at Co-operation in Rochdale. In 1830, after a previous strike, flannel weavers had formed a Rochdale Friendly Co-operative Society. It had had around 60 members, and a small library and sent a delegate to the Co-operative Congress of 1831. In 1833, probably arising

out of this society, came a store, which seems to have lasted until 1835, when it foundered through having given too much credit.[16] Charles Haworth and James Standring, two of the most active of the Pioneers, were both associated with this venture, as was John Mitchell, the grandfather of one of the most important Co-op leaders of the century, J. T. W. Mitchell. The failure of this earlier society does not seem to have stopped them trying again; many valuable lessons would have been learned. They were well aware, also, of Dr King's contribution to this earlier movement; James Smithies presented a complete set of Dr King's *Co-operator* to the library, and it was read by Samuel Ashworth and other Pioneers.

The founding of the Rochdale Equitable Pioneers Society

There was one option open to the weavers which has not yet been mentioned – emigration. A few poor weavers who got together at the end of 1843 to decide what to do considered this seriously, but as Holyoake says in his history 'that seemed like transportation for the crime of having been born poor'.[17] They turned instead to the idea of Co-operation, and resolved to put down the two pence a week which they had been used to paying into the Weavers' Union. They had learned that strikes were simply a waste of money, and wanted to do something more constructive. So, as Holyoake drily observes, these 'Lilliputian capitalists. . . fell back upon that talismanic and inevitable twopence, with which Rochdale manifestly thinks the world can be saved.'[18] They needed advice, and got plenty of it from the teetotallers, the Chartists and the Owenite Co-operators, but it was the last that they listened to, realising that, as Holyoake puts it, the day of redemption would be a long time coming, if they waited for the working classes to become teetotal and the government to concede everyone a vote.

It was not, in any case, an either/or decision. Several of the Pioneers were both Chartists and Co-operators, and were probably teetotal as well; it was only the diehards that insisted they had to follow one line to the exclusion of others. It was resolved that 'the weavers should co-operate, and use such means as they had at command to improve their condi-

Three of the original Pioneers – William Cooper, Charles Howarth and James Smithies.

The Pioneers' store in its original state (left) and after external alterations (above).

tion, without ceasing to be either Teetotallers or Chartists'.[19]

Five of the Pioneers assisted the weavers, and a committee was formed. Then, at a meeting three days later (15 August 1844) it was resolved that the Pioneers Society should begin. The list of 28 subscribers at this meeting gives us some idea of the sort of people who were attracted. The weavers had partly been superseded by better-placed artisans; of the original 28 men who signed up as members, only eight were flannel weavers (though more than half were in the textile trades), and there were two shoemakers, a clogger, a tailor, a joiner, cabinet-maker, and so on. As the official historian of the Co-operative Movement observes, these were men moved more by idealism than by hunger;[20] perhaps those who were hungry had not found the time or energy to see the project through. Half of them were Owenite Co-operators, five were Chartists, but careful piecing together of all the sources shows that at least another five were both Chartists and Co-operators, and some, like Charles Howarth, were involved in agitation for the Ten Hours Act, or like James Standring were also active Unitarian Methodists. Some were definitely also Teetotallers.

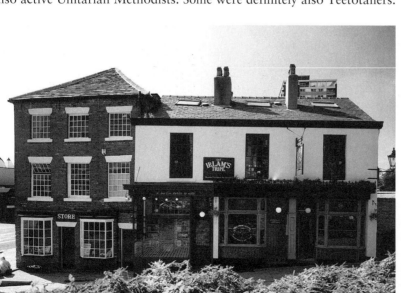

All that remains today of the original Toad Lane in Rochdale – now a conservation area with the original Rochdale Pioneers' store as a museum.

So all the Rochdale working-class movements were there.

At this meeting of August 15th the objects and rules of the Society were agreed. This was no hole-in-corner affair; the rules were adapted from an existing friendly society, and were registered on October 24th with the Registrar of Friendly Societies. Nor was it unsophisticated; as we shall see when outlining the rules below, it was very well thought out. Yet it was a pitifully small affair. There were forty subscribers, who agreed to pay three pence a week (just over 1p) to raise capital in order to open a shop. They raised £28 (a minimum shareholding of £1 each) and succeeded in renting the ground floor of an old warehouse (31 Toad Lane) for three years, at £10 per year, but only (according to Holyoake) because Charles Howarth agreed to put the lease in his name; the landlord did not trust the new Co-op. Toad Lane probably means 'the old lane' in Lancashire dialect but, as Holyoake dryly observes, its name did it no injustice. The premises were far from ideal, and some of the wives of the Pioneers were at first too ashamed to shop there. After repairs were made and fittings bought, there was only £16 left to buy stock, so they bought twenty eight pounds of butter, fifty six pounds of sugar, six hundredweight of flour, a sack of oatmeal and some tallow candles. One local shopkeeper boasted, with some justification, that he could come and cart the whole stock away in a wheelbarrow.

William Cooper was appointed cashier (Holyoake says his duties were very light at first), and Samuel Ashworth salesman. Let Holyoake take up the story, as the shop was about to be opened, on December 21st, 1844:

> It had got wind among the tradesmen of the town that their competitors were in the field, and many a curious eye was that day turned up Toad Lane, looking for the appearance of the enemy; but like other enemies of renown, they were rather shy of appearing. . . there they stood in that dismal lower room of the warehouse, like the conspirators under Guy Fawkes in the Parliamentary cellars, debating on whom should devolve the temerity of taking down the shutters. . . at length one bold fellow, utterly reckless of consequences, rushed at the shutters, and in a few minutes Toad Lane was in a titter.[21]

The local lads had gathered to make fun of them, but as Holyoake observed:

> many a bountiful and wholesome meal, and many a warm jacket have they had from that Store, which articles would never have reached their stomachs or their shoulders, had it not been for the provident temerity of the co-operative weavers.[22]

At first they opened on Saturday and Monday evenings, and the committee met weekly at the Weavers' Arms. But after three months they were able to open every weekday evening except Tuesday, and they added tea and tobacco to their stock. At the end of the first year, the total takings were a modest £710, the membership was 74, their capital had grown to £181 and they had made a surplus (not a profit – we shall explain the difference later) of £22. Progress was slow: they had to buy in small quantities, and the price and quality were not always good, some of the members were in debt to local shops and were constrained to shop there (in fear of legal action to recover the debt if they did not), and some of the members' wives were not keen. Holyoake declares 'If there are to be

Recreation of the Pioneers' original store with its simple fittings.

moral sellers, there must be moral buyers.' Luckily, he goes on to say,

> a staunch section of them were true co-operators, and would come far and near to make their purchases, and, whether the price was high or low, the quality good or bad, they bought, because it was their duty to buy.[23]

Yet the directors must have been disappointed; at one point James Daly proposed that non-buying members should be expelled, but Charles Howarth said it would destroy the freedom of the members, and the motion was withdrawn.

A trade depression could have wiped them out in 1847. Since 1845 all resistance to the New Poor Law had ceased in Rochdale, and so there was no unemployment relief available. Some members had to withdraw their capital in order to survive, but the Society continued to grow, though the surplus was down. 1848 began with great distress, but at its end trade was up to £2,276, capital to £397, the surplus to £118. 1849 was the turning point. The Rochdale Savings Bank collapsed, and many people lost their savings. They rushed to join the Co-op, which was now the only safe haven for their money. Membership grew from 140 to 390, trade from £2,276 to £6,612, capital from £397 to £1,194, and the

surplus from £118 to a remarkable £561.

From 1850 the trend was nearly always upwards. The Pioneers were helped by the fact that food was becoming cheaper – the Corn Laws had finally been abolished, and tariffs on imported foods were being reduced. There were signs at last that the enormous wealth generated by the industrial revolution was filtering down to the working classes, though as we shall see there were still some very lean times to come. Membership grew steadily, until by 1880 the original 28 Pioneers had been multiplied 379 times (see graph top left). It only faltered twice. Membership fell in 1862, the year of the cotton famine, when the civil war in the USA prevented raw cotton from being imported, and there was massive unemployment and short-time working in Lancashire; nearly 400 members (around 10 per cent) had to withdraw all their savings to survive, but they soon rejoined. Membership fell again by nearly 20 per cent in 1868–70, when there was a split in the Society and a rival co-op took several hundred members away, but it soon recovered. Capital invested in the Society grew dramatically, falling only a little during the cotton famine: £22,000 of members' savings were withdrawn, but the net fall was less than £4,500 (see graph top right). It fell heavily during the three years following the split in the Society, to two-thirds of its previous level, but then it recovered, and thereafter the Pioneers had an embarrassment of capital; it reached well over £300,000, losing only a little in 1879 with the trade depression. Sales figures are always the most affected by adverse circumstances, and they fell four times, three briefly because of trade depression and once, after the split in the Society which seems to have affected sales quite badly, by around 23 per cent; they took six years to recover their former level, but at least the trade was lost to another co-op (see graph bottom left). Surpluses made from trading (before interest on

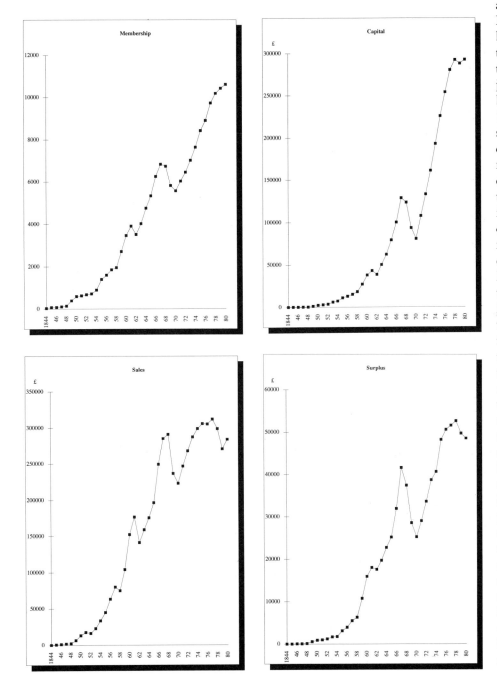

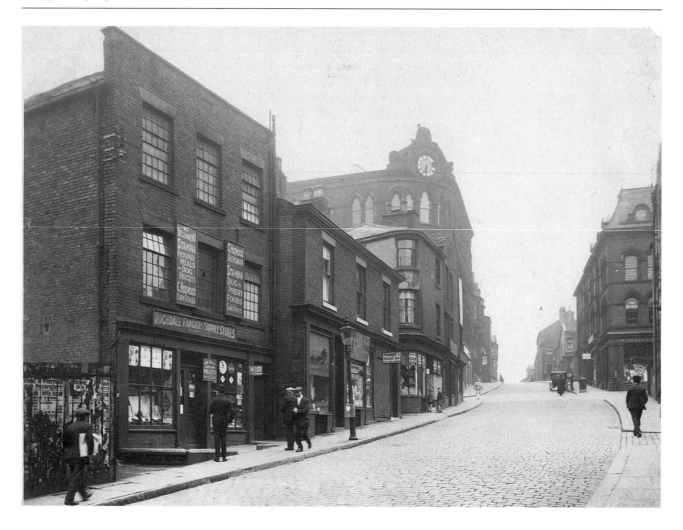

Toad Lane, Rochdale, in the early 20th century, showing the Pioneers' original store converted into a private pet shop and the imposing new Co-op central premises farther up the street with its clock and beehive sculpture.

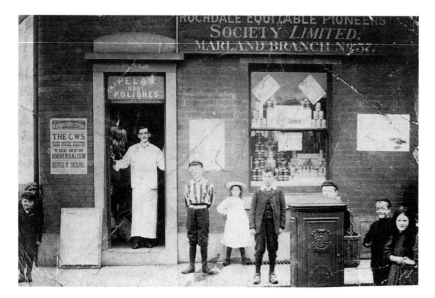

Wider still and wider – the Pioneers' branch store in Marland was the 37th to be opened.

Engraving of the Rochdale Pioneers' central store in Toad Lane in 1868.

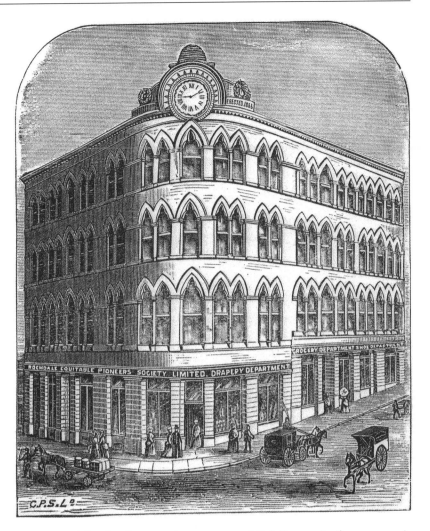

No candles were for sale when the Pioneers' store opened – they were used to light the shop as the Rochdale gas company refused to provide a supply, doubting their creditworthiness. But later CWS made its own candles available to all.

savings and dividend on purchases were paid) follow a similar pattern, in a good year such as 1878 paying out over £5 per member from total sales of under £30 per member – a rate of interest and dividend of over 16 per cent (see graph on page 45, bottom right).

There were three ways in which the original store trade grew. First, new lines would be stocked, and then when established would become separate departments under a specialist manager. Butchery, drapery, tailoring, bootmaking and clogging were all established in this way over the first ten years, using the whole of the Toad Lane warehouse, and then several other nearby buildings. Eventually, in 1867 a grand central store was opened, symbolising the strength and stability of a Society whose members knew they had really arrived. Second, from 1856 onwards the Society set up branch stores, beginning in the Oldham Road, and then multiplying rapidly, either through taking over smaller existing societies or responding to pressure from members in outlying areas. This set the pattern for the enormous growth of consumer co-ops throughout the rest of the century, a story which will be taken up in Chapter Five.

Third, in 1850 they began hesitantly to engage in wholesale trading, supplying other societies of which there were now several in the locality. That they began at all is a tribute to their enterprise, since prior to the 1852 Act they were not legally able to trade with other societies. The Act

cleared the way, and in 1855 wholesaling became a department in its own right, and then a year later a separate committee was formed to oversee it. However, losses were made through buying when prices were high and then having to sell when they had fallen, and a general meeting resolved to drop wholesaling altogether. Luckily (for the future of the Co-operative Movement) this resolution lacked the necessary consent of three-quarters of the members present, and so wholesaling continued. The rest of this story will be taken up in Chapter Five.

Conclusion

There is no doubt that the Society was a remarkably efficient and effective retailer. But it aimed to be more than this; its objects included building houses, putting the members to work in productive enterprises, buying land and eventually setting up an Owenite-style co-operative community. We can chart the progress of the Society in more detail through following up each of these aims in turn and seeing how far they achieved them.

Notes

[1] Cole J. (1988)
[2] *Ibid* p. 6
[3] Thompson, E. P. (1968)
[4] Cole, J. (1988) p. 15
[5] Thompson, E. P. (1968) p. 320
[6] *Ibid* p. 297
[7] Burnett, J. (1989) p. 41
[8] See Bonner, A. (1970)
[9] Burnett, J. (1989) p. 41
[10] Thompson, E. P. (1968) p. 322
[11] *Ibid* p. 326
[12] See Cole, G. D. H (1944)
[13] Holyoake, G. J. (1857) p. 25
[14] See Hadfield, A. M. (1970)
[15] Holyoake, G. J. (1857)
[16] See Bonner, A. (1970)
[17] Holyoake, G. J. (1857) p. 2
[18] *Ibid* p. 9
[19] *Ibid* p. 10
[20] Bonner, A. (1970)
[21] Holyoake, G. J. (1857) p. 13–14
[22] *Ibid* p. 14
[23] *Ibid* p. 15

ROCHDALE PIONEERS' SOCIETY,
LIMITED.

TOBACCO MANUFACTURERS.

AGENTS:

THE CO-OPERATIVE WHOLESALE SOCIETY, LIMITED.

For Prices, Qualities, &c., see their " WEEKLY PRICE LIST.*"*

Retailers become manufacturers – early advertisement showing the diversification of the Pioneers, with CWS acting as their agent.

Further expansion by the Rochdale Pioneers into the fuel trade, with their own coal trucks.

CHAPTER FOUR

The Rochdale principles

The ideas of its founders, set forth in its rules and the minutes of its meetings, make up a body of principles that have since imbued the Co-operative movement throughout the world. (Paul Lambert)

The aims of the Pioneers were clearly affected both by Owen's vision of a self-sufficient co-operative community and of Dr King's more realistic three-stage strategy of starting with a store, graduating to co-operative production and then forming either a rural or an urban community in which members might live. They were even more realistic than King, because they drew this out to five stages, seeing the building of houses and the buying of land as preliminary to forming a complete community. They also added as a sixth aim the building of a temperance hotel, which just shows how much the Owenites among them had to compromise with other interests among the Pioneers in order to get the Society started. Some commentators see this last item as something of an embarrassment, coming as it does after the grand aim of setting up a 'self-supporting home colony' of the sort that Owen thought would usher in a new world order. Yet it adds a touch of realism to the proceedings which might otherwise be missing, and it is sad, in a way, that they never got round to doing it.

Probably the first ever attempt at Co-operative housing – the Rochdale Land and Building Company cottages at the rear of Spotland Road, Rochdale.

The aims of the Pioneers

Their first aim was, of course, *the establishment of a store*, the history of which we have already traced in the last chapter. The second aim was the *building of a number of houses* for members. This was a bold aim for people who would still have to struggle to raise £28 to buy some groceries, because housing is hugely expensive to build, and the investment only pays off slowly over many years. This is why it was at that time mainly provided by private landlords who had money to invest, for a majority of people who did not. Not surprisingly, this aim had to wait 17 years. It turns up finally in the Almanac for 1861, when a Rochdale Pioneer Land and Building Company was formed whose aim was to build 'a superior class of dwelling for the working man'. It seems that the impetus came from a jealous local shopkeeper who was also a small landlord. He decided to raise the rents of some tenants who were also Co-op members (and who therefore did not patronise his shop), declaring that 'they should not have all the dividends to themselves'.[1] Though the Company was registered as a private limited company (perhaps because it might be easier for it to attract large amounts of capital), it was hoped that the taking out of shares by the prospective tenants as well as by other investors would ensure its co-operative nature.

Twenty-five houses were built on and behind the Spotland Road and, though they were quite small terraces, the rents were still too high for most tenants; they illustrated the problem for any self-financing co-op at this time, that wages were too low even to pay the rent on a modest cottage. The company continued until 1869, at which point it was taken over by the main Society, because the Pioneers had by now entered into the provision of housing themselves; in 1867 they built a co-operative estate, producing eighty-four houses in five substantial blocks of terraces, and naming two of their roads Pioneer Street and Equitable Street. By the end of the century the Society had become a large landlord, with about three hundred houses to rent. Even more importantly, the Pioneers had set up the Co-operative Building Society, which would become a major lender of finance to people wishing to buy their own homes.

The third aim was the *manufacture of articles for employment of members* suffering from unemployment or wage reductions. Even with-

Equitable Street on the Co-operative estate built by the Rochdale Pioneers in 1868.

The Pioneers and other early societies
milled their own pure flour – 1895
advertisement for the Carlisle South End
Co-operative Society.

Advertisement in the 1890s for the
Pioneers' own tobacco products.

out this commitment to employing members, it was inevitable that as a
large retailer the Co-op would begin to make some of its own products;
some of the selling already involved a kind of production, for instance
when a butcher cut up an animal, or when a tailor altered a garment for
a customer. Yet they were consciously trying to alter not only the condi-
tions under which people consumed but those under which they la-
boured, and so took every opportunity to develop 'producer
co-operation'. Only five years after opening the store, the Pioneers went
into tailoring, then bootmaking and clogging, but when large-scale pro-
duction came into view, they began quite sensibly to set up separate soci-
eties. These societies would have Pioneers on the committee and
substantial investment from the Society, but if they foundered they
would not then drag the main Society down with them.

Their first venture was (not surprisingly, given the history of earlier
co-ops) into flour-milling. In 1850, a Rochdale Co-operative Corn Mill
was started by an independent committee, but it languished through lack
of capital. The Pioneers, with their typical combination of enthusiasm
and shrewdness, invested £100 and put Charles Howarth in charge as
secretary and Abraham Greenwood (who had joined the Society in 1846)
as President. At first it nearly went under through bad management.
Holyoake describes how the first miller was dishonest and bought infe-
rior flour from an unofficial source on commission, how the second had
a weakness for 'toddy' (strong drink) and the third was a fool:

> So between the man who *would* not know what he was doing, and the
> man who *did* not know what he was doing, and the man who did not
> know what he was saying, the affairs of the Corn Mill got somewhat
> confused.[2]

They also used volunteer bookkeepers, so 'the books were duly bungled
for nothing'. With a loss of £450 they could have given up, particularly
since the uncertainty had caused rumours about the state of the parent
Society, and there was a run on the Pioneers' own money, with members
anxiously withdrawing their savings. But it was not for nothing that they
called themselves pioneers. James Smithies declared that their honour
was at stake, a proper bookkeeper was hired, and Greenwood agreed to
become manager of the mill. Though he knew nothing about milling, he
made such a good job of it that the deficit was soon cleared off, though,
as Holyoake remarks, he worked so hard it cost him his health and nearly
his life.

Even when they got it right they could not win, because (as we have
already noted) the pure flour the mill produced was not at first liked by
the customers. It was kept in business by the refusal of the Society to sell
anyone else's flour. Then by the end of 1852 there were 22 societies
dealing with it, each receiving a dividend on their purchases just like in
the original Society. In 1856 they moved from their old rented mill to a
specially built one at Weir Street. By 1860 it had a turnover of £133,000
and a surplus to distribute of over £10,000.

The Rochdale Manufacturing Society, set up in 1854, was also a com-
mercial success, but it provided a salutary lesson to the Pioneers in how
not to set up a Co-operative business. Again the Society invested along
with others in a mill, this time to produce cotton and woollen goods. The
rules were carefully drafted by an influential Christian Socialist and co-
operative developer, Vansittart Neale. Profits were to be divided equally

between capital and labour, after a 5 per cent interest had been paid to capital, and after assets had been marked down for depreciation.

Another Rochdale co-operator who was not an original Pioneer (but was later to become a national leader of the Movement), J. T. W. Mitchell, was voted in as chairman. They began by renting a ground floor of Bridgefield Mill in Duke Street, Rochdale, with 96 power looms for weaving cloth, and a workforce of 42 people. They then branched out into spinning in another rented mill, in 1859 built their own brand new mill at Mitchell Hey, and in 1866 built yet another mill. Clearly, the Society was a success.

At first, profit-sharing with the workers, the 'bonus to labour' as it was later called, paid off; the workers were well motivated and there was less need than usual for strict supervision of the work. Yet the business was expanding and needed periodic injections of capital, and this meant new shareholders. In 1860, the number of shareholders grew from about 200 up to 1,400, and the new members were much less committed to the idea of worker co-partnership, especially when profits began to be squeezed during the 'cotton famine'. In 1862 they succeeded in having the rules changed so that worker profit-sharing was abolished. The Pioneers were bitterly disappointed; William Cooper (one of the original Pioneers who had been its first cashier and then secretary) said 'It appears to me wrong for persons to enter a society with whose principles they disagree, and then destroy its constitution.'[3] The Society continued as a 'working class limited', one among many examples of companies set up and invested in by large numbers of working-class people, and in that respect it was a success. And as G. D. H. Cole points out, only 50 of the 500 workers were shareholders at the time when the rule was changed; workers generally preferred to spread the risk and invest their labour in

Co-operative farm established in 1851 at Jumbo, Middleton, which was to become one of the most significant locations in Co-operative history. It was here that retail societies in Northern England endorsed Abraham Greenwood's plan for a Wholesale Society.

one factory, their capital in another.[4]

Yet the disappointment at the 'apostasy' of the shareholders reverberated down the century, leading J. T. W. Mitchell, when he became chair of the Co-operative Wholesale Society (CWS), to remain suspicious of independent producer co-ops which he now saw as 'little capitalists'. He preferred to develop production through the Wholesale Society, where it would be firmly under the control of the retail co-operative societies. Now, as we have already noted, there are three directions in which profits can be distributed: to capitalist investors, workers, or consumers. It is ironic that in protecting the interests of the consumer against the capitalists the Co-operative Movement also gave up the principle of worker profit-sharing. By the end of the century, it was to become, under Mitchell's guidance, self-consciously a *consumer* movement. The Pioneers seem to have learned the same lesson. In 1869 another producer co-op was set up, the Rochdale Industrial Card-making Society, which also gave a bonus to labour. But in 1868 the Pioneers had also gone down the road to consumer-control, setting up their own manufacturing department for tobacco.

The fourth aim of the Pioneers was to *buy or rent an estate of land* to be cultivated by members suffering from unemployment. Though the Pioneers never got round to it directly, a co-operative farm was founded in 1851 at Jumbo Farm, near Oldham, and it lasted ten years. The Pioneers turned to other ways of ensuring the security of members which were more appropriate to an industrial society, founding the Rochdale Equitable Provident Sick and Benefit Society, followed later by the Co-operative Insurance Society which is now one of the major methods by which working class people are insured against life's troubles.

What of their fifth aim? They never got round to their co-operative

Security for members – an early heading for a policy of the Co-operative Insurance Company (later Society).

community. It is difficult to tell whether they were all that serious about it in the first place, or whether by 1844 it had just become a ritualistic nod in the direction of their master, Robert Owen, whose ideas they had already outgrown. Certainly, their adoption of the 'dividend principle' shows that they had decided to settle for improving their lot in the community they had been born into rather than escaping into a new one. They had cashed in Owen's vision of a thousand years of peace and plenty for a quarterly payment which would put shoes on their children's feet and, in the hard times still to come, food in their mouths. It is impossible to overemphasise how important this principle of the 'divi' was for the future of the Movement. Just how important, and how it interacted with the other principles, will now be explained.

The Rochdale principles

The Pioneers left very little to chance. They were cautious, practical and experienced people. They set out their rules in detail in 1844, then amended them in 1845 and 1854. They expressed eight fundamental principles. The first was *democracy*, the principle of one member one vote. There is nothing very remarkable in this, since it is what Chartism was all about, and in their chapels, and friendly societies, and trade unions, the Pioneers would be familiar with it. What *was* remarkable was that they were applying it to business; they could have given votes in proportion to share capital, as in capitalist firms, or in proportion to purchases, but here power was shared out to persons, not to property. Persons also meant women; though they do not seem to have taken an active role in the Society at this stage. Beatrice Potter pointed out that forty years before married women were allowed to keep their own property, women members got some control through having their own share account; the cashiers insisted that husbands who wanted access to it go through the courts first.[5]

The 1844 rules take one person one vote so much for granted that they do not actually mention it (this was rectified in 1845), but they do set out the machinery of government: quarterly general meetings at which members receive audited financial reports, appointment of president, treasurer and secretary, five directors and three trustees. The rules imply that all these officers were subject to annual re-election, and they impose fines of three pence for lateness and six pence for non-attendance; Holyoake remarks that this put a value on the five directors, and that if they all ran away the Society expected to lose only half-a-crown. There is an elaborate mechanism for arbitration if a member is aggrieved, and even a secret ballot if they want it, to choose the arbitrators. Despite these elaborately democratic rules, they were then improved on, when in 1845 they moved to fortnightly general meetings, at which it seems new members were to be introduced to the principles and aims of the Society.

However, it was one thing to make rules ensuring democracy, and quite another to make them work in practice. We know that any supposedly democratic organisation can be captured by an oligarchy, ruled by a few influential people, providing the majority are apathetic or ignorant.[6] It all depends how committed the members are. What was the quality of democracy among the Pioneers? The minutes of meetings do not provide much insight; they recorded the decisions, but not the process by which agreement was reached. So we have to rely here on the testimony of eye-

THE ROCHDALE PRINCIPLES

The Rochdale principles adopted by the Pioneers in 1844 and to-day recognised throughout the world are

1. Open membership.
2. Democratic control (one man, one vote).
3. Distribution of surplus in proportion to trade.
4. Payment of limited interest on capital.
5. Political and religious neutrality.
6. Cash trading.
7. Promotion of education.

The Rochdale Principles as displayed in the Rochdale Pioneers Museum.

Democratic control enshrined in the Rochdale Principles – poster for a members' meeting of the St Cuthbert's Co-operative Association, Edinburgh, in 1961.

St. Cuthbert's
Co-operative Association Ltd.

Board Room 92 Fountainbridge
Secretary: H. R. Robertson

members' meeting

will be held in Central Hall
Tollcross
Tuesday 24th October at 7 p.m.
admission by ticket (as per rules 32 and 40)

AGENDA

Synopsis of minutes of meeting held on 25th July 1961

Obituary references · President's Address
Consideration of Balance Sheet

Nominations for . . .
(a) President
(b) Four Directors
(c) Two Members' Delegates to Co-operative Union Congress, 1962
(d) Two Members' Delegates to Co-operative Party Conference, 1962
(e) Ten Members' Delegates to S.C.W.S. Meetings, 1962
(f) Tellers for 1962
(g) Six members to Society Co-operative Party

Synopsis of minutes of Directors' meetings to 7th September 1961

Education Committee Report

Society Co-operative party report

Employees' Welfare Association report

Delegates' report of S.C.W.S. quarterly meeting held in Glasgow on 9th September 1961

Recommendation by board of Directors "that the sum of £505 be granted to charities"

any competent business

MEMBERS QUALIFIED TO ATTEND AS PER RULES 32 AND 40
MUST FILL IN APPLICATION FORMS OBTAINABLE AT GROCERY BRANCHES.
TICKETS OF ADMISSION WILL THEN BE ISSUED
ALONG WITH QUARTERLY REPORTS AND BALANCE SHEETS.

witnesses such as Holyoake, who declares:

> Human nature must be different in Rochdale from what it is elsewhere – they have mastered the art of acting together, and holding together, as no other set of workmen in Great Britain have done.[7]

We know that they had disagreements, such as when James Daly wanted to expel members who did not shop with the Co-op but was overruled. We know also that they had the capacity to transcend these disagreements and to work together for many years on an astonishing variety of projects. As Holyoake puts it 'they have had the good sense to differ without disagreeing; to dissent from each other without separating; to hate at times, and yet always hold together'.[8] Anyone who has worked with co-ops can testify that this capacity is crucial to their survival.

Crucial also is the capacity to put up with and eventually overcome criticism and disruption from less committed members. The Pioneers had their share of what analysts call 'holdouts', people who are pessimistic about the value of the Co-op, and who want to see it fail.[9] Holyoake

describes members of the Rochdale Society 'who predict to everybody that the thing must fail, until they make it impossible that it can succeed, and then take credit for their treacherous foresight'.[10] He records that the Pioneers worked with these people, even though they were a dead weight and a constant irritant, and eventually overcame much of their scepticism simply by succeeding. Holyoake describes a man called Ben, who never said a word against the co-op, but 'was suspicious of everybody in a degree too great for utterance'. After two years of this he 'found speech and confidence together', after going up to the cashier to draw his profits, and coming down 'like Moses from the mountain, with his face shining'.[11] Another member was so sceptical that they made him a board member so he could see that things were being done right. Holyoake records that 'during his whole period of office, he actually sat with his back to the Board', and it was only the 'bribery of success' that eventually persuaded him to change his mind.

The women members also had their views changed by experience. Holyoake records: 'After a time, the women became conscious of the pride of paying ready money for their goods, and of feeling that the store was their own, and they began to take equal interest with their husbands.' It looks as if, as a democracy, the Rochdale Co-op was an outstanding success.

The second principle was *open membership*. At first, they limited the number of members to 250, probably because they had not yet realised they could grow through opening branches, and because they did not have much legal protection; the 1852 Industrial and Provident Societies Act, which some influential supporters sponsored for their benefit, gave them proper legal status, (though full limited liability was not granted until 1862) and so after this membership was simply allowed to grow and grow. The Act allowed them to sell to non-members, but this remained the exception, the rule being that the members and the users of the co-op's services were one and the same. The important point about this principle is that it was a generous one.[12] It allowed new people to come in on a down-payment of only a shilling, making the social wealth built up by past generations instantly available to newcomers. There would be none of the hoarding of profits by the original shareholders that we find in capitalist companies. The application of this principle can also be judged a success; having aimed at a membership of 250, by 1880 the co-op had over 10,000 members, a large proportion of the local population.

The third principle was *fixed and limited interest on capital*. 'Fixed' means that interest does not rise or fall with profits as it does in a capitalist company, and 'limited' means that the Society will only pay out for capital what it absolutely has to in order to finance its own development. It was one of Robert Owen's principles, that while capital has to be paid for, it should not enable the lender to cream off the surplus made from the labour of others. In this case the rate was fixed in 1844 at 3. 5 per cent, then set at varying rates by members' meetings, until in 1854 a maximum of 5 per cent was written into the statutes. Holyoake points out that many co-ops had failed because they refused to pay interest on capital at all, but the Pioneers were pragmatists; they recognised that in order to attract capital they had to pay for it and that owners were entitled to some payment for the risk attached to lending it, and so they were prepared, up to a point, to pay a varying and commercial rate of interest.

Yet they decided to limit the *size* of shareholdings, probably because they were worried that those members who had invested heavily might come to wield undue influence over the Society. So in 1845 they reduced the maximum shareholding from £50 to only £4, aiming to grow to a membership of 250 who would eventually, through weekly subscriptions of three pence, raise a capital of £1,000; Holyoake tells us that those holding more than £4 in shares had to sell these back to the Society. However, continued growth must have calmed their fears in this respect, and the 1852 Industrial and Provident Societies Act gave them limited liability, and allowed shareholdings to rise to a maximum of £100 (after which those wanting to invest could lend up to £400 in loan capital). The important principle here is that it is better to have many small investors than a few large ones, so that (again in contrast to capitalist companies) no one can gain power over the Society merely by being well off. Again, the application of the principle seems to have paid off; by 1880 the Society had an embarrassment of capital at its command, and was able to afford to pay low rates of interest to obtain it.

The fourth principle was *distribution of the surplus as dividend on purchases*, the famous 'Co-op divi'. This was the decisive step in breaking with the old Co-operative Movement which had assumed that surpluses would be built up until a co-operative community could be formed. There are in fact three types of people who can benefit from surpluses: those who lend capital, those who work in the business and those who are consumers. The distribution on the basis of purchases marked the Society off from both capitalist and worker-owned enterprises, and turned the Pioneers (though they may not yet have realised it) into a **consumer** co-operative. There was nothing remarkable in this. Though one of the

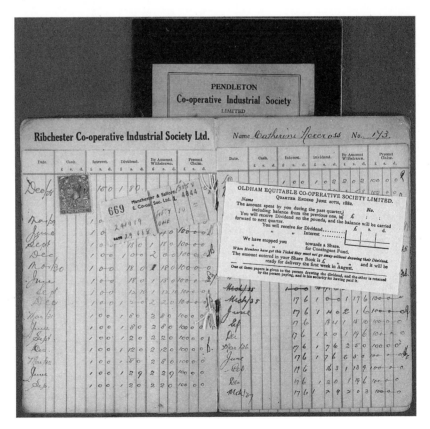

Distribution of surplus – examples of how dividend was recorded for Co-op members.

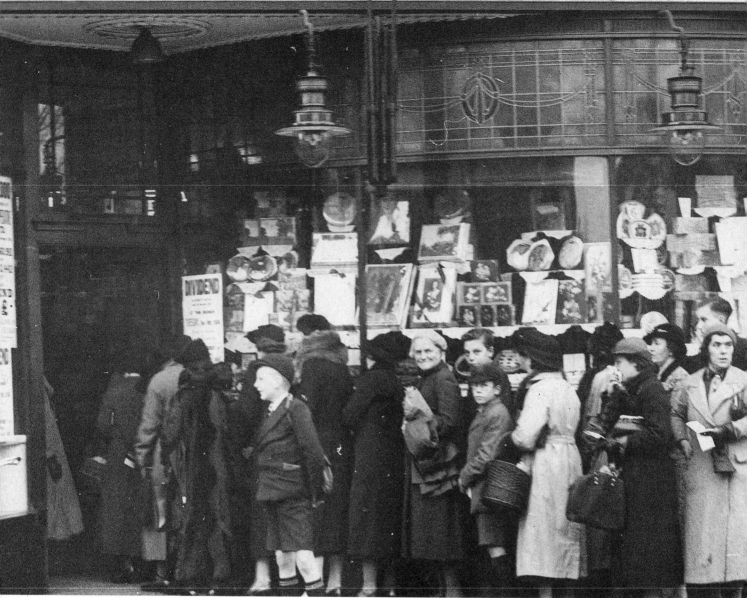

CO·OPERATIVE

Members queue for their share in the dividend distribution at a store in the 1940s.

Pioneers, Charles Howarth, had to reinvent the idea (perhaps because it had been frowned on by strict Owenites), Alexander Campbell, the 'father of Scottish co-operation' had been recommending it ever since 1822, and there were in fact several co-ops which had used the dividend principle since the mid-1820s, including Lennoxtown in Scotland, and Meltham Mills in Yorkshire. A meeting of the First Western Union Co-operative Society in 1832 had reported that dividend on purchases

> would confer immediate benefit upon all those who dealt extensively at the store. and remove the discouragements which the most zealous and persevering co-operators had hitherto experienced.[13]

In practice, it did just that. Holyoake tells some remarkable stories of poor people who, having been in debt to shopkeepers for thirty or forty years, suddenly found themselves with money in their pockets and £20 in

The fifth principle was cash trading only – and the demise of many early societies was due to the extension of credit to members (from a painting by Robert Broomfield).

The sixth principle was selling only pure and unadulterated goods. CWS advertisement for 1928 extolling the virtues of pure food, quality packaging and honest weights and measures.

their share account. Though the dividend was low at first, three pence in the pound, it rose steadily until the Society was paying up to two shillings and six pence in the pound. One old man claimed that in 11 years he had accumulated £77 in dividend, which had kept him out of the poor house in his old age.

The fifth principle was *cash trading*. This may seem unimportant to-day, and is no longer regarded as an essential principle, but to the Pioneers it was most important; though they knew it would restrict their membership, they felt so strongly that they wrote into their rules that any officer found giving or taking credit was to be disqualified from office and fined ten shillings. There was a universal dislike of being in debt to shopkeepers, but more than that, there was a realisation that previous societies had foundered on credit. As Holyoake said:

> So many co-operative experiments had been stranded by credit, that an almost universal opinion was prevalent, not only in Rochdale, but throughout the country and in Parliament, that co-operation was an exploded fallacy.[14]

Again, the principle seems to have paid off because, though its strict application in the early years undoubtedly limited its growth, the Society grew anyway.

The sixth principle was selling only *pure and unadulterated goods*. This was not a written rule, but it appeared in an important statement of first principles in the Almanac of 1860. We might think that providing wholesome, untainted food and giving full weight and measure to the customer ought to be taken for granted in a consumer-owned and controlled business. Yet there were considerable trading risks involved. Take the case of the flour which, though produced in their own mill, was rejected by members because it was browner than usual. Holyoake tells us that the directors could have bowed to pressure and added chemicals to whiten it, but that this was so much against their principles that they preferred to take the risk and after much discussion with the customers the pure flour eventually gained acceptance. Looking back on the story

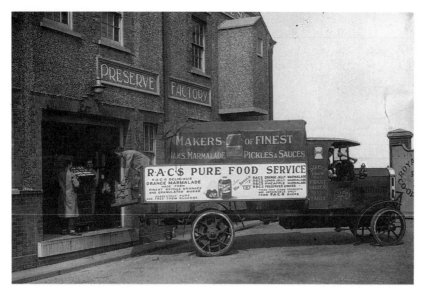

many years later Holyoake added this comment:

> The members had become more intelligent; they had learned the nature of good flour when they had it; their tastes were better educated than that of many gentlemen of the middle class, and the Directors were able to tell the purchasers, in a reckless manner, "If they wanted to adulterate the flour they could do it themselves."[15]

More generally, the effect of such commercial honesty was that buyer and seller were able, for the first time, to meet as friends, without suspicion on either side. Their surroundings may have been humble, the warehouse at Toad Lane unfashionable, but the relationships between the people were of the highest quality. Members were able to send their

The illustrations above show an early Royal Arsenal Co-operative Society motor lorry advertising the pure food service available from the Society, and a pure milk advertisement from the Co-op in Coronation Street, Sunderland.

Education was listed in the original Rochdale Principles and is still pursued by many societies today. 1885 advertisement showing a range of classes provided by the Manchester & Salford Co-operative Society.

children on errands to the store, knowing that they would not be taken advantage of, and that all would be treated alike and given the right quantity and quality of provisions. Adulteration remained a feature of commercial life well into the century, but as Holyoake describes it, the members of this humble co-op had gained access to goods which even the well-off could not be sure of obtaining:

> These crowds of humble working men, who never knew before when they put good food in their mouths, whose every dinner was adulterated, whose shoes let in the water a month too soon, whose waistcoats shone with devil's dust, and whose wives wore calico that would not wash, now buy in the markets like millionaires, and as far as pureness of food goes, live like lords.[16]

The seventh principle was *education*. The famous rule appears in the 1854 statutes, that a separate and distinct fund be set up for the 'intellectual improvement of the members' and their families. It was to be funded out of a 2.5 per cent levy on surpluses, and to have its own committee of 11 members, appointed at the annual meeting. The rule was actually a way of making systematic what the Pioneers had always done: as Owenites, they believed that only through basic education could people's characters be changed, and as followers of Dr King that only through acquiring commercial skills could they trade successfully. In 1846 they were already holding regular Saturday afternoon discussions at the store, and in 1848 they were able to set up a newsroom and book department, buying up the library of a failed People's Institute. By 1850 they were running their own school and adult education classes, and by 1860 had established the principle that each branch should have its own newsroom and library above the store.

So keen were they on education that they had originally proposed a levy of 10 per cent on surpluses, but because education had (through an

Upstairs room at Toad Lane, Rochdale, which was used by Pioneers Society members for reading and other educational pursuits.

oversight) not been included in the 1852 Act, the Registrar of Friendly Societies would not let them register it. The contest with the Registrar lasted several months, but eventually the 2.5 per cent seems to have been agreed as a compromise; it is a compromise that many co-ops since then have found difficult to live up to, but which is always cited as the measure of how committed they are to education. It caused disappointment at the time: Holyoake comments bitterly that the law seemed to prohibit workers from educating themselves, but the government refused them the vote on the grounds that they were not educated.

The eighth principle was *political and religious neutrality*. Political neutrality was assumed from the start, at least between different types of radical: Chartists, Owenites, Anti-Corn Law Leaguers and so on. G. D. H. Cole says that this does not mean that they expected to admit political conservatives, but there is no evidence that they ever tried to deny membership to anyone on political grounds, and some of the early members must have been less radical than the Pioneers themselves. Religious neutrality was also assumed from the start, because among the Pioneers were both Owenite secularists and members of a Unitarian congregation; at least one of them (John Garside) was a local preacher. So they were reared in what Holyoake (himself a militant atheist) called a 'school of practical toleration'. It was only when the local savings bank had collapsed and there was a sudden influx of more narrow-minded Methodists that trouble arose. The new members wanted to close the meeting room on Sundays, and to forbid religious controversy. Now Sundays had always been precious to the Pioneers as the one day they could use for self-improvement, and toleration had never meant a ban on free speech and vigorous discussion. They hit back with a resolution at a general meeting:

> That every member shall have full liberty to speak his sentiments on all subjects when brought before the meetings at a proper time, and in a proper manner; and all subjects shall be legitimate when properly proposed.[17]

They then, quite sensibly, closed the membership list to new members for

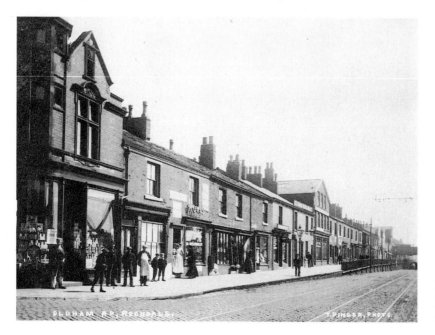

Rivals to the Pioneers – Rochdale Provident Co-operative Society store in Oldham Road, Rochdale.

six months while tempers cooled.

Despite this conviction, the Society came to be associated with a radical liberal line politically, and after 25 years of relative peace, in 1869 some more conservative members seceded to form a rival Rochdale Provident Co-operative Society, while others split from more obviously political motives to form the Rochdale Conservative Co-operative Society. The principle has, ever since, been difficult to apply, and there are many co-operative movements in other countries which have been set up on political or religious lines. Nevertheless, the International Co-operative Alliance, the umbrella body for the worldwide movement, has at least managed to remain studiously neutral.

Finally, in the 1854 statutes, the Pioneers added one more principle, that of *disposal of net assets without profit* to members; in the unlikely event that the Society might be wound up, the trustees would have to pay everyone what they held in their share accounts, and then distribute the rest of the assets to other co-operatives or to a charity. This meant that no one would be tempted to break up a co-op just to get at the assets. It is a rule which, with open membership and continued growth, they did not really need, but which has become crucial to the success of worker co-ops; in France, for instance, the state insists on it, and so the worker co-op movement has had a firm basis on which to build.

Dividend – the key to all the Rochdale Principles (from a painting by Robert Broomfield).

Conclusion

Together, these principles have travelled the world, providing a foundation for the Consumer Co-operative Movement, and being adapted here and there for new purposes, so that agricultural, fishing, credit, worker, housing and other types of co-op could be developed. The principles cannot be understood simply as eight or nine separate features though. The Pioneers' achievement was not to invent new principles but to bring them all into a right relation with each other. They must be understood in their *totality*; they are like a jigsaw puzzle, in which each part is essential if the whole picture is to emerge. Or, better still, they are like a car engine, in which the parts work together to create the forward motion. Organisation theorists talk of 'synergy', meaning that under certain circumstances different factors in an organisation 'work together', so that the total effect is greater than the sum of the parts. The synergy worked like this: democracy helped ensure that the directors stayed in touch with their customers, open membership guaranteed an influx of new members to ensure democracy, education built up commercial expertise and customer loyalty, religious neutrality helped membership to grow, and so on.

The key to them all was the dividend principle. This guaranteed democracy, because it gave members a real interest in running the Society. It guaranteed open membership, because the current members would see new members as helping to cut fixed costs, to enable goods to be bought in bulk, and so add to the dividend. It made cash trading possible, because it built up savings automatically. It even cut the cost of paying interest on capital, because new members were attracted and so capital flowed in.[18] It did all these things and more, because it reconciled self-interest with mutuality; by trading together individuals gained an economic reward, and because they gained an economic reward they continued to trade together. James Smithies, the Pioneers' secretary, put it this way, they were 'bound in chains of gold, and those of their own forging'. Eventually, as Dr King foresaw, Co-operation became a habit, and it generated fellow-feeling – the Rochdale principles had formed a virtuous circle which could not be broken.

Notes

[1] Rochdale Pioneers (1861)
[2] Holyoake, G. J. (1857) p. 30
[3] Quoted in Bonner, A. (1970) p. 54
[4] Cole, G. D. H. (1944)
[5] Potter, B. (1899)
[6] See Michels, R. (1949)
[7] Holyoake, G. J. (1857) p. 1
[8] *Ibid* p. 21
[9] See Birchall, J. (1987)
[10] Holyoake, G. J. (1857) p. 21
[11] *Ibid* pp. 22–3
[12] See Lambert (1963)
[13] Holyoake, G. J. (1857) p. 67
[14] *Ibid* p. 28
[15] Holyoake, G. J. (1906) p. 121
[16] Holyoake, G. J. (1857) pp. 39–40
[17] Quoted by Holyoake, G. J. (1857) p.20
[18] See Potter, B. (1899)

CHAPTER FIVE

A retailing revolution

Let co-operators compete with each other in zealous devotion to the cause they are engaged in – in understanding, thoroughly, the principles it depends upon – in explaining those principles to their friends and neighbours – in increasing, as far as in them lies, the number of members – in the punctual payment of subscriptions – in punctual attendance at the meetings – in spending every penny at some co-operative shop. (William King)

We have seen how the Rochdale Pioneers combined an uncommon skill in shopkeeping with that 'virtuous circle' of open membership and dividend on purchases which were bound to keep it growing. We might have expected that other similar societies would follow, and that they would also be quite successful. But no one, not even the most optimistic of the Pioneers, could have foreseen just how successful this new movement would become. Twenty years after the Pioneers decided to put in their three pence per week, there were around 100,000 Co-op members, with a combined turnover of about £2.5 million. By 1881 (after proper statistics had begun) there were 547,000 members in 971 societies, with sales of nearly £15.5 million. By 1900 membership had grown to 1,707,000 in 1,439 societies, with a turnover of over £50 million. By the time war had broken out in 1914 there were over three million members in slightly fewer societies (down to 1,385 – there had been amalgamations of smaller ones), and with a turnover of £88 million, which in those days was an awesome amount of money.

The co-operators had also expanded their business 'vertically' into the wholesaling and production of the goods they needed for their shops. Starting from nothing in 1863, the Co-operative Wholesale Society (CWS) had by 1914 become a massive business in its own right, with its own bank, a turnover of £35 million with retail societies, productions worth £9 million per year and a workforce of over 22,000 people.[1] The Scottish Co-operative Wholesale Society (SCWS) had grown along similar lines, and by 1914 had sales of £9.5 million. They achieved all this without having to attract any major capitalists as shareholders, and without relying on ruthless entrepreneurs as the driving force. In fact, though they had an abundance of capital, it was the combined strength of millions of tiny share accounts that financed it, and the combined wisdom of thousands of unpaid directors that drove it. It was a 'rags to riches' story, but with two crucial differences: it was not the story of one successful man but of a whole class of men and women, and the riches were shared

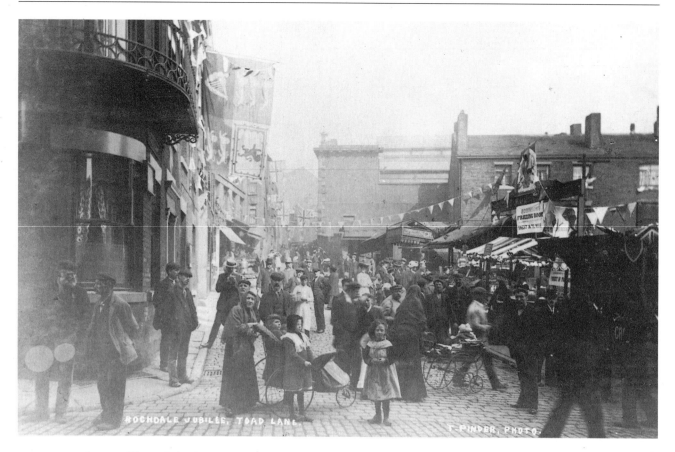

Buntings festoon Toad Lane Market in Rochdale to mark a special anniversary.

out among three million of them.

We know how the growth of this 'People's Business' happened and later in the chapter will tell the story, but first we need to work out *why* it happened, and this means identifying the underlying causes. There are two approaches, one focusing on why it grew as a business, the other on why it grew as a distinctively co-operative business. The first approach identifies causes such as the *need* for a better organised form of retailing, and the *ability* of the co-op to meet these needs through discovering new methods of retailing and wholesaling. The second approach identifies causes such as the *promotion* of the co-op by talented leaders, the existence of a favourable *climate of opinion* among those likely to benefit from it, and the gradual creation of a *legal framework* within which the new businesses could operate. This gives us five causes to explore: need, ability, promotion, climate of opinion, and legal framework.[2] Let us begin by looking at the need for co-op shopping.

The need for a retailing revolution

Suppose you were a working-class shopper in the mid-nineteenth century. Where would you have shopped? How much choice would you have had, and would you have got a good deal fom the shops of the time?

The industrial revolution would have made enormous changes to your working life, and brought cheap goods flooding into the market. But your shopping habits would not have been much different to those of your grandparents.

A genuine 'corner shop' (*c.* 1867) of a Rochdale private grocer.

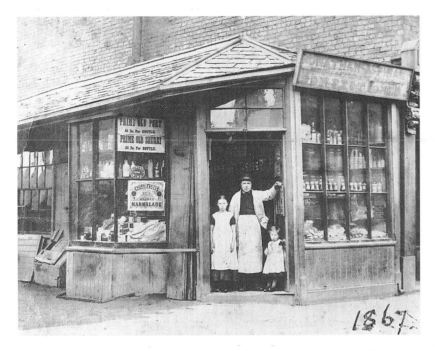

Until at least halfway through the century the size of shops, the kind of people who ran them and their methods of buying and selling were all very much as they had been a hundred years before.[3]

A revolution in the production of goods would have been happening all around you, but most historians argue that the revolution in their *distribution* was still to come.[4] There were four types of retail outlet: proper shops such as grocers, mercers, drapers, haberdashers, coal merchants, chandlers and 'general shops' which sold a bit of everything; producer-retailers such as boot and shoe-makers, bakers, tailors, blacksmiths, tinkers, cabinet-makers, butchers and dairy farmers; weekly markets set up

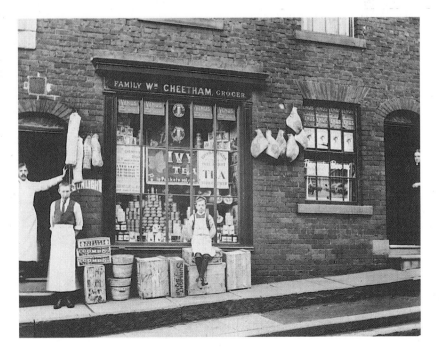

A family grocer in Rochdale trading in products of many kinds.

in the street; and lastly annual fairs and visits from travelling salesmen known as hawkers, pedlars or packmen.[5] So you would have had plenty of choice about where to buy.

Out of these four types, you would have relied far more than modern shoppers on the weekly street markets to which local farmers brought their produce for sale, on the annual fairs for luxury goods, and (if you lived out of town) on travelling salesmen for clothing and shoes. The problem was that in the growing industrial areas of mid-nineteenth century Britain the number of fixed shops could not keep up with the growth in population. One historian says that in the cities and big towns 'The working classes had shops to go to but they were few, meagrely stocked and struggling to counterbalance bad debts by high prices.'[6] They were mainly small and owned by independent traders, and it was rare for shopkeepers to own more than one shop; when they did, they would tend to put a trusted relative in charge rather than a manager. High-class grocers could afford to offer apprenticeships in what was still a skilled trade, where the quality of the goods had to be assessed, prices had to be negotiated carefully with a variety of wholesalers and producers, and a lot of production was done in the shop: tea had to be blended, weighed and packaged, bacon to be cured and cut, dried fruits had to be cleaned and washed, and so on.

But if you were working class you would probably not have been able to afford to patronise these stores; you would have relied on the 'general shops', where untrained assistants, generally members of the same family, would sell a wide variety of groceries, chandlery (candles, oil, soap and so on), hardware, drapery, and a range of 'drugs' or home remedies. This was not much different from the range stocked by the corner shops

A fleet of vessels owned by the CWS plied between Liverpool, Goole, Hamburg, Rouen and the Danish ports, importing directly produce from the Continent. All the vessels had names relating to Co-operation, such as 'Pioneer', 'Equity' and (shown here) 'Liberty'.

'Wagon train' of Grays Co-operative Society delivering its own bakery products (*c.* 1900).

of the 1960s,[7] except that the goods had to be packaged in the shop, so the quality and weight were not guaranteed (we have noted how they were often adulterated) and they came at a high price and usually on credit.

One reason why retailing was so inefficient was because the wholesaling of goods was not very well organised. Imagine the thousands of small producers, factory or workshop owners, self-employed tradesmen and farmers who needed to make contact with many more thousands of small retail shops, in an age when travel was slow and difficult. Under such circumstances, direct selling from one to the other was not always possible, and in the growing industrial towns and cities was certainly very inefficient, and so wholesalers began to fill the gap. These 'middlemen' have often got a bad reputation, seeming to do nothing but increase prices to the consumer, but they actually fill some vital roles: organising the buying from several producers, keeping stocks of goods, organising transport, undertaking some of the intermediate production work such as processing or packing the goods, and then selling them on to the shops. As we shall see, this wholesaling function became very sophisticated, but in the mid-nineteenth century it was as haphazard as the retailing, with producers not being able to sell their goods very easily, and the more enterprising shopkeepers filling the gap by doing some wholesaling for other retailers.

None of this would have mattered much if the number of customers had stayed the same and they had remained poor, because then they

would not have been able to turn their needs into market *demands*. But for the majority of working-class people better times were just around the corner. Between 1851 and 1911 the population was going to double from 18 million to 36 million, and become even more concentrated in the towns. Gradually the effects of the Factory Acts and other social legislation would be felt, and the growth of the trade unions would provide some protection against the misery of exploitation in the market for labour. Between 1850 and 1873 there would be a 'golden age' of Victorian prosperity, with wages more than keeping pace with rising prices, and with food prices rising much more slowly than others. From then until 1896 there would be continued improvement, even during the Great Depression (which affected farmers and farm workers more than the urban population), and real wages would increase by an average of 35 per cent.

All this meant that working-class demand was emerging 'that was worth catering for: big, stable, and important for the first time'. And the kind of demand that they made on shops was quite easy to cater for: 'homogeneous, predictable, concentrated and, in the mass, enormous'.[8] Yet the take-off of a retailing revolution was still not guaranteed; it needed a revolution in transport. In the mid-century, transport remained slow, with wagons on the turnpike roads being used to bring food to the towns, and with cattle being driven into the markets on foot (the canals were really only useful for carrying grain and fuel). While small market-towns were still able to draw their food from the surrounding countryside, this became more and more difficult for the growing industrial cities, as illustrated by the town dairies in which cows were kept under squalid conditions, fed on brewers' dregs and never seeing the light of day.[9]

The Pioneers were lucky in their timing, because the railways, which began to be built in the 1840s, provided a network of lines and stations (far more than we have now in the 1990s) which created a national market in food. They allowed for regular delivery to even the remotest areas, and for the first time working- class people were able to obtain a reliable supply of fresh fruit and vegetables, to drink enough fresh milk and eat fresh fish. John Burnett says:

> Without their powers of rapid, cheap distribution, England might not have survived the mounting pressure of demand on local sources of food supply and the social discontent which flared up at times of high prices and cyclical depression.[10]

The greater reliability of such transport allowed shopkeepers to stock a wider range of goods, to have a much faster turnover of stock, and to lower their costs.[11] Then the development of steam ships allowed the import of cheap foreign foods from all over the world: American wheat came in at half the price of British, then Canada and India followed. In the 1880s the development of refrigerated holds allowed the ships to carry pork, lamb and beef, and in the average diet more money began to be spent on meat than on bread.[12] Food was becoming cheaper; in the ten years from 1877–87, for instance, the price of food in a typical working-class family budget dropped by 30 per cent. In the last quarter of the century, the price of wheat, sugar and tea cheapened by more than 50 per cent, while that of butter and bacon fell by 25 per cent.[13]

But why a Co-operative revolution?

According to Dorothy Davis in her history of shopping

> These were the conditions in which the early co-operative societies, after so many false starts, struck such firm roots and made such phenomenal growth in the second half of the nineteenth century.[14]

Yet they do not explain why the Co-op did so well. As Davis puts it:

> Why did shops, because they were run on Co-operative lines, not merely keep going and pay their way like other shops, but rocket to such sudden and dizzy success under the leadership of the Rochdale Pioneers after 1844?[15]

One answer is that the Co-op did not have any rivals; as we have seen, the small, independently owned shops were not very well run. Rivals did eventually appear, in the form of the 'multiples' (companies set up to grow via standardised small shops selling exactly the same range of goods at low fixed prices) and the department stores (large multi-

Typical Co-operative Society branch store around 1900. Note the order boy poised to take weekly deliveries direct to members' homes.

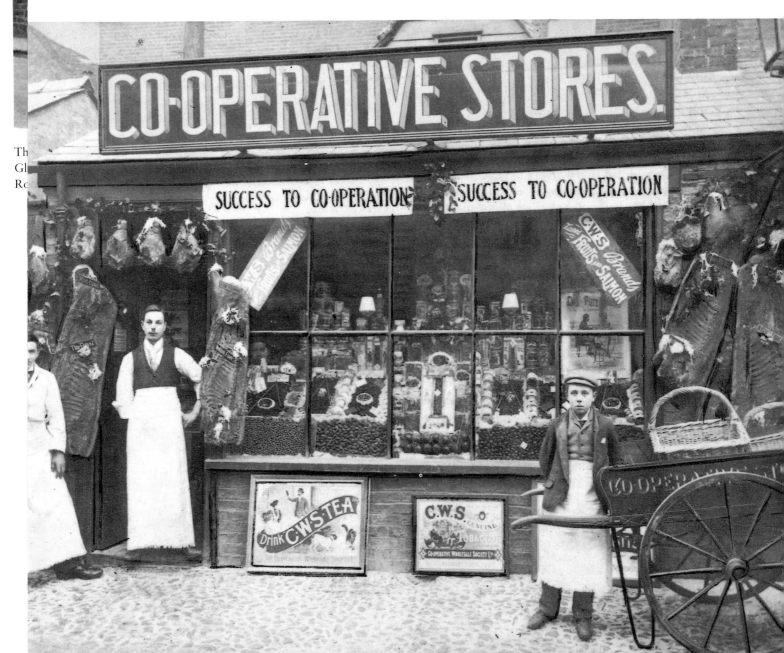

were formed in Lancashire and Cheshire, and 140 in Yorkshire.

From 1881 to 1900 the membership of societies tripled from 547,000 to 1,707,000. Some really big societies emerged, with Leeds the largest at 48,000 members, followed by Bolton, Plymouth, and St Cuthbert's in Edinburgh. The north of England and Scotland were still predominant, with 22 out of the top 25 societies. Yorkshire took over from Lancashire as the main growth point during this period.

Between 1900 and 1914 membership nearly doubled again, to over 3 million, but growth had slowed: there was heavier competition with the multiples and department stores, and a high dividend/high price policy in some areas and overlapping of societies in others had inhibited growth. Nevertheless, by 1914 the Movement was firmly established in the big towns and cities as well as in the traditional textile and mining areas: Derby and Birmingham had more than 29,000 members each, Leicester had 21,000, Glasgow had seven societies with 60,000 members between them, Newcastle upon Tyne had over 27,000 members, Sheffield had by now two societies with 49,000 members, and Portsmouth, Bristol and Plymouth were all well established. London had at last begun to catch up, with three societies having 93,000 members between them, but Manchester's 7 societies could still boast over 100,000 members. The number of societies in the traditional Co-op areas had by now reached saturation point, and the growth area had switched to the English Midlands.

Underpinning this growth in retail societies were the two wholesale federations, the CWS which began trading in 1864, and the SCWS which

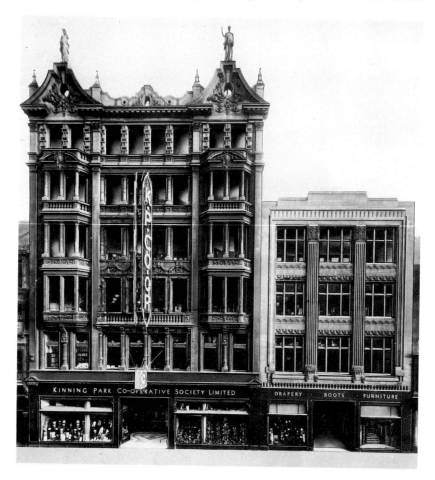

In Scotland they built Co-operative 'cathedrals' with superb sculpture and ornamentation, as in this example at Kinning Park, Glasgow.

Temperance hall under the railway arches where one of the series of meetings which led to the formation of the CWS was held.

began in 1868. We left the story of the CWS at the point where the Rochdale Pioneers had tried, not very successfully, to provide wholesale services to neighbouring societies. Without legal sanction for what they were doing, they had not been able to offer their customers membership in the wholesale organisation, and there was suspicion on both sides: either that the Pioneers were giving something for nothing, or that they were taking all the profits. There was no sharing either of risk or of control, and so co-operation (with a small 'c') was impossible. Yet there was still a pressing need for wholesaling, in a market in which small societies found themselves rebuffed or even boycotted, supplies came short or in poor quality, and canny buyers could all too easily get power over their committees. Societies could not go on bidding against each other in a competitive market – something had to be done.[21] The starting point is reckoned to be a meeting in August 1860 at Jumbo, Middleton, where co-operators had a six-acre farm and store. The setting is ironic, symbolising in a small way the old 'back to the land' dream which had so fascinated the Owenites and Chartists, yet the meeting starts a process leading to the development of one of the most modern business networks to take its place *within* existing Victorian society. Of course, the main topic for discussion was not wholesaling but the need to change the law so as to get started at all. It was going to be hard work; in William Cooper's minute book are recorded twenty meetings and conferences which followed over the next three years.

Picture one of them – it is Christmas Day, 1860, one of the coldest days ever known in Britain. The snow was ankle-deep and the frost 'arctic'. The thermometer fell to minus 15 degrees fahrenheit near Manchester, and it was to Manchester that Cooper and his friends travelled on the train, giving up one of a few precious annual holidays to sit in a temperance hall under a railway arch. 'The stove smoked, and the tea, when it came at six-thirty, was cold', but they managed to form a sub-committee to correspond with their friendly barrister, E. V. Neale, in order to start

distribution costs, and all the profits handed on to them in dividend. Secondly, they became manufacturers of those basic products which working-class people demanded in large and regular quantities: boots and shoes, clothing, soap, furniture, and those foods which needed processing such as biscuits, pickles and jam. In setting up production they were able to use the latest large-scale factory-based techniques (such as roller-milling of flour) and to keep ahead of the competition. Thirdly, they were able to take over federal productive enterprises originally started by the retail societies; in 1906 for instance, they took over the Rochdale and Oldham flour mills and became one of the largest flour-millers in the world. They also took over several ailing worker-owned societies which had started up during the brief boom years of the 1870s and then got into trouble. So they were both driving forward the boundaries of co-operative production and acting as an 'ambulance service' for those smaller, less efficient producer societies which could not keep up.

Key Events in the Growth of the CWS up to 1914

- 1866 first butter depot set up in Ireland at Tipperary
- 1868 first Balloon St warehouse built; began to develop the headquarters buildings; Kilmallock depot opened in Ireland
- 1869 split when cashier set up a rival business (it faded out within a year or two); Limerick depot set up
- 1872 began to sell boots, opened Newcastle branch, dropped North of England title from CWS; loan and deposit business begun
- 1873 bought Crumpsall Biscuit Works, first CWS factory, Leicester Boot Factory opened; Armagh, Waterford depots set up in Ireland.
- 1874 bought Durham Soap Works, opened London branch; Tralee depot set up
- 1875 opened Liverpool branch
- 1876 drapery and boot dept separated; purchased the *Plover*; first overseas depot at New York; banking department started, dealing with retail societies
- 1879 Rouen depot opened, trade conducted with own ship
- 1880 production of boots and shoes at Heckmondwike
- 1881 Copenhagen depot opened
- 1882 tea department began direct trade with Far East, Leeds branch opened
- 1884 Hamburg Depot opened, Bristol branch opened
- 1885 Huddersfield and Longton branches opened, Nottingham branch opened
- 1887 cloth-making begun at Batley, cocoa and chocolate production in Luton
- 1888 boot production begun at Enderby
- 1890 clothing begun at Leeds; Blackburn and Northampton branches opened
- 1891 new boot factory opened at Leicester, Cardiff branch opened; Aarhus, Denmark depot opened; corn-milling begun at Dunston on Tyne
- 1892 Birmingham branch opened
- 1893 Cabinet-making begun at Broughton

- 1894 Montreal depot opened, soap manufacture begun at Irlam
- 1895 Gothenberg depot opened, tailoring begun at Broughton, established own printing department
- 1896 Denia, Spain depot opened
- 1897 Sydney depot opened
- 1898 Odense, Denmark depot opened
- 1900 bacon factory at Herning, Denmark
- 1901 bacon factory at Tralee, Ireland
- 1905 Esbjerg depot opened
- 1906 took over Rochdale flour mill and Oldham Star Mill, and bought Sun Mill to become one of the largest flour millers in the world
- 1907 banking dept begins to lend for house building
- 1910 banking dept began to take deposits from individuals and trade unions
- 1912 Co-operative Insurance Society taken over by the two wholesales together
- 1913 tea estates purchased in Ceylon

Key Events in the Growth of the SCWS to 1914

- 1877 Leith branch opened
- 1878 Kilmarnock branch opened
- 1881 shirtmaking, tailoring begun; Dundee branch opens
- 1884 cabinet making begun
- 1885 boot factory
- 1886 hosiery works
- 1887 bought 12 acre site at Shieldhall: factories for boots, shoes, workmen's clothing, tannery, cabinet works, brush factory, jam works, confectionery, mantle factory, tobacco works, coffee, printing, chemicals, engineering shop, tinware, pickles, etc.
- 1898 Edinburgh branch opened
- 1900 joint tea committee established
- 1904 Calderwood Estate acquired, Calderwood Castle turned into a Co-operative Museum
- 1910 sets up own retail store in Elgin

Development by CWS tended to be spread out; there were factories, depots and salesrooms around the country serving each region's retail societies, and three main centres at Manchester, London and Newcastle, where from 1884 onwards warehouse extensions were continuously being built. The Scottish CWS concentrated its developments mainly on one site at Shieldhall near Glasgow. In both cases development took place naturally; the gradual build-up of sufficient demand from the shops led eventually to entry of the wholesales into new productions or imports which could not fail. Sometimes they were goaded into production when manufacturers were persuaded to boycott the Co-op (as in 1905 when the Proprietary Articles Trade Association objected to the dividend), or because they could not get the reliability and quality they needed from a supplier. Initially they steered clear of those areas in which retail societies already had productive interests – bakeries, flour mills, tailoring, farming and so on – but they became the Movement's bankers and (with

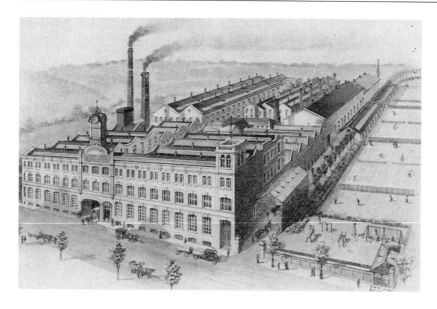

Left The first CWS factory at Crumpsall, near Manchester, home of the famous Crumpsall Cream Cracker.

Below The imposing facade of the headquarters of the former Scottish Co-operative Wholesale Society on Morrison Street, Glasgow.

CWS was a major investor and user of the Manchester Ship Canal, which opened on January 1, 1894. Members of the CWS Board and other prominent Co-operators are seen on the 'SS Pioneer' which was the first vessel to enter the port of Manchester.

the takeover of the Co-operative Insurance Society) insurers. Where they were strongest – in boot and shoe-making, clothing, food production – they developed a high degree of vertical integration by opening their own leather tanneries, cloth-making factories and farms. The CWS even produced its own string and twine for making up parcels.

Where they were strongest – in tea importing and flour milling for instance – they acted to prevent price fixing rings from extracting unfair profits from the shopper. Their coastal ships broke up a shipping ring in 1885, and in 1906 public indignation at a soap manufacturers' trust led to the doubling of production at Irlam and then the building of two new soap works; honesty was proved to be the best policy. Their great network of depots and salerooms enabled buyers to offer new lines at fair prices, educating the tastes of their members without manipulating them into false wants or getting them into debt. They looked after their members: the CWS set up a convalescent home so that retail societies could send sick members to recover, and from 1904 onwards the Co-operative Insurance Society offered death benefits so that societies could make sure

all their members were looked after literally 'from the cradle to the grave'. Yet in a society in which wealth was still shared out unequally (by 1911 the working class of 35 million people received about the same share of the wealth as did an upper class of 1. 4 millions), they offered cheap, good quality food and clothing, the profits from which went straight into the pockets of the shoppers themselves: in the first fifty years of trading the CWS returned nearly £7 million in dividends.

Conclusion

If a self-made businessman had set up these great wholesale societies he would have made his fortune, gained his knighthood and bought himself a long and prosperous retirement in a country mansion far from the mean streets of the industrial town where he had grown up. Consider what happened to those early board members of the CWS. William Cooper, that faithful 'handyman of Co-operation' was killed by typhus in 1868 at the age of 46, only four years after the Society had begun. The year before, as a committee member he had earned the right to receive an allowance of five shillings and second-class rail-travel for each board meeting. Ashworth, the manager, died in 1871 also aged 46, while Charles Howarth died at 54 and James Smithies at 50. Percy Redfern says:

> It is, indeed, a plain fact that faith and comradeship and a sense of duty inspired the devotion, and that Cooper, Ashworth, Howarth and Smithies (with Hooson and others also) gave their lives to establish first local and then national co-operative business. They died that the movement might live.[23]

Later board members gained little more in rewards: until 1906 they were unpaid, and then their salary was fixed at £350 per year. J. T. W. Mitchell, the President of the CWS, did not live quite long enough to see it hit £10 million sales; in the Winter of 1894–5 he laboured on with bronchitis, died in his cottage at Rochdale and, though he was in charge of one of the country's biggest businesses (and was rumoured to have made his fortune out of the Co-op), left only £350 to the neighbour who had nursed him. In Mitchell's philosophy there was no room for private profit; the Co-op, as a consumers' movement, would continue to return all surpluses to the consumer, from whom they originated.

Notes

[1] Redfern, P. (1937)
[2] See Birchall, J. (1988) for a similar analysis of the growth of the housing co-operative movement in Britain
[3] Davis, D. (1966) p. 252
[4] Winstanley, M. J. (1983)
[5] Jefferys, J. B. (1954)
[6] Davis, D. (1966) p. 263
[7] See Birchall, J. (1987)
[8] Davis, D..(1966) p. 278
[9] Burnett, J. (1989)
[10] *Ibid* p. 8
[11] Alexander, D. (1970)

12 Burnett, J. (1989)
13 Redfern, P. (1937)
14 Davis, D. (1966) p. 278
15 *Ibid* p. 279
16 Jefferys, J. B. (1954)
17 Davis, D. (1966) p. 280
18 *Ibid* p. 279
19 Cole, G. D. H. (1944) p. 125
20 Potter, B. (1899)
21 Redfern, P. (1937)
22 *Ibid* p. 21
23 *Ibid* p. 29

CHAPTER SIX

A *wider role in society*

It was evident that some co-operative societies were becoming selfish and it was necessary to teach Co-operation to co-operators, and steps should be taken to prevent the great principles of Co-operation from degenerating into merely co-operative stores...After a quarter of a century of shopkeeping it was surely time co-operators assumed a higher platform and a nobler task. (William Pare, paraphrased by Bonner)

The growth of the Co-op Movement was both a source of pride and of anxiety to its leaders. Had it spread too far, too quickly? Was quality being sacrificed for quantity? Were the directors of all the new societies as dedicated to changing the world as were the Pioneers, or were they simply after the material advantages Co-operation could bring? The anxiety was well expressed by E.V. Neale when he declared 'Co-operation seems in some danger at the present time of losing itself through its own success.'[1] Instead of reforming the world, it was feared that the Movement would itself be transformed into a bland acceptance of that world, and would lose its vision.

But what could be done about it? We can identify at least four needs which, if met, could revitalise the Movement. First, there was the need for a national-level organisation which could bind the Movement together and give it direction. This meant reviving the annual congresses (which had not been held at a national level since the first Co-operative Movement in the 1830s), and then setting up a central federal body to which all local societies could belong – the Co-operative Union. This was organised on a thoroughly decentralised basis, so that eventually 62 districts were grouped in seven regional sections, which then elected the Union's central board. Second, there was a need to put co-operative education on a sound basis, so that all active members, directors and managers of societies could be trained in Co-operative Principles and practices, and so not remain ignorant of their unique heritage: This was done mainly by educational associations which mirrored the Union's structure at each of the three levels, in order to support the education committees of each retail society. Third, there was a need to ensure that each society was run democratically and responsively, and this was done through the development of the guilds, in particular the Co-operative Women's Guild, which encouraged the 'women with the basket' to overcome male prejudice and become active members. Lastly, there was a need to involve the workers, and this was a contentious issue which began with a struggle for worker profit-sharing and co-partnership and ended with the

unionisation of the Co-op's workforce and a commitment to being the best employer in the industry.

Underlying these developments was a lively debate about what the Co-operative Movement was for. It had left behind the old aim of building self-sufficient communities which would allow people to escape from the miseries of the industrial revolution, and was now well (perhaps too well) integrated into Victorian society. Self-evidently, its first aim was to continue to improve the lot of working-class people by trading along 'Rochdale' lines, cutting out profits and the 'middleman', and so providing a valuable boost to earning power through the dividend. But what was its relationship to the wider society?

There were those who thought the Co-op would remain one sector within a mainly capitalist economy, providing these kinds of material benefits and helping to make the working class 'respectable'. These were the pragmatists of the Movement, who were content to build up its trading strength but who were suspicious of too much 'dabbling' in politics, in wider educational work, or in social causes. Then there were those who thought it could be part of a socialist movement in which the workers (not the consumers) would eventually take over industry and run it for themselves. These were the idealists who, swimming against the tide of success which was running strongly in favour of the consumer movement, insisted that the workers should take over all productive enterprises. They overlooked no occasion to promote their cause, and saw the development of the Co-operative Union, and then of an International Co-operative Alliance, as one way of doing this. Then there was a group of deeply-motivated women who saw the potential for the Co-op as a way of organising working-class women towards their own emancipation. Finally, there were those who, coming out of the consumer movement, began to believe that consumer co-operation, on its own, could transform society for the better. All of these viewpoints were present and were at times more or less influential in the development of the Co-operative Union, co-operative education, and the Women's Guild, and were represented in the debate over worker profit-sharing.

The Co-operative Union

By 1869, influential promoters such as E.V. Neale, William Pare and Edward Owen Greening were urging that an annual congress be organised. The northern co-operators had been holding successful regional conferences, but they were more concerned with the trading side of the Movement, particularly with building up the new wholesale federations, and this did not satisfy the more idealistic promoters, especially those based mainly in London who were interested in co-operative production along the lines of worker and consumer co-partnership. It is significant that while 400 consumer societies attended the Northern Congress of 1869, only 24 attended the London Congress, along with trade union and producer co-op representatives, yet the latter had the support of the most eminent co-operators: Lloyd Jones, Stanley Jevons, G. J. Holyoake, James Hole, Dr Travis, the Christian Socialists, and the great economist, J.S. Mill. When in 1870 a Co-operative Central Board was set up, from which emerged the Co-operative Union, it was obviously seen as a platform from which to preach the doctrine of worker, as well as consumer, control. However, such was the overwhelming success of the consumer

Programme of the 1892 Co-operative Congress – J. T. W. Mitchell, Abraham Greenwood and Thomas Cheetham were each day's Presidents.

Panoramic view of delegates from member-societies of the Co-operative Union at its 1895 Congress.

Holyoake House, headquarters of the Co-operative Union Ltd in Manchester and a memorial to George Jacob Holyoake.

movement that it quickly took a dominant role in the Union, and as Bonner puts it, it became less of a forum for the eminent and scholarly amateur and more for those more practical co-operators who had served an apprenticeship in the trading side of the Movement (though with E. V. Neale as its first secretary, this question of the role of the workers was bound to remain controversial).

The Union quickly established itself as the backbone of the Movement, working at the local, regional and national levels to nurse sickly societies, discipline the badly behaved, help stamp-out bad practices, slack management and indifferent bookkeeping. It helped to promote new societies in what had been co-operative 'deserts' and then consolidated their position by forming new sections to oversee them. Of course, as a federation of societies it was only as powerful as they would let it be; it relied on a subscription based on the membership (1.5 pence per member in 1911), and in return gave each society one vote per thousand members. Yet it was authoritative, and, along with the annual Congress which it organised and from which it took its mandate, was crucial in shaping co-operative opinion. It was able to defend the Movement's interests at national level, overseeing a new Industrial and Provident Societies Act in 1893, and its amendment in 1913, and setting up a panel to watch over its interests in Parliament.

Co-operative education

Educational work had come easily to the Rochdale Pioneers, partly because there was a crying need for basic adult education, and because of the legacy of Robert Owen, who had insisted that education to change people's habits and character was necessary for any social progress. So they had provided two types of educational opportunity: elementary education for adults who were semi-literate and a quite sophisticated opportunity to engage in free-thinking debate. By the 1870s, the first of these

The Rochdale Pioneers' principles spelled out the needs to educate members. They spent 2.5 per cent of their surplus on education.

had been catered for by the setting up of school boards, so that by 1876 there was a system of compulsory education for children in place. The second had been superseded by a more materialistic attitude; they were providing 14 libraries with 13,000 volumes on loan, they had a fully equipped laboratory, and even hired out microscopes to budding scientists yet, as G.D.H. Cole puts it, the Society 'was dispensing knowledge very much as it sold tea or bread'.[2] Moreover, it was providing facilities which elsewhere had already been taken over by local authorities, colleges or specialist voluntary agencies. It was partly because of resistance by the Pioneers that Rochdale did not get a public library until 1872, and then only after a public petition had been collected.[3]

Clearly, there had to be a rethink about the purposes of co-operative education. One partial solution was to put the weight of co-operative support behind new developments in adult education, and this was done to good effect. When the university extension movement was launched, linking academic lecturers with part-time students, the Co-op provided both the students and the grants to pay for their tuition. More directly, in 1903 Albert Mansbridge, a CWS employee, set up the Workers' Education Association. Its first two branches were formed by local retail societies at Reading and Rochdale, and several key co-operative figures joined its executive committee. The idea of the WEA was to give working-class people the opportunity to study not just through a series of lectures, but through intensive tutorial work. It was not easy; for instance, at Rochdale over 30 people had to be found who would agree to study economic history every Saturday afternoon over a two-year period. Bonner tells us that 43 enrolled, including one who sacrificed a promising career as a professional footballer, and he comments 'This was a generation with a proper sense of values.'[4] The pay-off was that their first tutor was the great R. H. Tawney, one of the finest economic historians and philosophers of socialism of this century.

Yet the problem remained: how to carve out a new and distinctive role for co-operative education, and then to get societies to adopt it? In 1882, the United Board of the Co-operative Union appointed an education committee, with Arthur Acland (an Oxford don who had pioneered university extension courses, launched, appropriately, in Rochdale) as its secretary. Two years later, he reported that in contrast to Rochdale, most societies were doing very little; he found that only £18,000 was being spent annually by the Movement, mainly on libraries, newsrooms, excursions and entertainments. The fact that other agencies were beginning to do the work (and were doing it more professionally) had allowed co-op societies to cut down on their education funds, and many were spending nothing at all. Yet here was an opportunity. As Bonner points out, this entry by other agencies into the field freed 'for the first time all the educational funds and energy of the Movement for their primary purpose, the making of Co-operators'.[5] In response to Acland's report, the committee recommended that societies concentrate on education in Co-operation, and that sectional education committees be set up to help with this. Eventually there emerged a network of educational associations, shadowing the Union's own structures and providing guidance on how to run courses in co-operative bookkeeping and auditing and other co-operative subjects.

By the mid-1890s there were correspondence courses and even junior classes in Co-operation. But in an inquiry of 1896 (demanded by

Members' meetings were cultural and educational events – a ball and a knife and fork tea!

From 1871 the *Co-operative News* has acted as the Movement's weekly newspaper.

A typical early cover from the Co-operative Wholesale Society's periodical *The Wheatsheaf*, which first appeared in 1896.

HARRINGTON

INDUSTRIAL CO-OPERATIVE SOCIETY, LD.

The Committee of the above Society beg to announce that the Ninth Year of the Society's existence will be celebrated by a

Public Knife & Fork Tea, Concert and Ball,

IN THE

Temperance Institute, Harrington,

On MONDAY, SEPTEMBER 19, 1892,

TEA ON THE TABLES FROM 5 TO 6·45 P.M., AFTER WHICH A

PUBLIC MEETING AND ENTERTAINMENT

Will be held. Chair to be taken at 7·30 by Mr. G. GLENN, President of the Society.

The Committee have secured the services of some of the best Local Artistes, who will render selections of

VOCAL & INSTRUMENTAL MUSIC.

Miss ALLATT, of Whitehaven, will preside at the Pianoforte.

Mr. KIRKPATRICK, Carlisle, Mr. SWALLOW, Leeds, Mr. WILLIAM LECK, Cleator Moor, and others will Address the Meeting.

For the convenience of Members and others living at a distance, arrangements have been made to run COVERED WAGGONETTES as under :—

For PARTON and DISTINGTON.—Leaving Brewery Brow Top at 4·30, picking up via Distington.

For LOWCA, Etc.—Leaving Lowca Brow at 4·30, picking up via High Lowca and Syke Whinns, arriving at Harrington at 5 p.m.

The Waggonettes will leave Church Road immediately after the Concert is over.

FARE FOR DOUBLE JOURNEY, 9d.

THE BALL

Will commence at 10 o'clock p.m., when Music will be supplied by an efficient String Band, under the Leadership of Mr. R. Graham, M.C., Mr. Williams.

Tickets for Tea and Concert, 1s. ; Concert only, 6d. Children under 12 Half-price.
Tickets for Ball, Gentlemen, 1s. 6d. ; Ladies, 1s. May be had from any of the Committee, Employees, or at the Store.

SUPPER WILL BE PROVIDED AT 12·30.

Welsh, Moss & Co., Printers, Whitehaven.

~ PROGRAMME. ~

Part 1.

ADDRESS	CHAIRMAN
DUET (Pianoforte), Selection from "The Gondoliers"			MISSES ALLATT
SONG	...	"Jessie's Dream"	MISS MORRIS
SONG	...	"The Irish Jubilee"	Mr. JOHN KIRKPATRICK
ADDRESS	Mr. KIRKPATRICK
DUET (Pianoforte)	...	"Marche Heroique"	MISSES BONNER
SONG	...	"Fiddee"	MISS WALLACE
SONG	...	"The Powder Monkey"	Mr. W. MORRIS
SONG	MISS SHAW
READING	...	"Bowl Aboot"	Mr. JOHN HERRON
SONG (in Character)	"Old Folk at Home"		Mr. A. STRONG
DUET	...	"Consolation"	MISSES MORRIS

Part 2.

ADDRESS	Mr. LECK
DUET (Pianoforte)	...	"Qui Vive"	MISSES BONNER
SONG (Comic)	...	"Sammy Stammers"	Mr. A. STRONG
SONG	MISS ROBERTSON
DUET	Miss MORRIS and Mr. MORRIS
SONG	...	"When other lips"	Mr. W. HALPIN
SONG	...	"In Old Madrid"	MISS WALLACE
ADDRESS	Mr. SWALLOW
SONG	MISS SHAW
SONG	...	"Enniscorthy"	Mr. JOHN KIRKPATRICK
SONG	...	"Annie Laurie"	MISS M. MORRIS
READING	...	"A long Story briefly told"	Mr. JOHN HERRON
DUET (Pianoforte)	...	"Marche Royale"	MISSES ALLATT
FINALE	...	"God Save the Queen"	COMPANY.

95

Margaret Llewelyn Davies, whom we shall meet below as the President of the Women's Guild) two problems were found. Firstly, this renewed emphasis on education for Co-operation was very narrow and technical, and was not preparing co-op members for their social duties; broader courses in citizenship were needed. Secondly, the spread of activity was still disappointing: of 402 societies who answered a questionnaire, a third had no education fund at all, and the rest had voted only £26,000 that year. Only 14 per cent were running education classes.[6] The Congress of 1898 resolved to reorganise the education committee, strengthening the representation of the sectional associations and the Women's Guild, and laying the foundations of an effective central education department. By 1900, the annual amount voted for education had grown to around £60,000, over 1000 people were enrolled for courses in book-keeping, auditing, management and 'elementary and advanced Co-operation'. Over 500 had sat exams in industrial history, bookkeeping and

'Unity is Strength' proclaims the banner of the St George Co-operative Society Women's Guild branch in Scotland.

citizenship, and over 900 'juniors' had sat their own exam. Clearly the Union was proving to be an effective agency for bringing about improvements in both quality and quantity on a subject for which individual co-ops needed a lot of guidance.

Between 1900 and 1914 funds earmarked for education rose from £64,000 per year to £113,000, and the number of students from 3,000 to 20,000. From 1906 the Education Department was organising classes in economics, from 1908 on co-operative subjects for adolescents, and in 1909 it started a valuable Easter weekend conference for education specialists. In 1913 it held its first residential summer school, and in 1914 appointed Fred Hall as the first director of studies, with a view to setting up a Co-operative College. The Great War intervened, but clearly the Union had succeeded in bringing about a return to the educational spirit of the Rochdale Pioneers, though it had had to invent some more sophisticated methods of delivering the message.

The Women's Guild

The consumers' democracy was a real democracy; every member of a co-operative society had one vote, regardless of the amount of share capital held, and from the 1870s onwards they had their own parliament in the annual congress and their own government in the Co-op Union. Yet it was a flawed democracy, because the people who did most of the shopping – the women – were almost completely excluded from it. Here is how Alice Acland, founder of the Guild, summed up the problem in her first appeal to women members:

> What are men always urged to do when there is a meeting held at any place to encourage or to start co-operative institutions? Come! Help! Vote! Criticise! Act! What are women urged to do? Come and *buy*. That is the limit of the special work pointed out to us women.[7]

There were several reasons why women were excluded. Many societies had limited membership to one person per family, who was usually the man. Even where joint membership was allowed it was usually the man who attended the quarterly business meeting, and some societies refused

Three attractive Women's Guild banners – each individual in its design and message.

to accept wives as members without their husbands' consent. Before women obtained the right in law to hold their own property (and even after, in some cases), women members had trouble claiming the dividend as their own, unless their husbands consented to it. In addition, there was a wall of prejudice which was even more insuperable in a way than the legal barriers. In the north, where factory-work made women more independent, there was a considerable female membership. But that did not make it any easier for them. Bonner tells of how even in the 1870s it took courage for James Smithies' daughter to enter the reading-room of the Rochdale Pioneers. A male oligarchy of committee men and officials objected to interference in the way the shops were run, and so, as Cole puts it, 'the struggle for open membership was long and arduous, especially in many parts of the north' where the prejudice was most strong.[8]

The Women's Co-operative Guild set out to remedy this situation, first by educating and raising the confidence of women members in their own autonomous organisations – the local guilds which were attached to each society. Then they did what the education associations were doing; set up organisations parallel to the Co-op Union at society, district, sectional and national level. They were then able systematically to sponsor women as candidates for places on boards of directors, sectional boards, and eventually as CWS directors and presidents of Congress. In making known the views of women as consumers they raised the quality of the debate at every level of the Movement, and made the officials accountable to what Margaret Lllewelyn Davies called 'the woman with the basket'. They did much more than this, though, preparing women for election to local authorities, and running national campaigns on women's issues which, arguably, had as much effect on the life of the nation as the rest of the Co-operative Movement put together.[9]

The whole movement started with a 'Women's Corner' in the *Co-operative News* donated by the sympathetic editor, Samuel Bamford, and written by Alice Acland (wife of Arthur Acland, pioneer of adult education). She began conventionally in her first editorial, saying that the purpose of the Corner was to link co-operative women together, and to discuss subjects such as cookery, childcare and needlework. Though she declared that the question of women's rights was beyond the scope of her first contribution, she could not help a passionate outburst of feeling which warned of stronger arguments to come:

> What I want to know is – why are we held in such little esteem among men? Why is the feeblest type of man called an old 'woman'? Why do our lecturers dislike to speak to a 'parcel of women'? Why is 'woman-hearted' a term of reproach?[10]

Then Mary Lawrenson (daughter of a Woolwich printer who was active in the Co-op) wrote in, suggesting modestly that they could set up 'an independent body to promote instructional and recreational classes for mothers and single girls'. Mrs Acland's response was that they should form a 'guild of women', to help in the cause of Co-operation, but more than that, to give women a support network, to end their sense that their 'efforts were isolated and of little value'.[11]

Still, for all the forthright talk in the 'Corner' they had to move carefully for fear of a male backlash. Acland reassured her readers that 'we can move in a quiet, womanly way to do true women's work', and at their first meeting at the Edinburgh Congress they decided not to do any

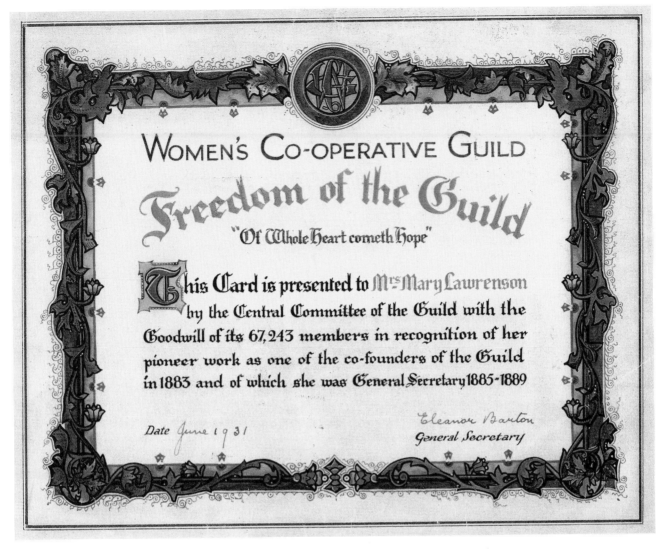

WOMEN'S CO-OPERATIVE GUILD

Freedom of the Guild

"Of Whole Heart cometh Hope"

This Card is presented to Mrs Mary Lawrenson by the Central Committee of the Guild with the Goodwill of its 67,243 members in recognition of her pioneer work as one of the co-founders of the Guild in 1883 and of which she was General Secretary 1885-1889

Date June 1931

Eleanor Barton
General Secretary

Certificate conferring the freedom of the Women's Guild on Mrs Mary Lawrenson, a leading figure in the Guild's development.

platform speaking or advertising. At the meeting, 50 women talked for over an hour, until they had to stop because the men had concluded their business, but they elected Acland as organising secretary for the first year, and the Guild had begun. Growth was slow at first, with three branches by the end of the first year, 1883, and 51 by 1889, with a membership of 1,800. In 1886 they gained official recognition with a Co-operative Union grant of £10. They had strong support from some eminent men – Samuel Bamford, Abraham Greenwood, E. V. Neale, and Ben Jones – but it was as if their wives and daughters had been just waiting to get out of the shadow of these great men, and when they emerged – Miss Bamford, Miss Greenwood, Mrs Jones, Miss Holyoake and others – they showed that they were every bit as talented and well taught in Co-operation as their husbands and fathers had been.

Mary Lawrenson succeeded as general secretary, and in 1885 was elected to the Education Committee of Royal Arsenal Co-operative Society. But the real turning point was in 1889 when Margaret Llewelyn Davies, the daughter of a Christian Socialist clergyman, was elected as secretary, and 'began at once to infuse a new vigour' into the Guild. Here is the assessment of a normally cautious historian: 'Her decision to

devote her entire life to the women's side of the Co-operative Movement was a turning-point in Co-operative history.'[12] In her long service as general secretary (she was 32 years in the office) she turned the Guild into a campaigning organisation whose influence extended far beyond the Co-op into the life of the nation. She used Fabian-style tactics, beginning with research into a problem through social investigations and questionnaires to guild members, then fed the conclusions back to the branches for discussion, then when the views of the members were known and she had a mandate, orchestrating a nationwide campaign on the issue. She was concerned that the guilds should not decline into 'mere sewing-classes', and guided them to study serious subjects such as women in local government, women as factory inspectors, women and labour legislation, women's suffrage, women's trade unions and so on, and if she was a little dictatorial in her methods and lost some members to the Guild, she gained many more, and turned it into 'the most progressive and intellectually fertile element within the Movement'.[13]

The first campaign was for open membership, persuading societies to

Margaret Llewelyn Davies, Women's Guild General Secretary for 32 years.

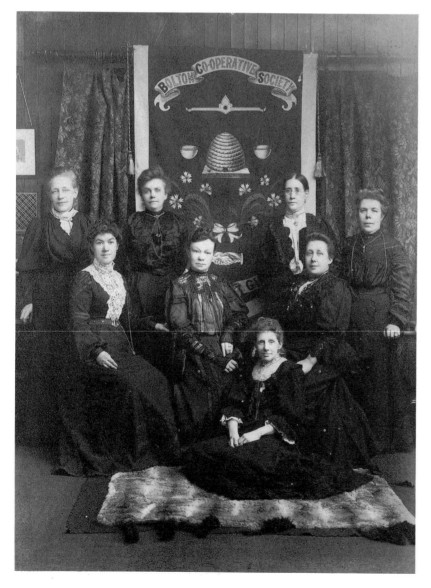

Bolton Co-operative Guildswomen celebrated their branch's 21st anniversary in October 1907; the beehive, symbol of industry, emblazons their Guild banner.

'People's Store' experiment in Sunderland.

allow more than one member per household. At the same time, women were trained by the Guild for public speaking and committee work, and encouraged to stand for co-op committees. The education committees were more open, partly because the Guild achieved some direct representation: in 1889 there were forty-two women on them, by 1891 seventy three. Yet even though there were 100,000 women among the one million members at this time, still only six had won seats on society management committees. The southern societies were more progressive, and in 1893 Mary Lawrenson and Catherine Webb were elected to the Central Board of the Co-op Union. By 1904 significant change had been achieved. At national level, a woman (Miss Spooner) became chair of the United Board of the Union, two women had seats on the Union's education committee, and 11 were serving on the Association of Education Committees. At the local level, 30 women were on the management committees of 20 societies, 238 on the education committees of 108 societies, between 60 and 70 were attending divisional meetings of the CWS and there were 16 women delegates at Congress.[14] Yet the struggle for representation continued; in the Midlands it was 1917 before a woman was elected to the sectional board of the Union, and it was only after the Great War (with all the changes in status for women which that entailed) that a woman, Mrs Cottrell of the Ten Acres and Stirchley Society, was elected to the hallowed ranks of the CWS directors.

Then came campaigns to return to the principle of cash trading, and to take co-op shops to the poorest people. This latter campaign bore fruit in an interesting experiment in Sunderland, where the local society set up a 'people's store' in a poor area of town, selling food at low prices and in small quantities, serving coffee, hot soup and cooked meats, with a loan department set up as an alternative to pawnshops and a small settlement with two resident community workers attached. With Margaret Davies herself overseeing it for the first three months, it worked well and after two years even produced a dividend of two shillings in the pound. Yet, after a resident worker resigned through ill health, the experiment was soon over and the store converted back to an ordinary branch. A faction within the local society had always resented the way the store had mixed self-help with philanthropy – the sale of hot soup and importation of social workers was foreign to the spirit of the Movement – and they took the first chance they could to end it. More successful was a vigorous and lengthy campaign to commit the Movement to a minimum-wage scale

for women workers; they began with a systematic inquiry which led in 1907 to the Movement's acceptance of their case, and then, after more campaigning to individual societies, agreeing to adopt the scale.

Looking outside the Movement, the Guild campaigned for women's trade unions. They got maternity benefits included in the 1911 Insurance Act, and then insisted the benefit be paid direct to women, in 1913 winning an amendment to that effect. They campaigned for improved health care for mothers and infants, through school clinics, maternity centres and municipal midwives. A government circular recommended adoption of their entire programme, and offered a 50 per cent grant to local authorities; Guild women who had been elected as local councillors then insisted it be implemented. They got into real trouble over divorce law reform. After circulating the members to find out their views, the Guild was able to show for the first time how working-class women felt about divorce, and they made a list of very radical demands. Some of these were soon granted: in 1923 equality of treatment of men and women was given, in 1937 grounds for divorce were extended to desertion, insanity and cruelty, in 1949 legal aid was given, but they had to wait until 1969 before their main demand for divorce by mutual consent was granted. Their strong stand on divorce led to pressure being applied by a Catholic organisation on the Co-operative Union, and to the Union cancelling the Guild's annual grant. They might have known the women would not give in; Margaret Davies immediately started an Independence Fund and made a personal loan to the Guild, and in 1918 the grant was restored. In 1922 she was the first woman to become President of the Co-operative Congress.

In 1889 a Scottish Women's Guild was started, which stimulated a useful movement for co-operative convalescent homes, but which never ranged so widely as the English Guild. In 1911 a Men's Guild was started, concentrating on educational and propagandist work within the Movement, but it was a pale shadow of the women's organisation; after all, the men already had opportunities of being involved in the wider Movement.

Not only Women's Guilds had their banners, as this example from Bermondsey shows.

What about the workers?

It is a strange fact that most of the promoters of the Consumer Co-operative Movement were, during the second half of the last century, more concerned with the role of the workers than that of the consumers. The Christian Socialists based their analysis on Ricardo's labour theory of value, believing that it was the workers who put the value into a product, not the capitalists or the consumers, and that it was therefore morally imperative to give the workers control over industry and first call on the profits. We have seen how during the 1850s their first attempts at setting up self-governing workshops all failed. During the 1860s and 1870s, many productive enterprises were set up, with a variety of investors – retail co-ops, the two wholesale agencies, trade unions, individual Christian socialist promoters, and workers – and often with the surpluses divided up between all the factors of production, capitalists, consumers and workers. They were set up in the bad times during strikes against ruthless employers, and in the good times in the hope of quick returns, and ranged from woollen and carpet manufacturers, through several coalmines, to a large engineering works at Ouseburn and an Industrial

Manor house of the CWS estate at Roden, Shropshire, which later became one of the Movement's convalescent homes. When tuberculosis was rife, Co-operative members and their families benefited from a healthy stay in a rural environment.

Bank set up to promote such ventures. The trouble was that, in the volatile conditions of the 1870s, most eventually failed. Only those concerns owned by the wholesale federations and the retail societies really flourished, owing to the stable demand which the consumer movement guaranteed.

There was strong opposition from the Christian Socialists to the CWS setting up its own factories; they thought that the line should be drawn between distribution and production and that the latter should be done by co-partnership co-ops in which the workers had a share in both management and profits. In 1872, under pressure from E. V. Neale, Edward Owen Greening and Dr J. H. Rutherford, the CWS reluctantly agreed to pay an annual bonus to labour, based on the surpluses made. It was not popular, since workers engaged in distribution did not see why they should be left out, and the workers' own leaders preferred good, regular wages. The bonus was abolished in 1875 (though it continued for a while longer in the Scottish CWS). So the idealists tried again, in 1882 forming the Co-operative Productive Federation (CPF) to promote new enterprises part-owned by the workers, in 1884 forming the Labour Association to continue the agitation for a bonus to labour and then, when the idea was finally and decisively rejected by the CWS in 1886, turning to the idea of co-partnership in industry, trying to persuade conventional firms to introduce worker shareholdings and bonuses. Under the capable leadership of Thomas Blandford, the CPF flourished. Unfortunately, like

so many other good co-operators, he wore himself out in the cause (and died in the flu epidemic of 1899), but the CPF had, by 1903, increased the number of producer societies to 126. However, these were mainly small and confined to trades which had skilled labour but were not capital-intensive, and relied on a ready market in the retail societies.

The worker viewpoint faced an implacable opponent in Beatrice Potter (later Beatrice Webb). In her book *The Co-operative Movement in Great Britain*, the first really definitive history of the Movement, she attacked the idealists with some ferocious arguments in favour of a **consumer** co-operative takeover of the whole of industry, in which the workers would be relegated to wage-earners protected by trade unions.[15] Her arguments were both theoretical and practical. At the theoretical level, she challenged her opponents to show how production could be separated from distribution. Supposing a factory-worker weighed and packaged tea, this would be production. Supposing a shopworker did the same, would this be production or distribution? Even more fundamentally, when a farmer harvested a crop, this would be production. When he took it to market, would this be distribution? The point was that there was no way of dividing the one from the other; both added value to the product. Nor was there any legitimate claim to a share in the profits, since consumer societies had already done away with profits, and their surpluses were really only a way of giving a rebate so that shop prices could be eventually adjusted down to cost price. Finally, like other more modern economists, she began to see that the labour theory of value was out of date, and that in a market society it was the consumer who decided what value to put on a product. All that the worker should ask for is a negotiated living-wage and decent working conditions.

Her practical arguments were just as devastating. She called her opponents 'individualists' and her position 'federalist'. Firstly, she showed how the most successful productive enterprises, the co-operative flour mills, had gradually been converting from **individual** forms of ownership, in which workers shared control with consumers, to outright ownership by consumer societies as **federal** agencies. Instead of being a sinister development, this takeover of production on behalf of the consumers was a natural one, based on the open democracy of the store.

The Manchester Tenants' Estate, set up by CWS employees as a co-partnership in which all tenants held shares.

Productive societies were co-partnership bodies jointly owned by their employees, Co-operative retail societies and trade unions.

Products of the Co-operative co-partner-ship societies were primarily footwear, clothing and printing – buckets and fenders too!

More fundamentally, she argued that worker-controlled societies were on the horns of a dilemma. On the one hand, there was a tendency for the workers to interfere with management (as the self-governing workshops had done) and to lack discipline, and so to fail. On the other hand, if they succeeded they tended to become exclusive, denying membership to new-comers, and retaining all the profits for themselves. Because they were competing in a market, they could then ruin other worker-controlled enterprises and so put each other out of business. Whether they failed or succeeded, then, the workers could not win.

Potter's argument was backed up with a ruthlessly logical analysis of the CPF statistics for 1890. She found only 54 associations working, and divided them into four classes. First there was the Christian Socialist ideal of the self-governing workshop, of which she found only eight. Then there was the same type, but with a manager who could not be removed by the workers, of which there were four. Then there were associations which had deformed into 'small masters', hiring workers who were denied membership: these were half the total. Lastly, there were societies which were largely owned by the retail societies but in which workers were encouraged to take shares. There were 13 of these, in none of which were workers on the committee, and, like the retail society-owned mills, they showed the greatest vitality. So, under the microscope, the ideal of worker self-government had proved to be an 'industrial phantom'.[16] Her judgement is merciless:

> Forty years of persistent self-devoted effort, the institution of some hundreds of Associations of Producers, have left us with eight establishments with constitutions more or less approximating the model self-governing workshop (four of diminutive stature), all in the stage of infancy or childhood.[17]

And, she declared, it was to these pseudo-democracies that the great CWS was being asked to hand over its factories!

A consumers' theory of Co-operation

So far, the advocates of worker co-operation had had the moral high ground. But, in fighting off the calls for profit-sharing, J. T. W. Mitchell, the chairman of CWS, had been forced to consider the wider significance of the consumer co-operative in society. He saw that there was no good reason why consumption should not be the basis of **all** growth in Co-operation. After all, consumer co-operation organised production efficiently on behalf of consumers, basing it on their known requirements and eliminating wasteful competition and duplication of effort. It eliminated profit, returning to the consumer any surpluses made after the expenses of the operation had been paid for. It was, in theory and to some extent in practice, a perfect economic system; why look any further? Beatrice Webb would not go so far, because she saw the need to add the protection of workers given by their trade unions, and the role of the state in guaranteeing a minimum of social welfare to all citizens.

However, in France an outstanding economist, Professor Charles Gide, was going further still. Basing his theory on the experience of consumer co-ops in Nîmes, he envisaged a complete transformation of society through consumer co-operation. He saw no reason why the combined economic power of the consumers could not extend gradually back

through all the stages of production to the extraction of raw materials (after all, consumer co-ops had been owners of coalmines and were beginning to be substantial farmers). Consumer co-ops were in his view not an elementary form of socialism which would culminate in the rule of the workers, but were themselves the pioneers of a new economic system, their own Co-operative Commonwealth.[18] In this he was simply continuing one strand in the thinking of the Rochdale Pioneers to its logical conclusion.

Notes

[1] Quoted by Bonner, A. (1970) p. 87

[2] Cole, G. D. H. (1944) p. 231

[3] Cole, J. (1988)

[4] Bonner, A. (1970) p. 122

[5] *Ibid* p. 118

[6] Cole, G. D. H. (1944) – figures recalculated

[7] Webb, C. (1927) p. 18

[8] Cole, G. D. H. (1944) p. 184

[9] For some moving accounts of the effect of the Guild on women who became members, and in their own words, see Davies, M. L. (ed.) (1977)

[10] Gaffin J. and Thoms, D. (1983) p. 2

[11] *Ibid* p. 3

[12] Cole, G. D. H. (1944) p. 218

[13] Gaffin, J. and Thoms, D. (1983) p. 43

[14] Figures supplied by Cole, G. D. H. (1944)

[15] Potter, B. (1899)

[16] *Ibid* p. 147

[17] *Ibid* p. 157

[18] See Lambert, P. (1963)

CHAPTER SEVEN

In war and peace

The corn-millers invite the Co-operative corn mills to unite in fixing prices; the bakers open up negotiations for jointly maintaining the price of the loaf ... there is a butter ring and a bacon ring, an incipient agreement among the soap- makers ... the Co-operative Movement will invariably have nothing to say to them. (Sydney and Beatrice Webb)

In 1913 the CWS celebrated its 50th anniversary and produced a beautiful commemorative casket and other memorabilia.

The Co-operative Wholesale Society had just celebrated its fiftieth anniversary, in September 1913, when a sudden cry for help came from the people of Dublin. A widespread transport strike had been going on for so long that food supplies had run dangerously low. No end to the dispute was in sight; the Irish employers refused to negotiate either with the Trades Union Congress (TUC) or a British Government Commission. From a city which was already the poorest and most slum-ridden in the kingdom, reports came in that thousands were destitute and that the children were beginning to starve. Within three days of receiving £5,000 worth of credit from the TUC, the CWS had chartered a ship and made up thirty thousand food parcels, consisting of ten pounds of potatoes, tinned fish, sugar, margarine, tea and jam, enough to feed a hundred thousand people for several days. From the Middleton Jam Works came '30,000 two pound jars, sealed and labelled'. 27,000 potato bags were delivered from the Goole depot, and the potato packers 'came on duty at four in the morning ... remained at work all that night and the day after'.[1] In Dublin, 'employers and shopkeepers had scoffed at the "food ship": it was all a deceit; it was impossible'.[2]

On the morning of the third day, the Dublin and Belfast Co-operative

The SS *Hare* arriving in Dublin with relief supplies for Irish co-operators.

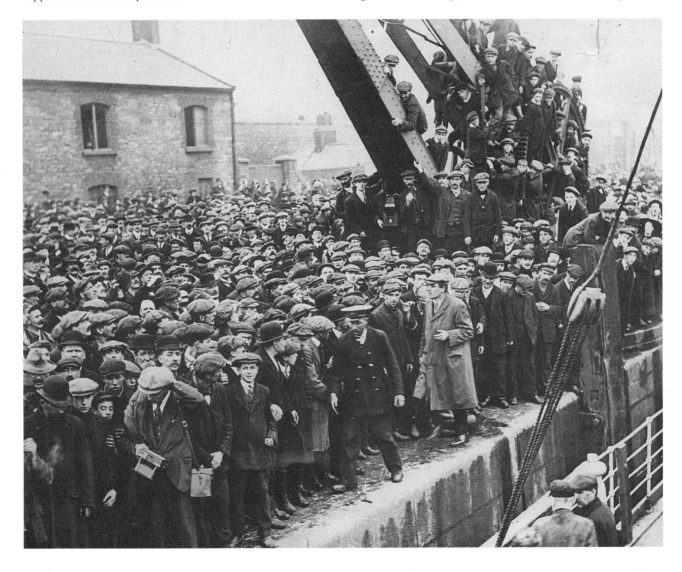

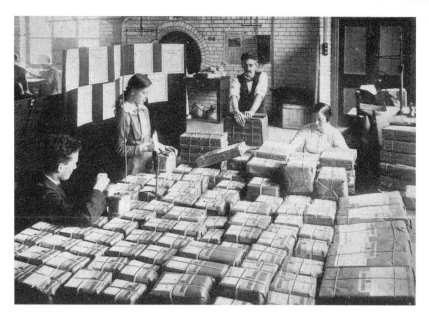

Tobacco and cigarettes from the CWS Manchester factory packed ready for distribution to British troops in 1915.

Societies supplied 12,000 loaves for distribution. The ship was greeted by a crowd who had waited six or seven hours in the rain, and when it was unloaded they filed through a long, low shed to receive a 'triple gift of potatoes, groceries and bread' needing (as Redfern, the CWS historian, puts it) a third hand to hold an extra pack of biscuits which had been given by the CWS Works at Crumpsall. A further surprise awaited. They found that the jam was of good quality, and a label invited customers to return it if unsatisfactory. The biscuits were unbroken: this was not charity but mutual aid. As Redfern puts it 'The gift was of the best, and as from their fellows. "Ah now", said one man proudly (he had not eaten for twenty-four hours), "it's themselves might be wanting our help some day."'[3]

The lesson of the food ship, and of the ones which followed over the next three months, was that the British Co-operative Movement had greater resources than any other organisation for meeting emergency needs. So it was not surprising that, within a few weeks of the First World War, the CWS was turning out 10,000 suits a day for the army, had stockpiled 70,000 blankets, and was working flat-out to supply the

A first world war winner of the Victoria Cross was Lt. W. E. Boulter (standing in front of this tank). He was in the 6th Batt. Northamptonshire Regiment and before he enlisted worked in the drapery department of the Kettering Co-operative Society.

government's needs at prices as close as possible to cost. In the midst of a food panic in which stocks were emptied from the shelves and prices soared, the Co-operative Movement sold all its stocks at the usual price until they ran out, and then tried to keep prices down as far as possible. Meanwhile, private traders made a killing, even buying from co-ops to resell goods at inflated prices. Co-op halls were requisitioned for troops, CWS drivers were sent to France to drive for the army, bakeries and factories were turned over to war production, the price of wholesale goods rose, sometimes hourly, and yet the Movement remained steadfastly loyal.

As the War wore on, the sacrifices became greater: the CWS agreed to pay the difference between all their employees' army pay and their Co-op wages, and to give three months wages to the relatives of anyone killed in action (nearly 6,000 CWS employees were called up, of whom 810 never came back). CWS goods became a familiar and comforting sign to the soldiers in the trenches, but because of the directors' determination to

Co-operative societies took the lead when the First World War began by issuing ration cards to members to ensure fair shares of scarce food for all.

Competitive retailers were always ready to attack Co-operative societies for their return of profits to the members in the form of dividend – as this contemporary cartoon shows.

take the lowest commission offered by the government, several factories began to trade at a loss. The problem was that their loyalty was not reciprocated. They could see that private traders were making excessive profits from hoarding food and then releasing it at higher prices. They wanted a national system of rationing which controlled prices and gave fair shares to all, and to prove it could be done they set up their own rationing system: the wholesale societies rationed the retails, and they in turn set up systems for sharing supplies with their members.

But the government was determined to uphold 'business as usual', and huge profits were made by the Co-op's competitors; all the Movement could do was to undersell them and keep the price rises in check. To make matters even worse, when rationing was introduced for sugar, the Co-op was not represented on the commission set up to control it, even though it was the largest wholesaler and retailer of sugar in the land. The same 'studied neglect' by government[4] led to the Co-op's exclusion from wheat and coal commissions, and the private traders cleverly set up a system which doubly disadvantaged the Movement. Firstly, goods were distributed according to the pre-war number of customers estimated for each shop, and as the Co-op had been growing rapidly, this meant that many of its members had to go back to using private shops for their supplies. Secondly, it relied on the honesty of traders in estimating their custom, and not many were as honest as the Co-op, whose membership was, of course, published for all to see. The result was summed up by T. W. Allen, a director of the CWS:

> The Movement stands in a relationship of one to seven with regard to supplies, and of one to four in respect of population. Here is the secret of all our trouble; here is the cause of resistance on the part of the 'trade' to any attempt to disturb the old order.[5]

At the local level, the lack of Co-operative representation was even more devastating. Local traders had always loathed the Co-op and had often banded together in traders' defence associations to try to persuade shoppers to boycott it. Occasionally their efforts had to be taken seriously; in

Contemporary Co-op leaflet defending the Movement's caring attitude.

What Co-operation is doing for the people during the War.

IT has helped to keep down the price of bread and coal, and many other necessities of the household. This is proved to the hilt by the enormous number of people who have joined Co-operative Societies since the outbreak of the war.

IT has helped the Government in the hour of its greatest need to clothe and feed our brave soldiers. Millions of pairs of the best boots in the world have been supplied to them. Co-operation helps to win the battle.

IT tided many a family over the panic of the first few weeks of the war—employers discharged men right and left, and they might with their families have been left to starve but for their accumulated savings in the Co-op.

Moral: JOIN AT ONCE.

1902 for instance, a St Helens association had financed anti-Co-op candidates in local elections, had boycotted the employment in their own shops of anyone who had a relative who was a co-op member, and had vilified the local Society in the press. But generally the effects of such public campaigns had been to drive more customers into the Co-op shops, and they had done the Movement little damage.[6]

Now that the traders had the power, they began to get their own back. Co-op members were excluded from local war-relief committees, to which their societies had contributed generously. Local military service tribunals were packed with private traders, who took the opportunity to send Co-op employees to the front, while exempting their own workers; one society lost 102 out of its workforce of 104, while surrounding shopkeepers were keeping their sons out of uniform. A private baker exempted his own foreman, and sent the Co-op foreman to war.[7] Some of the army officers sent in to oversee the process had naively explained that the Co-op was an unfair competitor in any case, and should be shut down. Then, to cap it all, the government introduced an Excess Profits Tax, and applied it, unfairly, to Co-operative surpluses; such surpluses are not profits but returns to the members of money they had paid in excess of cost price, and in any case the Movement was trying to limit profits by selling staple goods as near to cost as possible.

Sidney Elliott sums it up like this:

> Every action of the Government seemed to indicate a 'latent hostility' to co-operators, and an assumption that the only system for the distribution of commodities was that of the private merchant, wholesale dealer and shopkeeper.[8]

Other historians think it was not so much hostility as ignorance on the part of an upper-class government who were simply unaware that such an extensive working-class movement existed, and they point to the fact that, when civil servants began to regain control of the system from the ad hoc committees of business interests, the Co-op began to get its just recognition.[9] For instance, when Lord Rhondda succeeded Lord Devonport (a wholesale grocer and competitor of the Co-op) as Food Controller, and J. R. Clynes became his parliamentary secretary, the Movement 'to some extent came into its own' and several leading co-operators became temporary officials at the Ministry of Food, and then formed a strong contingent of six out of 18 members of a Consumers' Council set up to advise the Minister. It was still true, however, that as late as November 1917, while 12 per cent of the members of local food committees were private traders, only 2.5 per cent were Co-op members; by 1919 their representation had still only reached 5.5 per cent.[10] And they never got that place on the Sugar Commission.

The founding of the Co-operative Party

The wartime experience had its lighter side. A CWS traveller, waiting at a railway station on a dark night, was arrested by an angry mob as a spy, and had to be rescued by the local retail-society manager (the next night a traveller for a private firm was not so lucky and had to spend a night in the cells). During a Zeppelin raid on the CWS offices in Leman Street in London, falling telephone wires coiled themselves around a night-watchman, who thought he was being netted by a Zeppelin to be hauled up

Co-operative Party banner.

into the sky as a prisoner. There were heroics, too: a CWS ship, the *SS New Pioneer*, rescued thirty people from a ship torpedoed by a German submarine, and in doing so exposed itself to the same danger.[11] But the overwhelming feeling of co-operators coming out of the War was one of bitterness and anger that they had been treated so badly. Historians can see how this appeasement of the Co-op towards the end of the war was 'sufficient to create a renewal of the original spirit' of loyalty to the government.[12] But among the rank and file co-operators the bitterness lingered on. As one speaker at an emergency congress put it:

> Every country in Europe has used Co-operation more freely, and valued it more highly as a national asset, than Great Britain ... It is only in democratically enlightened Britain that Co-operation has been relegated to a back seat.[13]

They were determined that never again would they allow their Movement to be so exposed to their political enemies. The result was that in 1917 co-operators reversed a view on political neutrality which had stood firm for decades against all attempts to propel the Movement into politics. They decided to seek representation in parliament and local government.

There had always been a minority who had advocated political action, but they had been defeated three times in Congress by those who felt that a Joint Parliamentary Committee (set up in 1880), working with several Liberal MPs who were their friends in parliament, would look after their interests sufficiently. In fact, the Parliamentary Committee had always argued this was insufficient and that direct representation was needed, but prominent liberals such as E. O. Greening had succeeded in keeping the Movement strictly neutral. Greening had argued that bringing politics into Co-operation would alienate the substantial number of members who were Conservative voters, and would unite the opposition against the Movement. Yet such was the strength of feeling at the Swansea Congress in 1917 that an overwhelming vote in favour of seeking representation carried the day. There were two key questions to be answered: should Co-op representatives be independent or associated with the Labour Party, and should they vote only on issues connected with the Co-op or have a wider brief? Sceptics made the obvious point that they would have to fall in line with one party or another or they would not get elected, and that when elected an MP would have to vote on wider issues on which Co-operative opinion may well be divided. The Congress resolution decided the first question in favour of independent representation (only a minority wanted an alliance with the Labour Party) but did not answer the second.

The problem was so difficult that the Movement might have quietly forgotten about their resolution, but for the fact that the Prime Minister, Lloyd George, incensed the Parliamentary Committee by refusing to see them and, it was said, seeing the Jockey Club instead.[14]. The Committee called an emergency Congress at which delegates were so angry that Greening withdrew his opposition, and it was unanimously resolved

> that this conference desires to place on record its indignation at the contempt with which the present Prime Minister has treated British Co-operators, not only in refusing to receive the deputation appointed to place the grievance of the Movement before him, but also at his failure to take any steps, after repeated appeals, to recognise the existence or usefulness of the Co-operative Movement in the present national crisis.[15]

A National Co-operative Representation Committee was set up, and in the 1918 election ten Co-operative candidates stood, one, Alfred Waterson, becoming the first ever Co-operative Member of Parliament, in that old stronghold of Co-operation, Kettering.

Waterson decisively answered questions about what form representation should take by immediately joining the Labour Party and becoming a member of the Labour group in Parliament. Yet, in 1921, Congress was still voting against direct alliance with Labour, and in 1922 four independent Co-operative MPs were elected. Greening had been right, though, in his prediction that this could not last. In practice they had all been elected with the agreement of the local Labour Party, and again took the Labour Whip in Parliament. It would take until 1927 for a scheme for joint working to be passed at both Labour and Co-operative Party conferences, and until 1938 for a proper agreement to be signed, but in practice the two parties were to work together to produce 'Labour and Co-operative' MPs at every election. The logic was still difficult to understand; a party which was subject not to its own conference but to a

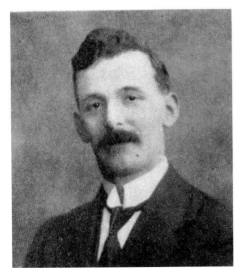

Alfred Waterson, first Co-operative Member of Parliament, elected for Kettering in 1918.

A. V. Alexander was the first Co-operative MP to gain Cabinet office and later became a stalwart defender of Co-operative interests in the House of Lords.

Co-operative Union committee (on which were some committee members from societies which refused to affiliate to the Party) was, in Parliament, almost indistinguishable from the Labour Party. It was a compromise which defies logic, but it worked.

Even Prime Ministers shop at the Co-op – London Society delivers to No. 10 Downing Street during the first Labour administration.

The Movement in peace time

At the end of World War I the Movement had never looked stronger. Its honesty and commitment to the consumer at all costs had caused membership to increase from three million to over four million, and trade turnover to more than double, from £88m to nearly £200m. With the inflated prices of the time the amount of real growth is hard to assess, but Sidney and Beatrice Webb put it this way: three-sevenths of all households were members, and the Co-op supplied half their food and a tenth of all their other purchases.[16] It was by far the largest business enterprise under the administration of the 'wage-earning class' in the world. What was the quality of the experience of people who were a part of this Movement? How did it affect their lives? Imagine that you were a new member of a Co-operative Society during the 1920s, and we shall try to describe what it would have been like. You would most likely be living in the Midlands or the South of England, which is where the inter-war expansion was concentrated, rather than in the fearfully depressed older industrial areas where membership had almost reached saturation point (between 1911 and 1939 these two areas almost doubled their share of the Co-op trade from 24 per cent to 46 per cent). You might have been less well-off than the average member, because it was in this period that Co-operation really began to reach out to unskilled and semi-skilled workers, more than doubling the membership again to over eight million by 1937. You would have been more and more likely to be a member of a large society (in 1900 the 24 largest societies had 25 per cent of the members, in 1939 37 per cent).

The experience would have varied depending on the type of Society you were part of. We can distinguish at least four types. Firstly there were *village and small-town societies*, with one or two shops and a membership of under 5,000: in 1920 these made up 1,154 out of 1,352

Kettering – perfect example of a small town society dealing in many trades and meeting members' needs from the cradle to the grave.

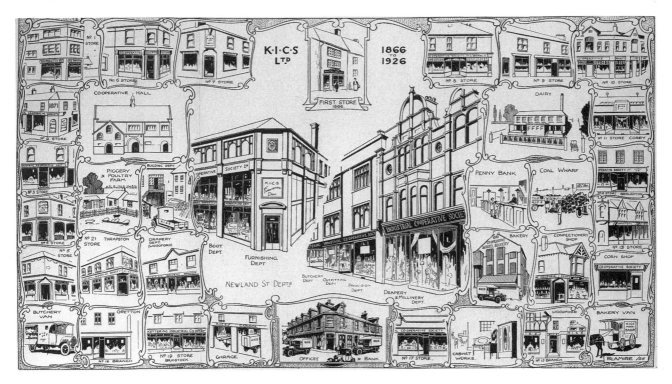

Windows to a New World

societies. Despite their size they could be outstandingly successful, with almost all the villagers enrolled as members, and supplying most of what they needed; the best example was Desborough in the east Midlands, with 2,160 members out of a population of under 5,000, and with sales of over £52 per head. In fact, the Desborough Industrial and Provident Society was so successful it ended up owning 3,425 acres of land, including Desborough and a neighbouring village, selling fruit and vegetables from its own farm, developing housing and allotment schemes, iron ore mining and brickmaking, and becoming collectively the lord of the manor. The Webbs report that 10 per cent of the members attended the quarterly business meetings, which they saw as a sign of apathy. But imagine being a member and squeezing into a hall with over 200 other people to call your board of directors to account for a whole miniature Co-operative economy; along with the day-to-day interaction between members and their committee, it must have ensured effective democratic control. Not all village societies were so enterprising, and because they were so small it was difficult for them to supply all the wants of their members. Their small size held them back from developing much more than basic grocery provisions, though in some areas (Leicestershire, for example) they were able to rely on larger town-based societies for milk and bread rounds, and sometimes made arrangements for members to shop at the larger society's store and still receive dividend.

Taking Co-operation to the villages – Askham village in the English Lake District makes an attractive setting for this visit by Penrith Co-operative Society's travelling grocery shop. This painting was one of a series commissioned by the CWS from Rowland Hilder RI in the early 1950s.

118

Above Shop small – Banbury Society's thatched shop in Wellesbourne.

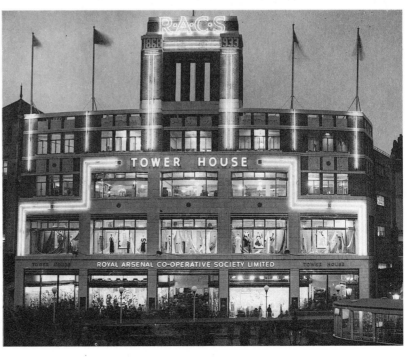

Right And massive – grand 1930s architecture at Royal Arsenal Society's Tower House.

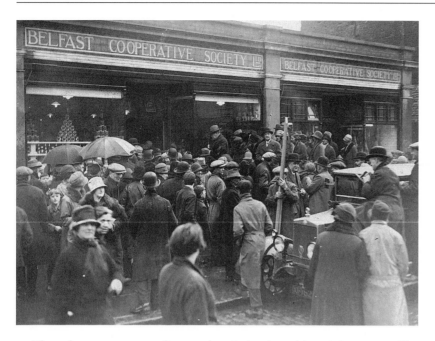

Crowds at the opening of a new store in Belfast.

Then there were more *dispersed societies*, based in market-towns like Banbury or Brecon, and covering enormous districts of small villages and hamlets, mainly by the use of that new invention the motor van. In this case, you would probably only have seen the Society's shops on a weekly trip to town, and yet would have been able to rely for nearly all your daily needs on the Co-op roundsman. In this way, such societies were at last beginning to make inroads into the rural areas which had previously been co-operative deserts. Then there were the *city societies*, which, since

Coal depot, bakery and bacon factory of the York Co-operative Society.

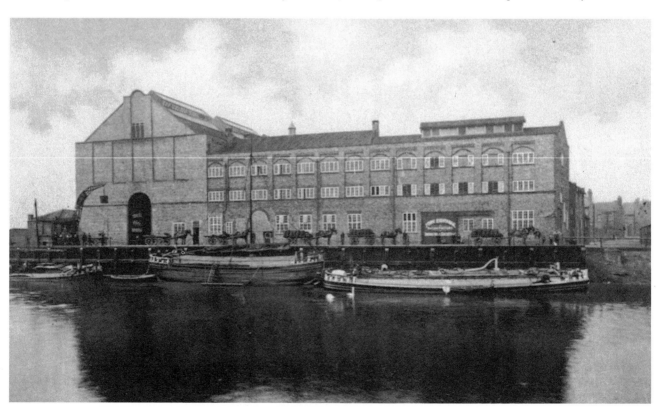

Daily delivery of milk was the trade in which the Co-op achieved deepest market penetration, supplying one household in every three.

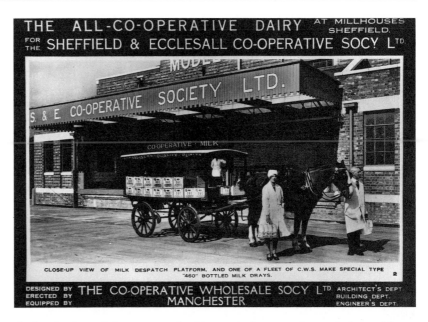

Transports of delight at the Nottingham Society garage and boot repair factory.

the beginning of the century, had become the most dynamic form. Virtually all the large industrial towns such as Leeds, Edinburgh, Birmingham, Plymouth, Derby and Liverpool, now had societies which measured their membership by the tens of thousands. Finally, there were the great *metropolitan societies of London*: the Royal Arsenal and South Suburban in the south, and the London Society which had, through several

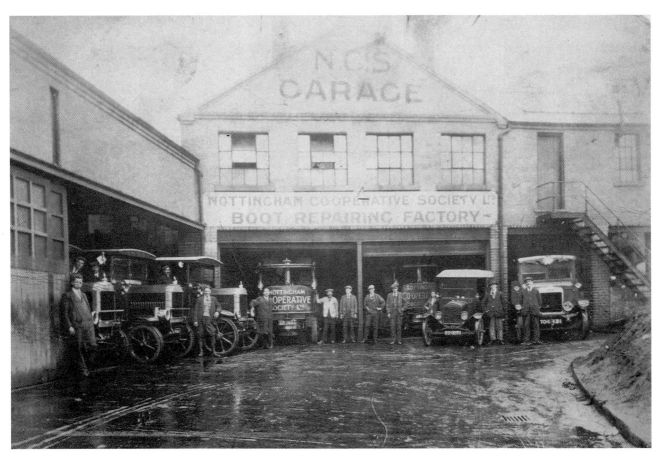

CWS advertising from the 1930s.

"THE POSTER OF THE YEAR."

A picture which attracted the attention of millions of people when it appeared on hoardings all over the country in 1929.

amalgamations, become the sole society north of the river. With 110,000 members, this had become the largest society in the UK. As a member of a city or metropolitan society, you would have shopped at one of a hundred branch stores, travelled to the city centre to have all kinds of needs met by an imposing department store, above which would have been a great assembly hall for the quarterly meetings, perhaps a lending library, billiard rooms and so on.

You might not have been aware of it, but the Society would have had its own gigantic bakery, flour mill, refrigeration store, coal wharfs, canal boats, railway trucks, motor lorries, even its own electric power plant. You might be renting a cottage from the Society, built by its own building department, having your clothes made in the Co-op tailoring workshop, and cleaned in the Society laundry. The Society might have been so big it had ceased to rely on the CWS, making its own jams, pickles, sweets, furniture, and providing food from its own farms and nurseries. From the society's milk rounds to its funeral undertaking department, you would be receiving literally a 'cradle to the grave' service.

In general, as a consumer you would have had a rising standard of living (unless, of course, you were among that great army of unemployed), and would spend a lower proportion of your income on food (from 50.7 per cent in 1920 to 46.6 per cent in 1938). You would be making more regular purchases than before, in smaller quantities, and so would shop daily for food at a local store, and visit a city centre department store to meet more special needs.

But what would the experience of shopping have been like? For those of us who remember the small Co-op store of the 1960s, just before self-service had really taken hold, the shop of the 1920s would have seemed quite modern. By now goods were being weighed and wrapped in the factory, and bore recognisable brand names which signified a known standard of quality and taste. The CWS followed the lead of other manufacturers and invented 'Pelaw Polish', 'Crumpsall biscuits', and other brand names based, rather unimaginatively, on the names of the factories where they were made. There were more and more brands to choose from, and manufacturers were beginning to invest heavily in advertising to induce 'brand loyalty'. Because Co-op members were buying these non-Co-op brands, again the CWS followed with its own advertising campaigns, though not with any great conviction (advertising, for a consumer-owned business, is bound to be seen as an unnecessary expense inducing members to buy goods they do not necessarily want).

The variety of goods coming on the shelves was enormous: ready-made products such as custard powder, jellies and blancmange were invented, American-style cereals such as cornflakes and puffed wheat came in, and canning meant that imported salmon and peaches became the fashion for Sunday tea. There was an enormous increase in packeted chocolate bars and snacks (1928 saw the first ever packet crisps), and customers were being persuaded to drink Bovril for strength and Horlicks for 'night starvation'.[17] New consumer goods, such as electric irons, vacuum cleaners, radios, sewing machines and bicycles had appeared.

All of this expansion in trade and reliance on large-scale production and distribution benefited the Co-op, but mainly in those areas where it was traditionally strong. By 1939 it had 25 per cent of the milk distribution, 40 per cent of butter, 20 per cent of tea, sugar and cheese sales, 10

The multiple store threat – Maypole employees drum up trade.

per cent of bread and bacon.[18] Yet it was weak where the independent traders were strong, on fresh food such as meat and vegetables, fruit and fish, and it was weak where the specialist shops were strong, on the new consumer goods. And even where it was strong, the same trends in retailing also benefited the Co-op's large-scale competitors. They were the city-centre department stores such as Debenhams, which stocked a vast range of clothing and fancy goods, specialist shops selling chemists goods, electrical appliances and bicycles, the 'bazaar stores' such as Woolworth and Marks and Spencer, selling thousands of lines at guaranteed prices, and the multiples such as Liptons, Home and Colonial and Maypole, competing vigorously against the Co-op with their concentration on a small range of cheaper and popular food lines.[19] Taken together, the multiples and bazaar stores had, by 1920, begun to overtake the Co-op, when they both had around 9 per cent of the retail trade.

Conspiracies against the consumer

After the War, a Conservative government quickly removed the wartime controls and, because production was slow to switch to peacetime commodities and raw materials were in short supply, another orgy of speculation and profiteering resulted. Then, in 1921, the boom turned into a nasty slump which was deepened by the government's insistence on keeping the value of the pound artificially high, so that exports suffered and unemployment rose to over a million. No sooner had the economy recovered than a world-wide crash in the 1930s swept a minority Labour government out of power and plunged the country into another recession, sending unemployment up to three million.

Capitalists lost their nerve and their belief in free trade, and began to co-operate both with each other and with the government to restrict output and keep up prices, always, of course, at the expense of the consumers. From 1921 onwards, one industry after another applied for protection, and the government voted itself wide powers which allowed the Board of Trade simply to fix import duties on foreign competitors in

return for a promise that they would reorganise their industries so as to make them more efficient. Then in 1932 the whole British Empire was ring-fenced and imports from outside the ring made prohibitively expensive. Farmers were subsidised directly for growing sugarbeet, then from 1933 encouraged to set up marketing boards which set quotas for imports and guaranteed high prices to British farmers; where the home production fell short, prices soared. This was 'capitalism on the dole'.[20]

What could the Co-op do about it? Firstly, it was not in the Movement's nature to speculate with its own wealth, and so its capital was safeguarded even during the booms and slumps. As Elliott puts it:

> Co-operators went through the financial boom of 1929 without inflating the value of their enormous capital holdings by one penny piece. They emerged from the crash of 1931 ... without losing a single penny piece.[21]

Because it was supplying basic commodities that everyone needed, it was able to survive even the worst slumps. The only time the CWS made a loss was in the first half of 1921, when, as Redfern describes it, 'the directors filed on to the platform ... less cheerfully than for a funeral,'[22] but the loss was only £3. 5million, and was more than covered by reserves. Turnover shrank from £105million in 1920 to £65million in 1921, but the retail societies got the benefit of cheaper prices and so the Movement's loss was also the consumer's gain.

Where it was strong enough, the Movement could break the pricerings apart. For instance, the Unilever soap combine had, through amalgamations, cornered 80 per cent of the private soap trade, and worked through a Soap Manufacturers' Association to keep up prices. Only the Co-op had the strength to keep prices lower and so frustrate the ring; in 1930 Co-operative production was 15 per cent of the total weight of soap manufactured, but only cost 9 per cent of the total wholesale price.

Reynolds News was the Movement's own
Sunday paper.

By 1924 the bulk of flour-milling was in the hands of three firms; luckily
for the consumer, one of these was the CWS, which acted as an effective
barrier to private control; in 1930 it provided 17 per cent of the national
output of flour, costing 15 per cent of the wholesale value. Local bakery
rings also fixed prices, but Co-op bakeries, which were larger than aver-
age and so could compete, stood out against them; bread prices were
effectively pegged by the Co-op. Where prices were fixed by official
marketing boards, at least the Co-op dividend was able to cut costs; this
helped the Movement to corner 22 per cent of the milk trade by 1935.
Again, as the world's largest distributor of tea (buying 20 per cent of the
tea on the British market and owning extensive estates in India and
Ceylon), the English and Scottish Joint Co-operative Wholesale Society

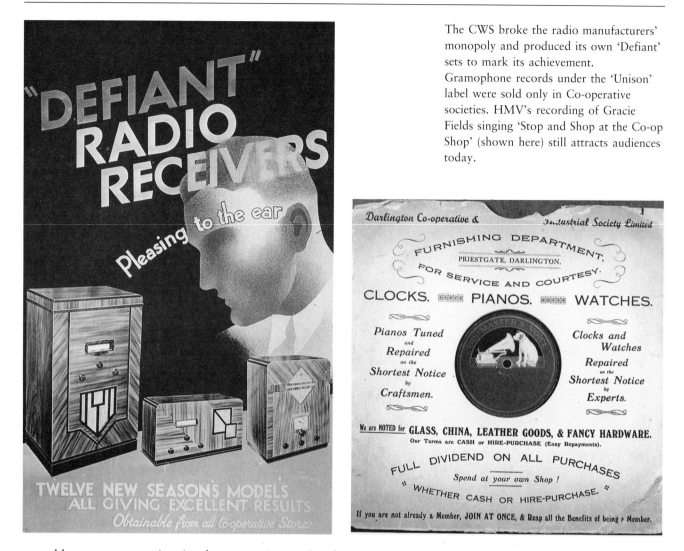

The CWS broke the radio manufacturers' monopoly and produced its own 'Defiant' sets to mark its achievement. Gramophone records under the 'Unison' label were sold only in Co-operative societies. HMV's recording of Gracie Fields singing 'Stop and Shop at the Co-op Shop' (shown here) still attracts audiences today.

was able to prevent a price-ring from emerging, and to force other traders to exclude the weight of the packet from the cost of the tea.

This success did not go unnoticed; the press was almost uniformly hostile to the Movement, and co-operators felt compelled to buy their own weekly newspaper, the *Reynolds News*. Nor did it go unchallenged; manufacturers refused to sell to the co-ops because their dividend undermined fixed prices. Gramophones, radios, electrical goods and chemists' goods became unavailable, so the wholesale societies had to begin to make their own (they gave their radio the appropriate brand name of Defiant). Worse still, the opposition united to press the government to tax the Co-op's surpluses. Individual Co-op members had always been taxed (if they earned enough to be eligible) on their dividend, and societies had been taxed on their land and buildings. But the idea of taxing societies on their surpluses was absurd; such surpluses were not profits but savings made by the collective action of the members; nobody was being profited from. In the Finance Act of 1933, despite a petition from 3.3 million co-operators, their reserve funds were taxed.

The ultimate in own-brand manufacturing – the Bell motor car produced in the CWS works at Chorlton, Manchester.

The Co-operative community

Suppose you had been an active Co-op member between the wars; what would this have meant? You would have joined not just a consumer-owned business but a strong community. To begin with, there were the Guilds. The Women's Guild would have had a branch in all but the smallest societies; the number of branches more than doubled to over 1,800 in 1939, and the total membership to over 87,000 (the Scottish Women's Guild had 32,000 members). Margaret Davies had retired in 1921, but this did not mean the Guild then became less radical; it was 'the Co-operative Party's most critical but stimulating partner in the Movement'[23] and on many issues was further to the left. As a member you would have been expected to turn out at election time to canvass for the Party, and to be an active distributor of Co-operative propaganda; ties with the local Labour Party were also very close. The weekly meetings were still rather earnest, with discussion of difficult and controver-

ILFORD WOMEN'S CO-OPERATIVE GUILD. BRIGHTON OUTING. 24-6-26.

sial subjects mixed with coach trips and social events. There were many campaigns: for minimum wages, family allowances, public spending to alleviate unemployment, promotion of Co-operative production of milk, raising the school leaving age, advice on contraception, and so on. Your energies would have been quite diffused, though; as one commentator put it, there was 'a danger of the movement losing itself in an orgy of more "resolution passing", especially at its annual Congress', and it

Societies were alive to new leisure areas – Ilford Women's Guild trip to Brighton in 1926.

Manchester and Salford Society's Grand Pageant at Belle Vue, Manchester, in 1939, which members supported in their thousands.

Welcome Little Comrades – Women's Guild cradle roll lists the new arrivals into the Movement during the 1930s and 1940s.

The Woodcraft Folk were established in 1925.

might have been more effective in limiting itself to fewer but more intensive campaigns.[24]

As a Guild member, you would have taken to wearing a white poppy on Peace Day as a symbol of the peace movement, in which the Guild was very active during the 1930s. You would have stood a good chance of gaining political power: by 1939 the Guild could count two mayors, 18 mayoresses, 24 aldermen, 24 county council members, 255 city or town councillors and 137 magistrates among its members. You would have been busy several evenings per week, co-opted to represent the Guild on a bewildering variety of other local committees, and attending Co-operative business meetings where you would have kept the Co-op's managers on their toes by asking uncomfortably well-informed questions. The high point of your year would have been the annual Women's Guild Congress, which 1,500 delegates attended. The high point of the whole period would undoubtedly have been the fiftieth anniversary celebration at Crystal Palace in 1933, when 15,000 women sang Guild songs, heard a speech from the Guild's founder, Mrs Lawrenson (who was now 83 years old), and paraded with their banners in a floral procession representing the eight sections of the Guild.[25] If you were very lucky, you might even have attended the Congress of the International Women's Guild, in which 15 countries were by now represented.

If you had been a male co-operator, you could have joined the Men's Guild, though this was much smaller (with a membership of 10,000 by 1935, in 330 branches), and much less active. As Sidney and Beatrice Webb put it 'It cannot be said that the Men's Guilds … have, except in a few societies, shown any great activity or developed much local life.'[26] On the other hand, if you had wanted to become a director of your local society, this was the way to do it; the Guild was a 'stepping stone to influence', and would have schooled you thoroughly in the trading side of the Movement. Despite their having more than eight times as many members, the Women's Guild, in 1938, had 412 members on Society management committees compared with the Men's 592. Typically, the women had 930 members on education committees to the Men's Guild's 412; the seat of power in the Co-op was still male-dominated.

Had you wanted to attend meetings with your spouse, there was also (from 1926 onwards) a small 'National Guild' of 5,000 members which was mixed. Your children could (from 1924) have attended the British Federation of Co-operative Youth, or the Woodcraft Folk (set up in 1925), which was independent of the Co-op but had close links with some local societies. If you had any evenings left in the week, you could have attended education classes; there were nearly 3,000 of these by 1938, and the number of students had risen to 70,000.

Then, in a substantial minority of society areas there was the local Co-operative Party. Despite its difficulties in defining its role in relation to its partner, the Labour Party, and its boss, the Co-operative Union, the Co-op Party had managed to win several 'Labour and Co-op' seats at each general election. If you were ambitious, you might have seen the Party as one way of starting a political career, spurred on no doubt by the example of A. V. Alexander. Alexander had been a senior clerk in a county council education department and vice-chair of his local Co-op society. While taking his daughter on a day-trip to London, he had seen an advert in the local paper for Secretary of the Co-operative Union's Parliamentary Committee. Out of 160 applicants he got the job.

Within a year and a half he was in Parliament; within two and a half years in the Government; within seven and a half years he was in the Cabinet. He ended up with an earldom, a Companion of Honour, and Leader of the Labour peers in the House of Lords.[27]

Though as First Lord of the Admiralty one wonders how much time he had left to serve the interests of the Co-op.

Had you expected to be schooled in a distinctively Co-operative philosophy, you would have been disappointed, for there was 'a dreadful lack of clarity as to the political philosophy of the Party'.[28] It mainly followed the lead of its much more dominant partner, the Labour Party. This is a pity, because it might have argued for more democratic and consumer-led forms of nationalisation than those which were set up after the Second World War. It might have tempered Labour's more centralised, producer dominated forms with some genuine consumer ownership and control, which might have made the nationalised industries and welfare services more efficient, more popular and therefore more politically secure than they later proved to be during the 1980s.

On the other side, the trade union movement might have been clearer about the 'Co-operative difference' when it came to taking strike action. In the 1926 General Strike the Co-operative Bank was expected to provide cash from trade union accounts, and the wholesale and retail societies to distribute food supplies. Yet there was confusion, with CWS vehicles able to move freely in some areas and being turned back in others, and with those retail societies which the CWS could not reach being offered any amount of supplies from private wholesalers. In several CWS factories, workers were called out on strike while those in private firms were left working. At the CWS coalmine at Shilbottle, miners came out on strike even though the CWS was not involved in the dispute and had offered the men the terms for which they were fighting. It seemed that just because Co-op societies were highly unionised they were seen as an easy target for strike action. Here is the CWS historian's view:

> Though the conflict did not reach tragedy, there was something false somewhere in a theory of action which meant not only half-throttling trade union supporters and suppliers, but thereby assisting non-union and anti-union distributors.[29]

In 1927 the CWS offered that in return for complete observance of trade union wages and conditions it should be left out of national strikes. It took until 1938 before the trade union movement could be persuaded to agree. Hardly anyone, even in the Co-operative Party, could see that in the Consumer Co-operative Movement a viable form of socialism had already arrived.

Suppose, as well as being an active member, you had been a Co-operative employee. You would have been comparatively lucky because, in general, wages and conditions were substantially better than in the private sector. As a CWS worker, from 1919 onwards you would have had a maximum 48 hour week (compared to 74 hours in some London firms), and holidays with pay (which only one in four workers had gained even by 1937). From 1928 an occupational pension scheme had been agreed, which doubled the value of a retired employee's National Health Insurance pension, and from 1930 generous sick pay was guaranteed. If you had been an inefficient employee, it is likely you would have

A Royal Arsenal Society exhibition poster, 1927.

One of the stands at the 1927 RACS Exhibition, featuring services available to members.

been fitted in where you could do least harm, because once appointed, you would have had almost total job security.[30] Yet if you had been talented, there was nothing stopping you from achieving high office, providing you were prepared to start work as a junior straight after elementary school and work your way up; this was still an exclusively working-class movement which liked 'home-grown' leaders and was suspicious of formal education. You would, of course, have had the opportunity to study a whole range of subjects through the education wing of the Movement, or even, if you were very lucky, to study full-time at the Co-operative College which had been set up at Holyoake House in 1919.

The state of the Movement before the Second World War

The Co-operative Movement mattered not only to its members but also to many sympathetic observers, some of whom took a great deal of trouble to study it: the Webbs wrote an extensive report in 1922, and three university professors did the same in 1938, so we have some outside evidence of the health of the Movement which spans the beginning and end of the inter-war period.

Sidney and Beatrice Webb were concerned not with some supposed weaknesses such as the persistence of credit trading in some societies, the tendency to keep a high dividend, or the supposed dangers of bureaucracy (none of which they thought were important) but with real structural weaknesses which were holding the Movement back. These were an arrested development in some vital markets such as butchery, greengrocery, milk and coal, the persistence of some areas of the country and some social groups untouched by the Movement, and the 'disease of overlapping' by which societies poached each other's customers and

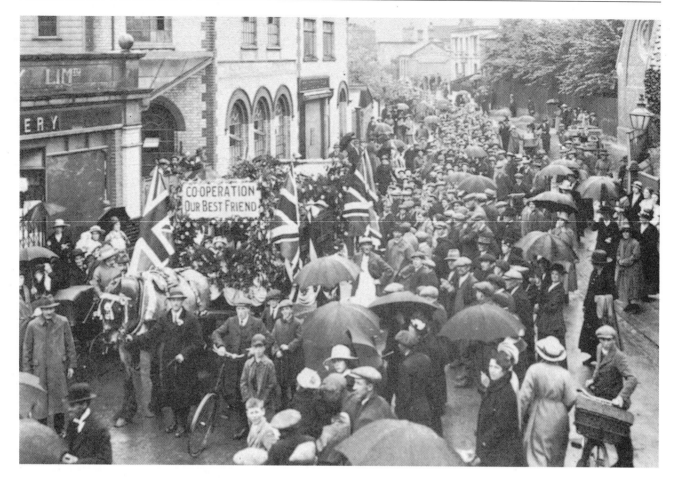

prevented each other from developing rationally. The underlying problem was the historical legacy of many extremely small societies in those areas which had developed first during the 1850s and 1860s, and the inability of a voluntary movement to sort this out. Their remedy was to propose increased powers for the Co-operative Union, and the introduction of an independent 'efficiency audit' unit which would expose the inefficiencies of these older societies and galvanise the Movement into action.

The Union was reorganised in 1932 with a more effective executive committee in control, and in 1936 its Research and Statistics Department was set up. These went some way towards meeting the Webbs' demands. By 1938, Carr-Saunders and his team could report that overlapping and competition between societies had virtually been eliminated. The tremendous efficiency savings of which both Co-operative wholesaling and retailing were capable had been realised, and the Movement had captured 11 per cent of the entire retail trade of the country, beating off the multiples to take a huge share of the market in staples such as milk, coal and bread. What it had failed to do was to diversify into non-foods to the same extent, and in all but the staple products of clothes, boots and shoes and household goods it had fallen badly behind. It had failed actively to plan its growth but had continued to grow organically along the lines of least resistance, where it was already strong and its market guaranteed. The researchers agreed that at its best the Movement could be outstanding, but at its worst, it could be parochial, unimaginative, complacent

Newmarket Society celebrated its coming of age in 1920 with a grand procession of members, banners and trade floats.

and badly managed.

On the other hand, it is easy to be too hard on these inter-war co-operators in retrospect. After all, by 1914 the Movement was already quite old. Age and success are a dangerous combination, leading to a tendency to cling to obsolete methods, to be content with what has been achieved so far, and to want a quiet life. In fact, the Movement showed 'a vitality and adaptability remarkable for so old, widespread and complex a Movement'.[31] It had survived a world war and the depressions of the 1920s and 1930s, having nearly tripled in size both in its membership and its retail trade.

Notes

[1] Redfern, P. (1937) p. 76

[2] *Ibid* p. 78

[3] *Ibid* p. 79

[4] Cole, G. D. H. (1944) p. 265

[5] Redfern, P. (1937) p. 142

[6] See Winstanley M. J. (1983) ch. 6

[7] Cited by Bonner, A. (1970)

[8] Elliott, S. (1937) p. 63

[9] The view of the Webbs, S. and B. (1922)

[10] Figures from Bonner, A. (1970)

[11] The story is told by Redfern, P. (1937)

[12] *Ibid* p. 130

[13] Quoted in Bonner, A. (1970) p. 143

[14] Carbery, T. (1969)

[15] *Ibid* p. 22

[16] Webb, S. and B. (1922)

[17] Burnett, J. (1989)

[18] Figures from Burnett, J. (1989)

[19] See Jefferys, J. B. (1954)

[20] Elliott, S. (1937)

[21] *Ibid* p. 86

[22] Redfern, P. (1937) p. 250

[23] Gaffin, J. and Thoms, D. (1983) p. 88

[24] The view of Carr-Saunders *et al.* (1938) p. 239

[25] See Gaffin, J. and Thoms, D. (1983)

[26] Webb, S. and B. (1922) p. 178

[27] Carbery, T (1969) p. 29

[28] *Ibid* p. 35

[29] Redfern, P. (1937) p. 270

[30] The judgement of the Carr-Saunders report (1938)

[31] Bonner, A. (1970) p. 174

CHAPTER EIGHT

In war and peace again

Narrow local divisions are rapidly breaking down; the most successful capitalist enterprises today are conceived and organised on a national basis under single national control. The problem of the Co-operative Movement now is to secure the same unified direction, without destroying its democratic character or losing anything of its distinctive features. (Carr-Saunders Report)

The British Co-operative Movement entered the Second World War at the peak of its development. It had 8.5 million members, which of course meant that far more than this were in Co-op households; when rationing was introduced, 28 per cent of the entire population (13.5 million people) registered with the Co-op for their supplies. There were 1,100 societies controlling 24,000 shops, and they had captured around 40 per cent of the market in butter, 26 per cent of the milk, 23 per cent of grocery and provisions, 20 per cent of tea, sugar and cheese, 16 per cent of the household stores and bread markets, and 10 per cent of the meat trade; altogether the Movement had around 11 per cent of the total retail trade.[1] With a turnover of £272 million and with trade per member, despite the worries of many activists, remaining steady since the end of the First World War, there was some justification for that air of self-satisfaction, even (some critics said) of complacency, which pervaded the Movement.

Into a war again

1939 was not a rerun of 1914; this time there was no way that the government could ignore such a strong and extensive Movement. There was the direct political influence of the nine Co-op Members of Parliament and the hundreds of local councillors sponsored by the Co-op Party and Women's Guild. Then there was the Movement's importance as a major employer of labour; on the retail side, the Movement employed a quarter of a million people, with another hundred thousand in production and distribution. But probably, with total war looming, the most important influence on government was that of the Movement as a large-scale producer; with 155 factories, the CWS was easily the largest consumers' self-supply organisation in the world. On the food production side, for instance, it had ten flour-mills, nine farms, five bacon works, four aerated-water factories, four preserve works, four abattoirs, four packing factories, three butter factories, three soap works, three milk products

Fuselages of the 'Hamilcar' glider were constructed at the CWS Shopfittings Factory in Salford.

factories, two glass factories, two biscuit works, and a margarine factory. On the non-food side it had nine cabinet and upholstery factories, seven footwear factories, six printworks, six clothing and five shirt factories, three cotton and three woollen mills, a colliery and a railway wagon works.[2] The CWS and SCWS together were major importers from 59 countries, via 12 overseas depots, and tea was grown on 31 gardens in India and 13 in Ceylon.[3] This time, each of the 1,550 local food committees set up throughout Britain to control rationing had to have one Co-op official on it, and many Co-op members also served as consumer representatives. By the end of the War, CWS officials were serving on 30 advisory bodies for food, and six for non-foods (two Scottish CWS directors were also engaged on government committees). Contacts with government had, in fact, started well before the War, when the National Co-operative Authority (NCA, the umbrella organisation representing the Co-operative Union, the Wholesales and so on) had been consulted by the defence plans department as to its capacity to aid the fight. Despite the strong anti-war feelings the Movement had held during the 1930s, there was no doubting its willingness to serve. The NCA asked that 'the whole strength of co-operative societies should be mobilised to assist the nation in its defence of Co-operative ideals'.[4] The Fascists had already been made clear their attitude to Co-operation; by mid-1939 the Co-operative Movement had been destroyed in Germany, Austria, Spain, Italy and Czechoslovakia. On Hitler's birthday, the Nazis had made him a present of a million deutschmarks (around £50,000) from Co-operative funds.[5] Later, the Co-operative Union's General Secretary, R. A. Palmer had the distinction to be put on Hitler's death list.[6]

Ploughshares were turned into swords. In Scotland, the Taybank jute works began to turn out millions of sandbags; in England, the Manchester shopfitting works changed to making parts for gliders, the Radcliffe cabinet works to making assault boats and the Pelaw quilt factory to making flying suits. Later in the war, the Shieldhall sheet-metal works began to turn out a secret weapon for the Normandy landings, a massive shell called the 'flying dustbin'. Altogether, the clothing factories made two million battledresses for the army, and half a million for the RAF (not to mention the millions of boots which they had been producing

since well before the war started). The high degree of integration within the wholesales led to the production and cross-supply between the factories of a huge and complex variety of parts for all aspects of the war machine. Among these there are entries both sad and strange: the Birmingham cycle factory switched production to making wheelchairs for injured soldiers while the SCWS became the official supplier of pigeon food to the RAF.[7] As in the First World War, the Co-op was found able and willing to sacrifice profit in a good cause; the SCWS took on the unrewarding task of supplying canteen facilities for aerodrome works in several remote parts of the Western Isles. This time, 15,000 CWS employees served in the forces, and 545 of them lost their lives, with another 400 being taken prisoner.

As in the First World War, co-operators wanted immediate food rationing to be introduced on a fair and equal basis, not just for sugar (which as before was the first to be rationed) but for all staple foods. Again they took their case to the Prime Minister and this time Chamberlain (unlike Lloyd George) did agree to meet them; within a few days of the meeting, bacon and butter were also rationed. For these foods individuals registered with their local shop, and so the Co-op got its fair share of business. For other foods, such as canned goods, biscuits, sweets and milk, a points system was devised which was based on the old datum

Hitler's Luftwaffe destroyed the top floor of Holyoake House, the Manchester headquarters of the Co-operative Union Ltd, in December 1940.

line by which co-operators had been so disadvantaged in the First World War; it meant that supplies went to retailers on the basis of the customers they had before the war, taking no account of increases in Co-op membership. The Co-operative Union fought hard against this but with little success. Other measures also hurt the Movement; rationalisation of production meant the closing down of some factories and consolidation of CWS and SCWS production with that of private firms. Because the Government controlled food supplies to retailers, Co-operative wholesale supplies sometimes went to customers of private firms, and mix-ups could occur; in one case cited by A. V. Alexander, Co-op members got no butter at all while the multiple firms' customers were buying CWS-branded butter.[8] However, in general the Movement was treated fairly, and their grievances were no more serious than those of their competitors. The main effect of the War, and of the subsequent years of austerity and continued food rationing, was to freeze the pattern of retail trading so that the Movement would emerge out of the war with about the same economic strength, relative to its rivals, as it had on entering it.

The key word here is 'relative'; there was an enormous amount of damage done. In the blitz of 1940 Brightside and Carbrook Society had its great modern emporium destroyed in a single night. Clydebank Society in two nights had 38 shops destroyed and another 56 badly damaged. Greenock East End had all its shops damaged, its offices, bakery, meeting hall and garage practically destroyed and its general manager killed. The Silvertown works was totally destroyed, and in the East End of London the Leman Street administration blocks, warehouses and factories were damaged. In Manchester the Mitchell Memorial Hall was destroyed, the Co-operative Union damaged and the CWS telephone exchange wrecked. In Birmingham factories were damaged and lives lost, and Liverpool and Hull works also suffered. Then in the V-bomb raids of 1944, an incredible total of 1,100 Co-op shops were destroyed or damaged; Canterbury Society had every one of its properties hit.

Yet it is clear that the strengths of the Movement, both in its national wholesale network and in the more localised mutual aid between retail societies, allowed the Co-op a considerable advantage over its private sector rivals. The ability to switch production between factories in different parts of the country gave the CWS in particular a built-in advantage over other producers. The close relationship between wholesale and retail societies, and the instinctive feelings of mutual aid which co-operators could draw on, meant that their members were not without supplies for long. For instance, Brighton had 27 shops damaged one night, but was trading again within 24 hours. Coventry Society lost a department store, bakery, drug warehouse, ten branch-stores and a motor maintenance workshop in one night, yet its branches opened for business the next day. Portsea Island Society in one night lost its central premises, grocery warehouse, despatch department, furnishing, dressmaking and tailoring workshops, offices, two grocery branches, a meeting hall and a bakery, yet with bread supplies rushed from other societies and goods replenished by CWS its trade actually increased.

There was a less tangible kind of damage done to the social and educational side of the Movement. Though one effect of the war was once again to stiffen the Movement's support for the Co-operative Party (which ended the war with its affiliated membership up from six million to nine million people), the guilds suffered a drastic decline. As the

The ornate and colourful banner of the City of Perth Co-operative Society Women's Guild.

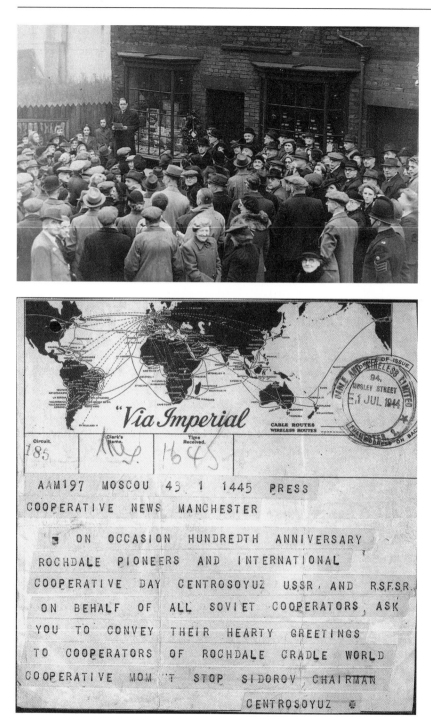

A crowd gathered at the Pioneers' original Store in Rochdale for the 1944 centenary celebration on December 21.

Left One of dozens of congratulatory telegrams sent by Co-operative organisations worldwide in 1944.

historians of the Women's Guild put it 'The war dealt the Guild a blow from which it never recovered.'[9] Its members and potential recruits were evacuated, called up to work in factories or for national service, and their meeting rooms were requisitioned. The Guild's head office was bombed, and then after they moved to the CWS offices at Leman Street it too was bombed. Not surprisingly, membership fell from over 87,000 in 1939 to 57,000 in 1946. The quality of the Guild's activities also suffered. Their congresses continued to pass resolutions on women's rights, individual members represented the women's point of view on official committees,

Opposite above The fine frontage of Stanford Hall, near Loughborough, which was purchased for the Movement as its Co-operative College in 1944.

Opposite below Leeds Society celebrating a 'Century of Progress' in 1947.

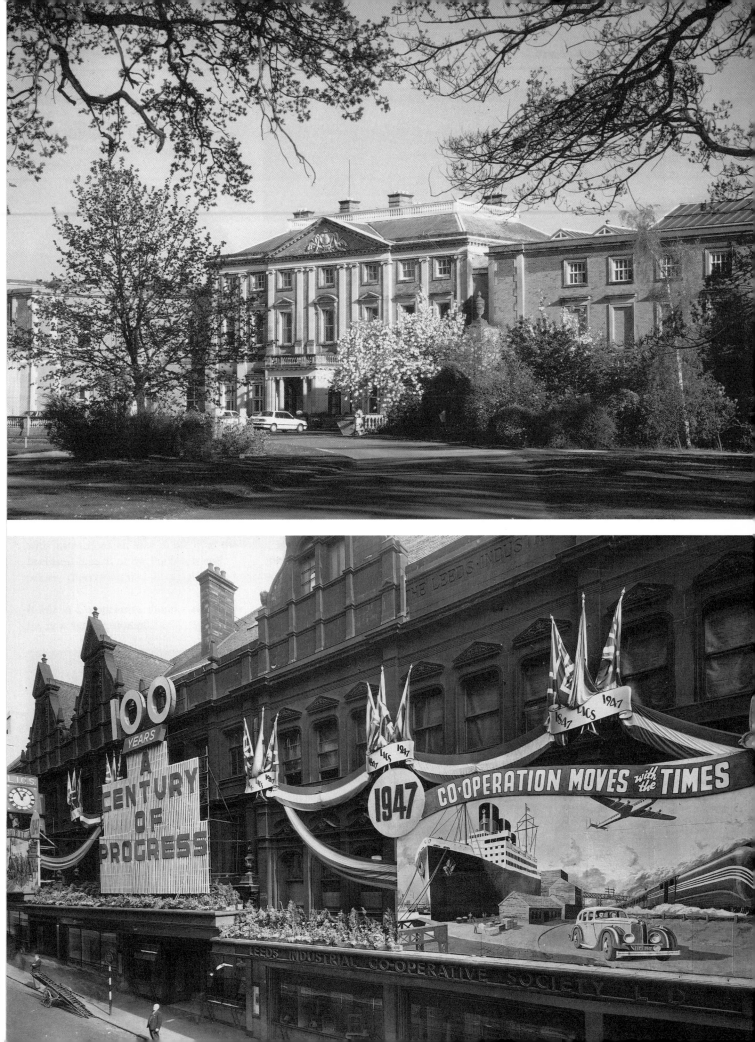

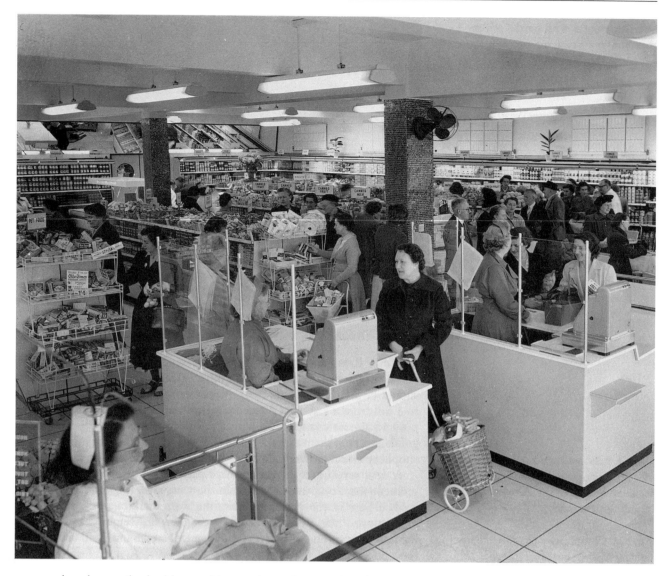

course, that the retailer had less and less to do, and was reduced to passing packages, jars and tins across the counter to customers who knew exactly what they wanted. In 1942 someone in the London Society tried out an American idea – stunningly original at the time, but with hindsight quite obvious – of taking away the counter, giving the customers a basket and letting them do the work, placing a shop assistant and a small counter between them and the door so they could not get out without paying. In 1947, the Portsea Island Society began to convert its shops to self-service, and between 1947 and 1954 saw its grocery trade increase by 141 per cent, against a national rate of only 69 per cent. By 1950, 90 per cent of all self-service shops were co-operatives.

The size of shops had been limited by the need to store the goods behind a counter. Once they had dispensed with counter service, they could become much bigger, limited only by the willingness of the customers to walk around carrying a basket. The idea of the supermarket was born, and again the Co-op took the lead; in 1950 there were 50 supermarkets in Britain, of which 20 were Co-operative. It is difficult now to imagine the impact these, by our standards, quite small shops of

Early checkouts at a London Society food hall in Kingsbury.

144

over 2,000 square feet had on food shopping. They struck fear into the hearts of the corner shopkeeper, whose store was little more than a tenth of the size.[12] The prospects for the Co-op looked bright; one eminent retail analyst, writing in 1950, predicted that the Movement was most likely to take the lead because its shops were larger than those of its rivals the multiples, and could more easily be converted.[13] There was unease about the inability to make much headway in the non-food trades, where the multiples were well in the lead, but otherwise some complacency.

Under the surface, though, an even bigger revolution was taking place, which was completely to change the relationship between retailer, wholesaler and manufacturer, and was destined by the late 1950s to give the Co-operative Movement a nasty shock. The multiple traders had gradually been losing their family firm image, and by 1950 most of the larger ones had become public limited companies.[14] This meant they had ready access to large amounts of capital, which they began to concentrate to acquire town-centre sites, selling a narrow but heavily advertised range of goods and, where there was competition from the Co-op, aggressively cutting prices. Through a series of takeovers and mergers, they had now become big enough as retailers to dispense altogether with wholesalers and to deal direct with the manufacturers. During the 1930s, the large-scale manufacturers had been able to dominate the market, offering retailers known brands which the public could recognise and had already been persuaded to buy. They had pressurised the retailers into selling their goods at 'manufacturers' recommended prices', and in some cases had acquired their own chains of shops. But now the multiple

Post-war department store development at Bexley Heath by the Royal Arsenal Co-operative Society.

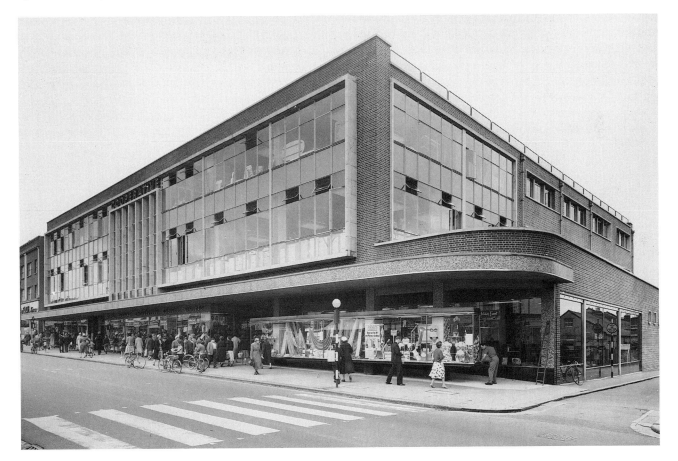

retailers, because they had so many shops, were able to reverse the traditional power relationship and to begin to dictate their own terms. Meanwhile, the manufacturers had also grown bigger, and were able to make standardised goods of known quality at low prices, and on a vast scale. They had lost control of the retailers, but in return had got a guaranteed market. The system worked well for both sides, and the Co-op, with over a thousand retail societies many of which were still very small, and with its vast range of productive and wholesaling interests, found it increasingly difficult to compete.

To make matters worse, the small independent retailers also reorganised. They could not deal directly with the manufacturers, and needed a wholesaler to carry large stocks, break them down into small quantities, and regularly to deliver them to thousands of small shops. They solved the problem by learning to co-operate, in voluntary chains and buying groups mainly organised by the wholesalers but sometimes taking the form of a retailers' co-operative. Increasingly they looked to these groups to provide quite sophisticated promotional material, general advice, and assistance with the appearance and layout of the shops.

The result was that by the late 1950s, for the first time in its history, the British Co-operative Movement had stopped growing. On paper it looked impressive: when the Co-operative Independent Commission (CIC) reported in 1958, membership stood at over 12 million, turnover was nearly a billion pounds, there were over 30,000 shops and 250 factories, and it was still the largest wholesaler in the country. It had 60 per cent of the self-service outlets, was leading the way in supermarkets and was building 'some of the most impressive department stores in the country' .[15] Yet in a rapidly expanding market, its share of the total retail trade was still around 11 per cent while the market share of the multiples had reached 22 per cent. Since the war it had only managed to increase its share of the market by 3 per cent, while the multiples had increased theirs by 20 per cent. There had been a marked decline in the share of the clothing and footwear trade, (from 6.8 per cent in 1950 to 6.1 per cent in 1955), though the Co-op had held on to its already low share of the 'dry goods' trade. Most worrying of all, though, its share of the people's staple diet, the food and household stores market, had declined from 15.1 per cent to 14.5 per cent. Many of the wholesale societies' factories were working well below their capacity because of lack of orders. And yet the Movement was still benefiting from retail price maintenance, whereby staple goods were sold by all retailers at manufacturers' recommended prices (the removal of this price umbrella in a few years' time was to make matters even worse).

It was clear that there was something fundamentally wrong, and that the structure of this ageing Movement was due for a major overhaul.

The Co-operative Independent Commission Report

Two things were needed: an understanding of what was wrong, and the willingness to put it right. Trying to put it right without a real understanding could, of course, have made the situation worse. Understanding the situation without being able to do anything about it would just have led to frustration. A third factor was also needed – time. As we shall see, time was not on the Co-op's side and reforms were almost always delayed too long, though as one historian puts it 'At almost the last minute of the

last hour the Movement pulled itself back from the edge of disaster.'[16]

The first reforms showed neither much willingness to change nor much understanding of the problem. In 1944 a merger of the two whole-sale societies was planned but rejected by the Scottish CWS. It would not have affected the major problem, which was lack of integration between the wholesale and retail movements. The main competition was seen as coming from 'bazaar traders' such as Woolworths, and the new mail order companies. The retail societies would not agree to let the CWS develop a Co-operative alternative to the 'bazaars', and did not give a CWS mail order business enough support to make it work. This was a pity, but again if it had worked it would not have affected the major problem, which was the growing strength of the multiple chains.

Between 1953 and 1964, there were four major inquiries into the state of the Movement: two into the CWS, one into the Movement as a whole and one into relationships between the wholesalers and the Co-operative Union. The main problem was eventually recognised to be this:

> The Movement had so far failed to co-ordinate the enormous buying power of the retail and wholesale sides and wield it as a national market-ing and sales promotion force. Fragmentation and local autonomy pre-vailed in almost every field of Co-operative trading at a time when private enterprise was marshalling its forces into specialised, nationally control-led units.[17]

Knowledge was not enough. It was action that was needed, but power in the Movement was still decentralised to around a thousand retail socie-ties whose members, while willing to see some changes made, were anx-ious to preserve their autonomy, small-scale democracy and sense of local community. This was understandable; after all, these had until re-cently been the strengths of the Movement which had enabled it to grow in the first place. It was hard for co-operators to accept that they had suddenly become weaknesses, and that the values for which they stood had become, in this new post-war world, the very things which were holding them back. The result was (as Richardson ably puts it) that the Movement was 'constantly pulling up its roots, examining them, and then replanting them in much the same soil as before'.[18]

Yet there was one report which was so powerful in its analysis and so disinterested in its motives that it set the agenda for a process of change which is still, towards the end of the century, being worked out; this was the Co-operative Independent Commission Report. It was set up in 1955 with Hugh Gaitskell (at that time deputy leader of the Labour Party, but by the end of the year to become its leader) in the chair and C. A. R. Crosland (an ex-Labour MP and well-known economist) as secretary,

Members of the Co-operative Independent Commission.

and with a committee consisting of some of the best Co-operative and retailing experts of the day. Beginning from the sharp end of the Movement, it looked at the quality of Co-op shops, and found four main weaknesses. Firstly, for historic reasons there were now too many grocery shops in the north, and not yet enough in the south and west, while other types of shop, selling greengrocery, fish and wines were in short supply everywhere. The most serious deficiency was still in non-foods; the number of specialist clothing shops had remained static, while footwear outlets had actually declined. In the Greater London area there were only 31 non-food goods shops compared with the multiples' 688 outlets. Secondly, the distribution was failing to correspond with the pattern of trade. Food shops were still distributed quite effectively, but department stores had been founded in old working-class areas which had now become unfashionable. Non-food shops were especially poorly situated; the Co-op was weakest in the larger towns, strongest in the country and small towns, yet the customers were increasingly doing their shopping for clothes, electrical goods and shoes in these larger towns whose centres offered bigger shops and a wider range of choice.

Thirdly, the quality of the shops was very variable. The Report described a depressingly low average:

> A ponderous, unrestored, and unimaginative grocery-cum-butchery-cum drapery cluster, built in the early 1900s, still operating counter service, the window display old-fashioned, the exterior clumsy and badly in need of paint, the interior frowzy and unattractive.[19]

The Co-op was now paying the penalty for being the first of the large-scale retailers, and must now unlock its considerable assets (much of them invested outside the Movement) and put its money back into renovating the humble branch store. Lastly, the Report noted that the Co-op image was in need of updating to appeal to a younger generation. For instance, the goods sold were old-fashioned, particularly in women's and children's wear, and the old Co-op inhibition towards giving credit was seriously restricting the trade in furniture and electrical goods; customers

Advertisement for football boots designed by Stanley Matthews, the great English footballer, and manufactured at the CWS Heckmondwike factory.

Stanley Matthews signing autographs for Co-op footwear customers in a retail society store.

A small store in much need of development to meet the growing competition.

were turning to other firms who offered hire purchase.

Underlying these visible deficiencies was the problem of management, which the report described as varying from excellent to deplorable. It found that similar-sized societies in similar areas were performing quite differently, and that the only explanation for this was that some people were very good at what they did while others were mediocre. The report warned that 'the quality of this management in the future will largely determine whether the Movement expands or stagnates.'[20] Good managers have always been hard to find, but the Co-op had saddled itself with an out-of-date attitude to education, recruiting its staff almost exclusively from school-leavers who were content to leave after the bare minimum of schooling and work their way up the ranks of the local Society. They were then paid much lower salaries than their equivalents in the private sector, but generally had a lifetime's expectation of secure employment in a

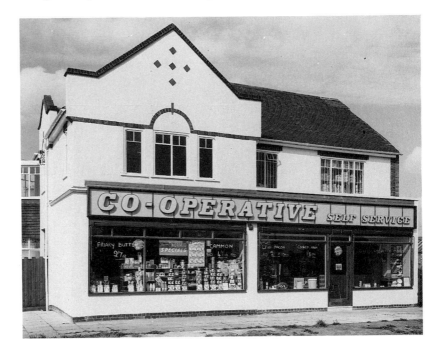

A facelifted food store which could radically change the Movement's image.

Movement which gave them high status and a real sense of community. Previous reports had warned about this in 1922 and again in 1939[21] but, ironically, the Movement had until the 1940s been benefiting from an unequal class system which had stopped talented working-class children from gaining a decent education. With the opening up of access to the grammar schools after the war, the best working-class students were beginning to stay on at school and even go to college. It was not that an academic education made someone a better manager, more that those who would have made the best managers were now passing the Co-op by.

The problem was compounded by a mistaken view among boards of directors about their role in relation to the managers. Some boards liked to interfere in day-to-day management, with directors getting immersed in the details and making all the decisions. The result was that they never had time to plan ahead and give a clear strategic direction to their society, while their managers were either demoralised by the constant interference or content to give up responsibility and let the board take the blame when things went wrong. Other boards went to the opposite extreme and acted more as a 'consumers' vigilance committee', letting the managers run the society and rubber-stamping their decisions but then blaming *them* when things went wrong. The correct role was, of course, somewhere in between, with the board concentrating on major policy, selection of their chief officials, sanctioning of capital development, liaising with their members, but allowing the managers to get on with the increasingly specialised and professional business of management.

Digging even deeper into the Movement's soul, the Commission then asked why there were so many societies – nearly a thousand at that time – and condemned the enormous duplication and waste of resources it entailed: too many warehouses, too many specialist staff, inefficient use of transport, waste of office space, and so on. More serious still, this fragmentation meant that the Movement's considerable capital was held by societies who did not need it while others who needed to expand could not find the capital. Larger societies would, in their view, lead to better management, larger scale of buying, central warehousing, standardisation, the spreading of overheads, access to finance and a much larger market. Comparing the Co-op with the multiples, they found that in the

More than just a trading organisation – a wide range of member activities supported by the Movement ...

Left Co-operative youth clubs in London during the 1950s.

Below Ipswich Society's drama group for young people which stages magnificent productions every year.

THE IPSWICH CO-OPERATIVE SOCIETY
MEMBER EDUCATION COMMITTEE

Are proud to present

THE IPSWICH CO-OP JUNIORS

Belfast Society trade float adds spectacle to the city's 1964 carnival.

Music making in the 1990s by an Ipswich Society choir

Members of the Woodcraft Folk, a national organisation of youth groups supported by the Movement.

food trade 73 per cent of multiple shops were operated by firms with over 50 branches, compared with only 37 per cent of Co-op shops. In the non-food trades, the contrast was so great that even through amalgamation the Co-op could never close the gap; national specialist chains would be needed if the multiples were ever to be challenged.

Although one of the Commission's members wrote a minority report advocating a national society (a suggestion which had first been made by J. C. Gray in 1906, but had never been taken seriously), the majority thought this would be far too big. The right size for a society ought to be determined by natural shopping areas, which were determined by where people actually shopped. The criteria they set out were that Societies should have a minimum of 15 grocery shops, and that there should be one society to each main shopping-centre, able to plan its development around a natural catchment area. The result would be a Movement drastically slimmed down to between 200 and 300 societies.

Turning then to the national level, the Commission saw an urgent need for three major reforms. Firstly, national specialist chains were needed in footwear and clothing, to be set up along the lines of the existing National Co-operative Chemists. Secondly, a new national federation, a Co-operative Retail Development Society, should be set up charged with providing 'a systematic centralisation of the Movement's vast experience in one recognised place where it can be utilised by any society at will'.[22] There were already national services provided by the Union and the wholesale societies, but they were found to be overstretched, deficient in quantity and lacking in sufficient authority. What

Specialist shops were one of the recommendations of the Independent Commission to open up new areas of trading – this example was established by the Rochdale Pioneers Society.

was required (as the Webbs had advocated in 1922) was an organisation able to audit the performance of every single retail society and then to offer a comprehensive service to boards of directors so as to raise all societies to an acceptable level of efficiency. Beyond this, the Development Society would have control over the considerable surplus capital of the Movement, in order to underwrite all new developments. It would have an economic planning division able to look right into the future and anticipate new directions for the Movement as a whole, so that it would never again be caught out by its competitors.

The third reform was of the wholesale societies. They should change their role from that of being sellers of goods to the retail societies to that of buying on their behalf, supplying the real needs of the Co-op shops even if this meant cutting back on their own production and buying from private manufacturers. Their own factories would have to sink or swim depending on their merits. There were three factors which would determine whether or not Co-op production would survive: the scale of production, the number of outlets taking it, and the extent to which advertising had already diverted customers to privately branded goods. Those Co-op lines which were produced on a large scale, were stocked by a large number of shops and were not harmed by the demand for branded goods would still be popular. Finally, the wholesale societies, like the retails, must separate democratic control from day-to-day management; the full-time board should be replaced with a larger but part-time elected body, with managers being given much more authority to manage.

The Commission spent a lot of time trying to work out how much capital the Movement had at its disposal. Compared with their competitors, co-ops paid out a much higher proportion of their surpluses in dividend (70 per cent compared to 42 per cent) and retained a minute part of their surpluses to finance future expansion (3 per cent compared with the multiples' 37 per cent). The reasons were that retained income was subject to tax, and that Co-op members had grown used to high dividends. Yet such had been the success of the Movement in the past, and so cautious had been their leaders, that they still had a vast reserve of non-trade assets (amounting to 42 per cent of their total assets), much of it locked away in safe investments outside of retailing. If the Movement wanted it could mobilise all the capital it needed for development – around £100 millions. If more were needed the CWS could unlock some of its vast reserves and borrow against its very undervalued assets. The message was that the Co-operative Movement could finance a radical modernisation programme, if only it had the will to do so.

The Co-operative Independent Commission provided a very heavy and challenging agenda for reform. The Movement held a special Congress to discuss its report, and it was received with enthusiasm, delegates voting to accept virtually all of its recommendations. But the story does not end here – in fact, it only begins. As one historian puts it, the report was 'more of a springboard than a force for immediate change'.[23] The means to implement the most radical of the proposals were lacking, because powerful new centralised powers would hardly be conceded overnight by a decentralised movement jealous of its autonomy. Yet there was not much time left. Between 1957 and 1961 retail trade increased by 15 per cent, but the Movement only grew by 7 per cent. Most of the increase was taken by the multiples, which grew by a staggering 29 per cent, and the department stores, which grew by 16 per cent, but even the independent shopkeepers

recorded growth of 11 per cent; the Co-op was falling behind all of its competitors. Let us take one by one the points made by the CIC Report and trace the extent to which action resulted, the length of time it took to get such action, and the effect this had on the Movement's fortunes.

The shops and their management

What about the state of the shops? Not much happened until ten years after the Report, when in 1968 the CWS launched Operation Facelift, a loose consortium of specialist firms which offered a package of shop refurbishments; within six months, 1,300 shops had been modernised. A new national symbol – 'CO-OP', on a blue background – was designed, and formal licence agreements were signed by retail societies to use it (but only after the board had nearly accepted an alternative logo 'Gold Mark', which would have shown a disastrous lack of confidence in the Movement's most basic identity). The process of modernisation was, however, dwarfed by a more negative method of improving standards – that of closing the older, least well-sited and smallest of the shops. In 1958 the CIC Report had not considered the size of shops to be very important. It noted that the Co-op grocery shops were generally larger than those of their competitors, while the department stores and some non-food stores were smaller. However, it could not have foreseen the way in which the impact of the supermarket, followed by the growth of car ownership and extension of the road network around towns, would lead to the development of huge new superstores and retail warehouses on the outskirts of urban areas, which would threaten to undermine the Movement's reliance on small shops.

At the time of the report in 1958 there had been 30,000 shops open, but by the early 1980s there were only 9,000 left. The average size had, of course, increased, with 1,760 supermarkets (over 4,000 sq. ft), 43 new superstores (defined as being over 25,000 sq. ft) and 256 department

One of the Movement's early superstores opened by the Pioneers Society in Oldham in 1976.

Another twist in the retailing story – a convenience store operated by United Norwest Co-operatives. The convenience format has breathed new life into many of the Movement's smaller stores, enabling them to find a distinctive market niche by providing consumers with an extended range of merchandise over longer hours. United Norwest Co-operatives has the largest directly managed chain of convenience stores in the country, many of them including newsagencies and post offices.

stores, but still over 60 per cent of the trade was done by small neighbourhood shops and small supermarkets of under 4,000 sq. ft. The Movement's shops had by now fallen on average to a third of the size of those of the multiples, the top four of whom were doing nearly twice the Co-op trade from only 1,300 outlets. Strenuous efforts were made by societies to respond to the new trend, by borrowing heavily, closing their small shops and building new superstores; by 1985 the Movement had become the third largest operator of superstores in the UK.[24] Those who were stuck with large numbers of small shops, though, were in trouble. The small size of shop has been blamed for the relative weakness of the Movement in Scotland, and was a major factor in the takeover of the largest society – London – by the CRS; after the takeover, 80 per cent of the Society's grocery shops were closed.[25]

And then, in the late 1980s came another twist in the story of post-war retailing, with the arrival of the convenience store. It had been thought that small shops would continue to be threatened by the opening of new superstores, but then some traders recognised that the small shop could complement the superstore, by opening long hours in convenient locations, and providing 'top-up' shopping for people who do their main weekly shop at the large store.[26] The CWS set up two 'C-Stores' on an experimental basis, and then built up a franchise operation with 12 stores, setting an example which regional societies soon followed. Instead of seeing their small stores as a liability, they found that in some locations (but not all) they could be refurbished and made highly profitable. For instance, by 1987 the Norwest Society was taking half its turnover from ten 'Shopping Giant' superstores, but another 10 per cent from 15 'C-stores'.[27] And the conversion of the stores was very rapid; the North Eastern Society converted 127 shops in one year. In fact, so successful have the Co-ops been in utilising their small-shop base, that they are now the leading C-store operators, leaving behind both the independents, who are less well organised, and the multiples, who cannot easily find good sites.

At first it was thought that the superstore would kill off the medium-sized supermarket. However, people without cars, and those who cannot easily walk the long corridors of a large store are keeping to the tradi-

An out-of-town Homeworld store, one of a chain being opened by Co-operative Retail Services. CRS has shown great flair and commitment to non-food retailing and the Homeworld format – with one large store serving a massive catchment area – has enhanced the image of the Co-op among consumers in many parts of the country.

tional supermarket which, in the right locations, has also proved to be resilient. Again the Co-op has succeeded because of its diverse range of different sized shops. On the non-food side the picture is broadly similar. At first there was a rash of closures; at the time of the CIC Report there were over 6,000 outlets, down twenty years later to under 2,000. The same process of moving to large, edge-of-town sites has meant the moving of 'durables' such as electrical goods and home furnishings to new warehouses, while the old Co-op department stores have been revamped for the comparison goods trade which now dominates the city centres.

Underpinning these enormous changes in the size, siting and layout of shops has been a significant improvement in the quality of Co-op

Department store revamped by Co-operative Retail Services.

management. Again there are positive and negative reasons. On the positive side, most societies reorganised their staff into management teams responsible in a clear hierarchy to a chief officer. On the negative side, the process of amalgamation of retail Societies, together with growth in their average size, has meant the retirement of many management teams and the introduction of younger and more specialised managers. These new managers have been supported by the Co-operative College, which has set up courses for management trainees, senior management development programmes, courses tailor-made for large regional societies, and a graduate training scheme which meets the CIC's criticism of the Co-op for failing to recruit the best students. The new cadre of managers which results demands more specific goals and a clearer image of the future from their employers.[28]

The role of the board of directors has also changed for the better, and for similar reasons. On the positive side, this was one reform which was embraced by most retail societies quite quickly, and those which had been called management committees changed their name to board of directors as the report had suggested, and began to allow management to manage.[29] Typically, though, in such a decentralised Movement some societies continued to operate in the old way, eventually with dire consequences for their trading results; as late as 1978 Colchester and East Essex Society, for instance, still had department heads reporting directly to individual board members.[30] Another effect of mergers between societies was to concentrate the talent the Movement possessed in fewer societies. The wholesale societies also modernised quite quickly. In 1964, after suffering substantial losses in some of its operations, the board of the CWS made the mistake of asking a Remuneration Committee to agree to increases in salary; the Committee took the chance to link salary improvements to fundamental change, and the board had to agree to become part-time and to create a modern management executive. The board of the Scottish CWS soon followed suit.

More difficult to put right, though, was the underlying problem faced by lay members of making their role effective, in a world in which retailing was changing fast and becoming more and more specialised. There was much suspicion in the Movement that the new professional managers

An Institute of Co-operative Directors training course in session.

would use their expertise and monopoly over information to take over the decision-making role, leaving the boards relatively powerless. This was especially the case when top-level private sector managers began to be hired at very large salaries, who had not yet internalised Co-operative principles. As late as 1992, one Co-op watcher was warning that boards require knowledge of control technology which many of them do not possess, and that the emergence of able directors is too much left to chance.[31] On the other hand, giant strides have been made. An Institute of Co-op Directors was set up in 1987 by the Co-operative Union to help promote the right kinds of skills and attitudes among today's directors. Around 400 have joined the Institute, and almost two thirds of societies have directors who are members. In 1988 a Certificate was launched to accredit the training directors receive.[32] This does not entirely solve the problem, however, since the majority of serving directors still have not undertaken any formal training. Suggestions have been made for a commission of inquiry which would open controversial issues such as the appointment of experts as co-opted members, the payment of fees, and an insistence that all directors should receive formal training.[33]

Local autonomy – the still single shop society at Langdale in the English Lake District.

The amalgamation of Societies

The CIC Report's recommendation that the number of societies be reduced to 2–300 was its most contentious and hardest to achieve, because it hit at the heart of the Movement's most precious value, local autonomy. There were three types of reaction to it, which we might label localist, regionalist and nationalist. The *localists* rejected the very idea that mergers would lead to trading improvements, and over the next twenty years they were able to point to quite small societies that had, by good management and concentration on markets where the competition was weak (notably the travel, funeral and motor trades) remained financially healthy. Yet overwhelming evidence was accumulating against them, and by the time of the superstore revolution, they had become a small minority whose arguments were no longer taken seriously.

The *nationalists* went to the other extreme, arguing that only by amalgamating everything into one national society could the Co-op survive. Their argument was weakened at first by the fact that none of the multiples was anywhere near as large as the combined Co-operative Movement, and that the CIC majority report had come out against it, both on the grounds that it would destroy the democratic base and that it would be too large to be effectively managed. From the 1980s, though, their argument has become more persuasive, partly because the number of societies has reduced and two national societies have emerged (CWS Retail and CRS, which could conceivably be combined into one super-society), and because the leading multiples were edging nearer to the Co-op's overall lead in retail sales, with Sainsbury taking the lead in the early 1990's. Sympathetic expert commentators from outside the Movement are exasperated that it has not amalgamated, because they see the need for one single control, administered by a top flight management team, able to move investments to where they will yield the best return, centralising functions so as to reduce operating costs, and so on.[34] However, to their surprise (because the outsiders see the arguments as simply obvious), attempts to combine CRS and CWS Services have as yet come to nothing.

The *regionalists* have been in control of national policy, aiming somewhere between these two extremes. They have had the best arguments, firstly because their stance was most likely to succeed, and secondly because statistics have consistently shown that the best performing societies have been the medium-sized rather than the large or small. In 1960, the Co-operative Union responded to the CIC Report by carrying out a national survey on the issue of amalgamations, which endorsed the Commission's analysis, recommending a reduction to 307 societies; by 1968 a substantial reduction had been achieved down to 539 societies. The Union then produced a regional plan setting an eventual target of only 55 societies (including five to cover Scotland); by 1974 the numbers were down to 260, and a second plan was produced reducing the target to 26 societies. Progress thereafter was much slower. Those which had amalgamated had almost all done so out of economic weakness rather than conviction, and further significant amalgamations had to wait for another downturn in the economy in the early 1980s.

Many societies had preferred to transfer to the national organisation, CRS, where they could retain some of their identity in a regional committee, rather than to other neighbouring societies where they might lose

their identity altogether. CRS became the biggest retail society in the Movement, having taken in 162 societies by 1977. Then in 1981 it took on the ailing London Society, and got into serious difficulty, making an operating loss for the next three years and having to use £27m of its reserves just to survive.[35] It could no longer afford to absorb any more, and the CWS, which had already acquired the Scottish wholesale society's retail division, stepped in to save more English societies, including the two other London-based ones, Royal Arsenal and South Suburban. The prospect of the Movement's wholesaler becoming a major retailer filled the localists and some of the regionalists with alarm, but it could not be avoided.

Finally, in the early 1990s some important mergers did occur not through weakness but through strength: North Eastern Society became a region of CWS, and two very large regionals, Norwest and United, decided to amalgamate. The Movement is now down to fewer than 60 societies, grouped in three bands: the 15 or so big players who now turn in a solid retail performance, the regionals with good to very good performance and a long 'tail' of small societies whose performance is generally poor.[36] On the other hand, there is emerging a three-society 'top tier', with CWS, CRS and United Norwest doing over half the Movement's trade between them. Together they could form a national society.

A national Co-operative strategy

The response to the CIC report's recommendations for a national strategy to counter the Movement's competitors was disappointing. Firstly, the report had declared bluntly that only national specialist chains could regain some of the lost ground in non-food trading. The CWS had already made a start in chemists, travel and dental services, but in response to the Commission's report it set up Society Footwear (later to be called Shoefayre), a national chain to be jointly controlled by CWS and seventy retail societies. Two private firms were acquired to add to 10 specialist shops the CWS already had, giving it a decisive start with 154 outlets. All the advantages which the CIC report claimed for this form of organisation proved to be correct: specialist buyers and window-dressers could be hired at national level, shoes could be bought direct from manufacturers and held at one central warehouse from which stock could be distributed and then redistributed to achieve maximum sales from each outlet.[37] By 1977 the firm had sales of £8m, but few new initiatives followed. CWS was not really allowed to develop more chains, and instead contented itself with small demonstration projects such as experimental supermarkets and then convenience stores, and then offered the lessons learned in technical services to retail societies. Twenty years later, experts were still spelling out the arguments – that societies should abandon some kinds of non-food and look to the national chains, because they are only marginally involved in some sectors anyway[38] – but resistance from retail societies was as strong as ever.

Secondly, the report had recommended that the CWS change from being a 'seller to' to a 'buyer for' the retail societies, and in 1965 a Joint Reorganisation Committee had agreed. Strangely enough, this meant going back to the original method advocated by Charles Howarth in 1863, of acting as an agent for the retailers, adding a service fee to cover the wholesaler's costs rather than selling at market prices. The

CWS – changed to a 'seller to' retail societies.

immediate impact on the production side of the CWS was hard: factories which were losing money were closed, production was concentrated on a few sites, and where factories were unable to work at full capacity (e. g. in flour-milling and bacon curing) the Co-operative interest was merged with that of a private company which could guarantee more sales. Own productions now began to earn their keep against vigorous private sector competition, and where the latter had the price advantage even Co-op label goods began to be produced by private manufacturers. The result was that CWS sales, having suffered a small loss in 1967, grew rapidly from just over half a billion pounds in 1968 to over a billion in 1971. A corner had definitely been turned.

Co-op Brand own label goods distributed by CWS.

Yet this did not completely solve the problem of how to co-ordinate the Movement's potentially massive buying power. By the late 1970s it was apparent that the solution proposed in 1965 had only partly succeeded. The CWS had done everything that the CIC report had asked of it, but societies had retained their pre-1965 purchasing methods virtually intact.[39] The smaller ones were taking advantage of CWS buying power, but the bigger societies were by-passing the CWS in their own joint buying groups,[40] a disturbing development which, with the growth of regional societies, could only make matters worse for the CWS. Where buying was co-ordinated nationally (as in the electrical and television trade) it flourished, but where local societies insisted on doing their own buying (as in fashion clothing) the Co-op market share continued to decline.

An even more important recommendation from the CIC report was the setting up of a Co-operative Retail Development Society. The executive of the Co-operative Union did not see the need for this, and instead decided to expand its own advisory services. It was 1970 before a logical separation of trading and non-trading advice services was made and the CWS took over some of the Union's work, coming closer to the kind of national development agency which the Commission had envisaged. Meanwhile, the CWS also took on some of the functions which a national development society might have had. It launched a 'Come Co-operative Shopping' advertising campaign, and set up regional distribution warehouses which would eventually replace all their existing warehouses with a more rational and cost-effective network. In 1968 CWS tested a national scheme for dividend stamps which by the mid-1970s had virtually replaced the old-fashioned quarterly cash dividend payments which in an increasingly affluent society were beginning to lose their attraction. And then another massive advertising campaign declared 'It's all at the Co-op – Now!'.

All this helped improve the Co-op's outdated image, but it never achieved the kind of united approach to long-term strategic planning which the report had envisaged. Nearly twenty years later observers were still calling for a national 'think-tank' on strategy, and for an efficiency audit unit which would really get to grips with retail societies' performance.[41] By 1990 the same call was being heard, that a central agency is needed to co-ordinate marketing policies, and to provide the strategic thinking the Movement lacks. Yet societies are still determined to resist this, to develop their own individual strategies, and do all their own developments.[42]

If the national federal agencies had been amalgamated, that might have led to a real national strategy emerging, though equally it might not, since it is not so much the fragmentation at national level but the autonomy of the retail societies which has been the problem. Such national mergers have proved even more difficult to arrange than mergers of retail societies. An attempt in 1962 to get all the national bodies to amalgamate failed when the Scottish CWS rejected it. In 1970, proposals to merge the CWS and the Co-operative Union were shelved because it was felt that there were more urgent problems facing the Movement. From the early 1980s a merger between CRS and CWS has been debated, but has never quite come off. Lurking at the back of the talks has always been the fear that the wholesale interest might take power from the retailers; again, in another form, the defence of local society autonomy reappears.

A new superstore opened by CWS Scottish Retail Group in 1993. Through a series of mergers during the 1980s and early 1990s, CWS has become a significant retailer in its own right, operating outlets from the South East of England to the far North of Scotland.

What is ironic about these failures is that the multiples have gained enormously from mergers between companies which have amalgamated while strong. The only successful national-level merger which the Co-op managed was that between the two wholesale societies in 1973, when the Scottish society was forced to agree because of a financial crisis in its banking department.

Survival is not enough

Since the CIC Report in 1958, the market share of the Co-operative Movement has dropped from 11 per cent to a low but now quite stable 4 per cent. It is still the second biggest retailer in the UK, with sales of over £7 billion per year. The number of societies has dropped from nearly a thousand to below 60, but since 90 per cent of the trade is done by 25 societies the Movement has really reached the point aimed at by the Co-operative Union's regionalisation plan. The number of shops has fallen from 30,000 to 4,500 (though they are, on average, much larger), the number of employees has reduced from 350,000 to 80,000, but the central message of the post-war period is that the Co-op has survived. This is despite having to compete with probably the best multiple retailers in the

Towering giant – the Co-operative Insurance Society headquarters in Manchester. The Rochdale Pioneers played a leading role in the formation of the CIS in 1867, and since then it has grown into one of the country's leading insurers, serving four million families. The CIS has always traded on Co-operative Principles and prides itself that the interests of its customers, i.e. the policyholders, always come first, with all profits used for their benefit.

Opposite One of the unique features of the Co-operative Bank is its in-store banking network which includes Bankpoint kiosks providing 24-hour access to the latest high technology equipment for transactions. The Bank has pioneered a number of customer-friendly services and has started to use Co-operative history as a sophisticated marketing tool, differentiating its products in a competitive marketplace. From the profile of Robert Owen on its Visa cards to its forthright ethical policy and its declarations about openness, the Bank successfully proclaims what its values are and where they have come from.

world, through a series of revolutionary changes in retailing which are still going on. It is despite having started with a legacy of old shops, outdated management and decentralised decision-making structures which had to be completely overhauled even while the multiples were threatening the Movement's very existence. As an example of organisational survival in a turbulent environment, it is probably without

parallel; private firms faced with a tenth of the Movement's problems would long ago have gone out of business.

To committed co-operators, though, survival of the Co-op has never been an end in itself. They want it to survive not just as business but as a **Co-operative** business, one which still reflects Co-operative values of participatory democracy, local community, and social purpose. Faced

with the seemingly impossible task of reconciling commercial needs – to merge into larger societies, to give more power to their managers, to close community shops – with these Co-operative values, they have sometimes despaired. Yet there are now definite signs that a revitalised Movement is on the way, one which has held its share of the market and is beginning to grow again, and which, by reinterpreting Co-operative values for the twenty-first century may begin to discover ways of reconciling them with commercial survival.

Notes

[1] Figures from Jefferys, J. B. (1953), Burnett, J. (1989)

[2] Unfortunately, a similar list is not currently available for the Scottish CWS

[3] Richardson, W. (1977)

[4] Flanagan, D. (1969) pp. 88–9

[5] Richardson, W. (1977)

[6] Flanagan, D. (1969)

[7] Kinloch, J. and Butt, J. (1981)

[8] Cited in Bonner, A. (1970)

[9] Gaffin, J. and Thoms, D. (1983) p. 117

[10] *Ibid* p. 133

[11] Figures from Richardson, W. (1977)

[12] See Birchall, J. (1987) ch. 1

[13] Jefferys, J. B. (1953)

[14] Butler, J. (1986)

[15] Co-operative Independent Commission (1958) p. 2

[16] Richardson, W. (1977) p. 375

[17] *Ibid* p. 199

[18] *Ibid* p. 274

[19] CIC Report (1958) p. 45

[20] *Ibid* p. 52

[21] Webb, S. and B. (1922) and Carr-Saunders *et al.* (1938)

[22] CIC Report (1938) p. 120

[23] Richardson, W. (1977) p. 222

[24] Bamfield, J. (1985)

[25] Hutton, D. (1986)

[26] See Birchall, J. (1987)

[27] Walker, G. (1988)

[28] Houlton, R. (1987)

[29] Paxton, P. (1983)

[30] Round, F. D. (1985)

[31] Branton, N. (1992)

[32] Butler, J. (1988)

[33] Butler, J. (1992)

[34] Wood, J. (1984)

[35] Farrow, W. (1985)

[36] Sparks, L. (1992)

[37] Clayton, J. (1978)

[38] Stephenson, E. (1978)

[39] Byrom, R. (1978)

[40] Edmondson, T. R. (1978)

[41] Harrison, L. (1975)

[42] Bunn, G. (1990)

Co-op Brand wines in a Co-operative superstore.

CHAPTER NINE

The growth of international Co-operation

> Co-operation has gone both slow and far. It has issued like the tortoise from its Lancashire home in England; it has traversed France, Germany, and even the frozen steppes of Russia; the bright-minded Bengalese are applying it, as is the soon-seeing and far-seeing American; and our own emigrant countrymen in Australia are endeavouring to naturalise it there. Like a good chronometer, Co-operation is unaffected by change of climate, and goes well in every land. (G. J. Holyoake)

Co-operative theorists have always found it easy to be internationalists. Their vision of a mutual aid society has no need to stop at the borders of nation states, and their conviction that they have found a new economic system which replaces competition with self-conscious Co-operation leads them to expect that it will flourish everywhere. Their faith can sound like megalomania, especially when they are speaking at a time when actual examples of such Co-operation are thin on the ground. For instance, in 1828 Dr William King, speaking from the experience of a few small societies on the south coast of England, declared:

> Every year, therefore, will the influence of Co-operation spread with increasing energy; nor will any obstacle arrest its course, till it has reached, in splendid triumph, the utmost limits of the habitable globe.[1]

And in 1835, when King's first co-operative movement had all but vanished away, Robert Owen founded a grandly titled Association of All Classes and All Nations, envisaging a central co-operative society which would have 'branches in all parts of the globe'.[2] He embarked on a tour of Europe and then of the United States, spreading the word about Co-operation, but with very little success.

In the end, they were both proved right, because Co-operation did reach to all nations (if not to all classes), and did develop into an international Movement when, in 1895, the International Co-operative Alliance was founded. What had happened between the opening of the Pioneers' shop in Rochdale in 1844 and the launch of the international Movement just half a century later? Was it, as Holyoake claimed, that the example of Rochdale had spread far and wide, or was it that Co-operation had sprung up naturally in each country, taking the form best suited to local conditions? As we shall see, both interpretations are true to some extent; the British Consumer Co-operative Movement based on Rochdale was important, but so were other local forms which either sprang up independently (out of older forms of mutual aid) or evolved from the

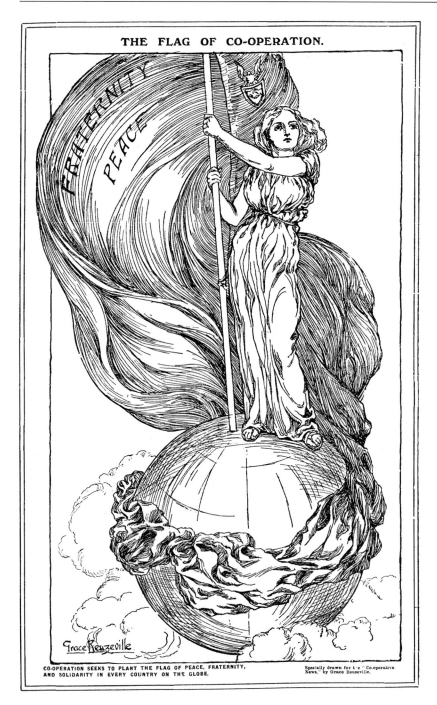

THE FLAG OF CO-OPERATION.

CO-OPERATION SEEKS TO PLANT THE FLAG OF PEACE, FRATERNITY, AND SOLIDARITY IN EVERY COUNTRY ON THE GLOBE.

Specially drawn for t'e "Co-operative News," by Grace Beuzeville.

The Flag of Co-operation – illustration from the *Co-operative News*, August 1913, by Grace Beuzeville.

'Boutique du commerce véridique et social' at Lyons which comfortably predated the Rochdale Pioneers.

Rochdale system into something else.

It is a complex story which can best be told through an analogy. Imagine that Co-operation is a kind of plant species which can be found throughout the world in different forms, flourishing more or less well according to the habitat. The Rochdale *consumer co-op* is a particularly vigorous type, and as its seed scatters across Europe it takes root quickly and firmly. At around the same time, though, in the late 1840s and nurtured by two dedicated promoters, Raiffeisen and Schulze-Delitzsch, another type begins to take root in Germany – the *credit co-op* or co-operative savings bank. This is similar to the Rochdale co-op but is

not derived from it, and because it begins to supply farmer-members with seeds it could be said to give rise to a new variant, the *agricultural co-op*. However, the soil of Germany is not so congenial for this variant, and it really only begins to flourish in Denmark, where the importation of the Rochdale consumer co-op model leads naturally to the development of all forms of agricultural supply, production and marketing co-ops. Meanwhile, France has its own co-operative philosopher – Fourier – and its own developers – St Simon and Buchez – who, in parallel with the growth of the British Consumer Movement put the emphasis on emancipation through work, and develop the *worker co-op*. Here is how it happened.

Consumer Co-operation

There were at least four ways in which the Rochdale model was made known in continental Europe. Firstly, the Christian Socialists were active correspondents with like-minded people in France; they were actively importing the idea of the worker co-op, but in return they exported the idea of consumer co-operation, though sometimes more by accident than by design. The German Professor Huber, for instance, discovered the much larger consumer co-op while inspecting some of the Christian Socialists' more modest self-governing workshops (as we shall see when we come to the founding of the International Co-operative Alliance, it was not the first or the last time they would accidentally promote the consumer movement while trying to sell the idea of worker co-ops). Secondly, that great publicist of the Movement, George Jacob Holyoake, wrote a history of the Pioneers which was serialised in the *London Daily News*, and was translated into several European languages. Thirdly, the old Owenite missionary, William Pare, became a representative for an iron foundry, and travelled extensively in Scandinavia, becoming what he called a 'commercial traveller' for Co-operation. And lastly, after the 1848 revolution in France and the repression which followed it, several prominent French co-operators fled to England, where they saw the Rochdale Movement at first hand.

We should not be surprised to learn that there had been isolated attempts to open stores before Rochdale in other parts of Europe; the idea was just too obvious to be entirely a British invention. Nor should we be surprised to learn that it tended to start with providing for that simplest of human needs – bread. The forerunners of the Rochdale co-op are credited with buying a bag of flour at wholesale prices and dividing it. This was exactly what Friedrich Raiffeisen, the mayor of an agricultural area in Germany, did when the crops failed in 1846, only on a much larger scale. After food aid from the government had all been exhausted, he and some friends clubbed together to buy several cartloads of grain from a wholesaler and then loaned it to local farmers.[3] As we shall see, this led not to a 'store movement' but to his distinctive contribution to the worldwide Co-operative Movement, the rural credit co-op. But here is another example; in 1851, the Zurich Konsumverein began as a bakery, set up to alleviate the same distress as was felt in Germany, and by 1853 it had begun to sell groceries. Though it was the first in the German-speaking world to use the term 'consumers' society', it seems to have been independent of Rochdale.[4] In France a stray society is recorded at Hargicourt in 1848, but the Movement began around 1866, again beginning with

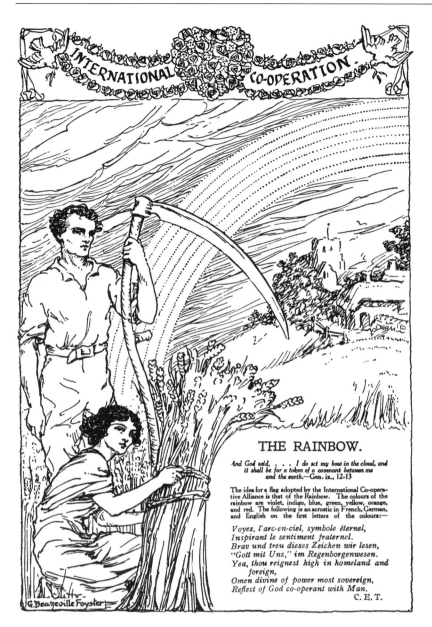

INTERNATIONAL CO-OPERATION

THE RAINBOW.

*And God said, . . . I do set my bow in the cloud, and
it shall be for a token of a covenant between me
and the earth.*—Gen. ix., 12-13

The idea for a flag adopted by the International Co-opera-
tive Alliance is that of the Rainbow. The colours of the
rainbow are violet, indigo, blue, green, yellow, orange,
and red. The following is an acrostic in French, German,
and English on the first letters of the colours:—

*Voyez, l'arc-en-ciel, symbole éternel,
Inspirant le sentiment fraternel.
Brav und treu dieses Zeichen wir lesen,
"Gott mit Uns," im Regenborgenwesen.
Yea, thou reignest high in homeland and
 foreign,
Omen divine of power most sovereign,
Reflect of God co-operant with Man.*

C. E. T.

Acrostic verse spelling out the colours of the Rainbow – symbol of the International Co-operative Alliance. Illustration by Grace Beuzeville from a Co-operative publication in the mid-1920s.

The Rainbow Flag is featured on this banner from Tang Hall Branch of the Co-operative Women's Guild.

CO-OPERATIVE WOMENS GUILD TANG HALL BRANCH

co-operative bakeries. In Italy, a consumer co-op began at Turin as early as 1850; this was similar to the Zurich co-op in selling at cost prices. In the USA, in the 1840s working-class New Englanders were experiencing similar problems to those of Rochdale, and their response was similar; in 1845 a Workingmen's Protection Association opened a store in Boston which, like Zurich and Turin, set prices to cover costs plus expenses.

All of these early movements were like the first British movement of the 1820s and 1830s; they failed or petered out, leaving a few isolated survivors to learn from Rochdale, adopt its principles, and begin again on more secure foundations. Throughout Europe these new, Rochdale inspired movements began to prosper until they too had gone through the same stages of growth: founding enough retail societies to move to wholesaling, then securing a large enough market to do own-production, then finally forming a national Co-operative Union. It is no exaggeration to call them 'Rochdale-inspired'; as C. R Fay, a shrewd observer of the

time put it:

> One may measure the stores of other nations by the degree in which they fall short of the English model; for it is the measure which they themselves apply.[5]

In Switzerland this period of conscious imitation of Rochdale began in 1863, with the Schwanden Society (its rules even had the English translations in brackets).[6] In 1865 the Basel Allgemeiner Konsumverein was set up, which was to become the biggest society in Switzerland, and existing societies such as Zurich and Olten converted to the Rochdale system. By 1895 there were 110 societies, federated in a General Union of Swiss Co-operative Stores, and in 1898 they began a wholesale society based on Basel which soon began its own productions. By 1905, there were 204 societies, in a movement characterised (in the words of C. R. Fay) by its uniformity, enthusiasm and permanence.

Development in France was inhibited at first by the scattered nature of the movement, and by antagonism from socialists. Following Lassalle, who promulgated the doctrine of the 'iron law of wages', they thought that consumer co-ops would do more harm than good, because any savings they made for their members would simply result in wage reductions by employers. However, the results proved the theory wrong, and by 1907 there were 2,166 *sociétés Coopérative de Consommation*, with over 600,000 members. The Belgian consumer movement began in 1880 with the founding of the Vooruit at Ghent. Unfortunately, development was inhibited by the fact that the movement was split in four camps: socialists, political neutrals, Catholics and government employees. A wholesale society only began in 1899, and national federation in 1905, with only 99 out of 168 societies affiliated. However, there is no mistaking its origins; on visiting the (by now combined) Wholesale and Co-op Union offices, C. R. Fay found a huge poster hanging in the office, proclaiming 'the system of the Rochdale Pioneers'.

In Italy, the 'English period' began in the 1880s, with the founding of the Milan Society. It really took off after 1885, when an Italian co-operator, Buffoli, wrote a pamphlet demonstrating the superiority of

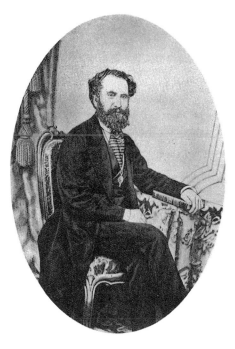

William Pare, Owenite missionary.

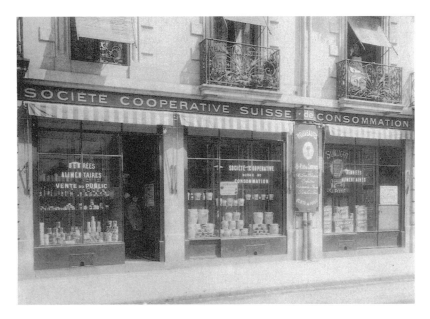

An early Swiss co-operative shop trading on the Rochdale model.

171

Rochdale; as C. R. Fay concludes, 'After considerable opposition, the Rochdale system was adopted generally throughout Italy.'[7] By 1904 there were 1,448 registered societies, with about a third more unregistered. Several provincial federations had started wholesale societies, but their national organisation, the Lega Nazionale, was distinctive in representing all types of co-op, not just the Consumer Movement.

In Germany, Rochdale-type Co-operation did not really begin until the 1890s, but growth was rapid. By 1901 the membership of the stores exceeded that of the well-established credit co-operative movement, and by 1905 a Central Union of German Consumer Co-ops had 787 societies in membership, compared to 260 which were still attached to the credit banks. They were underpinned by a German Wholesale Society, based in Hamburg, whose leaders had in 1898 visited Britain and carried back lessons not only from Rochdale but from the growth of the CWS; they expanded their business into own-production, and began to buy tea from the British, cheese from the Swiss and to sell to the Danish wholesales. There is no doubt from where they drew their inspiration; their official history ended with the wish 'that there be fulfilled more and more completely the dream of the weavers of Rochdale'.[8]

In Denmark, the Movement was based on Rochdale principles from the start. The first store was set up in Copenhagen among shipyard workers in 1865, but it was the first village society, founded at Thisted in Jutland in 1866, which set the pattern. It was founded by Dean Sonne, who may have heard about Rochdale from William Pare on one of his visits. By 1869 the rural consumer societies were in the majority, and the Movement has remained distinctively rural ever since, by the beginning of this century becoming a normal part of village life.[9]

Though most of the development prior to the First World War was in Europe, the Rochdale system had 'seeded itself' much further. It reached the USA by 1864, when a Union Co-operative Association in Philadelphia adopted Rochdale rules. There were several experiments, but in the individualistic and fast-changing world of the American frontier they were too heavily dependent on individual promoters, and did not succeed

The Rochdale Pioneers influenced the development of Co-operation in Denmark.

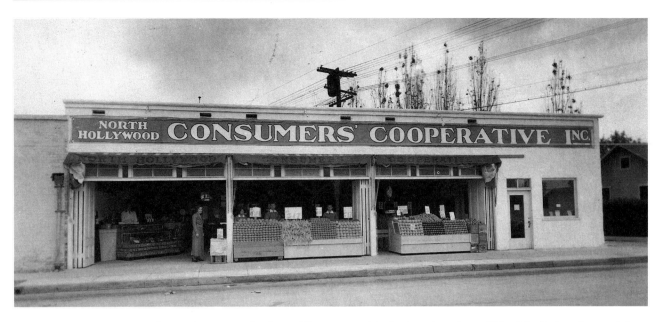

Co-operation in a bastion of capitalism – consumer store in the USA.

for long. However, with the immigration of Finnish, Bohemian and Jewish settlers to New York who had experience of setting up co-ops in Europe, a successful movement did begin; by 1920 they had set up 2,600 societies, linked in a Co-operative League of the USA.[10]

By the late nineteenth century, the idea had reached throughout the world. Such was its energy that it only took one or two people to plant the seed. For instance, the Movement in Maritime Canada began in 1892 when an English doctor, Wilfred Grenfell, arrived at the outpost of Labrador in Newfoundland. The people here were of British and Eskimo stock, and lived simply as hunters and fishermen. The story has many parallels with Rochdale itself. They were (as so many poor people are) deeply in debt to the local trading company, which bought their fish and gave them in return coloured counters which they had to use at the company 'truck' store. They were illiterate, and the only man who could read and write became the Co-op secretary. It took them a year of near-starvation to pay off their debts to the moneylender, and another year to save up $85, but the doctor lent them some money and eventually their store was opened.[11] In this case, the opening of a store did not lead to a Consumer Movement because their real needs were for supply and marketing co-ops. But these different types were able to grow out of the Rochdale system with only minor alterations in their structure.

Credit Co-operation

While the British working-classes were struggling to survive in a new urbanised and industrialised world, the Germans were still a nation mainly of peasant farmers and self-employed artisans. Their first need was not so much for cheap food as for capital, so that they could run their own businesses without being constantly in debt to moneylenders. We have noted how Raiffeisen began with essentially philanthropic work with the small farmers; it took him until 1862 to found a loan society in which the farmers were themselves members. By this time another promoter, Schulze-Delitzsch (who had also begun work during the hardship year of 1848), had perfected the idea of the town bank, had written a

book on the subject, and had set up so many banks that they had, in 1859, federated in a General Union of German Industrial Co-operative Societies. By 1905 there were 'popular banks' in just about every town in Germany, over a thousand of them, with over half a million members. It took Raiffeisen until 1877 to set up his own General Union of Rural Co-operative Societies, but by 1905 his form had grown to an incredible 13,000 societies, vastly outnumbering the town banks and with twice the membership, but granting only about a sixth of the loans. More than half the independent farmers of Germany were members, and another 10 per cent (the larger farmers) were in the town banks.[12]

So Germany became the model country for every form of credit co-op or mutual savings bank. The rural banks also became the springboard for agricultural supply societies, because once farmers saw the advantages of Co-operation they naturally began to create societies to meet their other needs. The two models were different in one important respect; Schulze-Delitzsch felt that members should invest real share capital, while Raiffeisen wanted the poorer farmers to become members on only a nominal shareholding. This was sufficient to keep the two movements apart, but they had in common the Rochdale principles of dividend being earned according to the amount of business done, and of open membership. Both types soon spread to Italy, Switzerland, Belgium and France, while the rural form was also tried out in Ireland.[13] They did not catch on in Britain, perhaps because the consumer co-ops and building societies were already providing a safe haven for people's savings, nor in Denmark, where the very success of agricultural co-operation made private banks willing to lend to the farmers. Strangely enough, they were to become the most popular form in the most developed country in the world – the USA – and in the most underdeveloped countries of Africa and South East Asia.

Agricultural Co-operation

There are three main types of agricultural need which can be met through Co-operation. Farmers need inputs of seed, fertiliser, livestock and so on, and these are provided through *supply co-ops*. They need to sell their produce, through *marketing co-ops*, and in cases where it is advantageous to process the product first – turning milk into butter, or pigs into cured bacon – they can set up agricultural *production co-ops*. These three forms can be found, separately or combined, throughout the world, and they apply to all forms of agriculture, extending to forestry and even to fishing, where family-owned boats can be seen as roughly equivalent to family farms.[14] They are such a natural form that it is hard to say where they first originated, but the distinction probably belongs to Germany, where the first supply society was set up in 1860 and the first productive society in 1871. It spread rapidly to Italy, Switzerland, France and Belgium. Yet for the sheer size and intensity of the Movement, the home of agricultural co-operation is undoubtedly Denmark.

The conditions here were perfect. Firstly, it was a country of small farmers, owning around 20–70 acres each, who were relatively well-educated (compulsory education had started in 1814), and had a common interest in producing high-quality processed foods, mainly for export to Britain. There were no political or religious divides, there were natural leaders among the farmers and village teachers, and the idea could put

down cultural roots in a folk-movement which provided opportunities for adult education in 'folk high-schools', and for meeting in village halls. Co-operation began in the 1880s at the time of an agricultural revolution in artificial fertilisers, scientific breeding and land drainage which was enabling farmers to switch from grain production to intensive animal husbandry. Instead of being used as a defence against the changes, it became a way for small farmers to join in.

The invention of the cream separator, along with the opening up of the British market (CWS had opened its first depot at Copenhagen in 1881) meant that Danish farmers had to find a way of combining to produce butter. The first co-operative dairy was set up in 1882 at Hjedding, and its constitution was copied throughout the country: it stipulated (in a development of the Rochdale principles) that dividend be paid on the amount of milk delivered, and that there should be one vote per member regardless of herd size. In the following year eight creameries were started, then growth became exponential; by 1909 there were

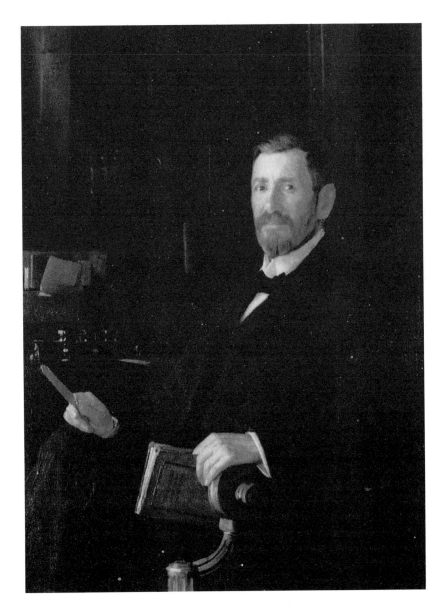

Horace Plunkett, Irish enthusiast for agricultural Co-operation.

1,157 co-op creameries, to which 90 per cent of the farmers belonged.[15]

Dairying led to by-products being used for pig production, and in 1887 the first co-operative bacon factory was set up; again growth was dramatic, though in this case private factories already existed with which to compete. By 1913 there were 41 co-operative and 21 private factories, but the co-ops were producing 85 per cent of the product. Supply co-ops then began to make an impact, breaking down private monopolies by manufacturing farm machinery, and jointly purchasing feedstuffs and fertilisers; by 1907 there were 800 of them, one in nearly every village.[16] By the time of the First World War, almost half of all rural households were members of a consumer co-op, 86 per cent of all cattle herds were in a dairy co-op, and almost 50 per cent of the pigs in a bacon co-op.[17] Add in the water and electricity co-ops, and auxiliary enterprises such as insurance and banking, and it would have been hard to find a farmer who was not involved in one co-op or another.

The Danish experience led to rapid growth of agricultural co-ops throughout Scandinavia. It stimulated a small band of enthusiasts, led by Horace Plunkett, to attempt it in Ireland, backed up at first by the British Co-operative Union and then by their own Irish Agricultural Organisation Society. Though the circumstances were superficially similar – small farmers producing dairy produce for export to Britain – some important factors were missing. The Irish farmers lacked that necessary basic education, they had become fatalistic over centuries of British rule, they were riven by religious and political divides, and so progress was slow.[18] However, Plunkett and his supporters persevered and, beginning in 1889, they had by 1900 produced 58 agricultural supply societies, 138

CWS expansion in Ireland – Limerick Branch at the end of the nineteenth century.

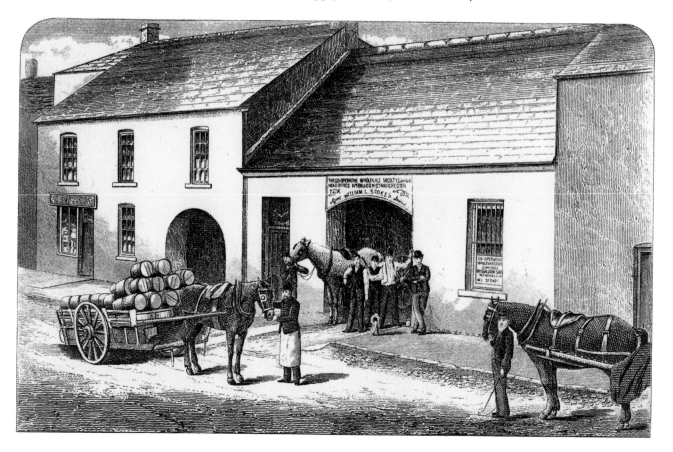

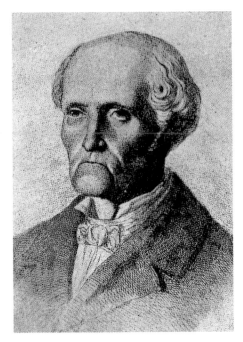

Charles Fourier, France's Co-operative visionary.

agricultural productive societies, and (by 1907) 216 credit societies on the Raiffeisen model.[19] No one had foreseen, though, that when agricultural co-ops and consumer co-ops enter the same markets, there might be a fundamental clash of interests. Yet this was what happened when the English CWS, being bombarded with requests from Irish farmers to set up creameries in their districts, and then being faced with the imminent collapse of a creamery co-op whose members had quarrelled over religion, reluctantly took the society over and began to expand its business in Ireland. This caused so much trouble that eventually, in a spirit of conciliation, the Society sold all its 34 main and 51 auxiliary creameries to the Irish and left them to it.

In Britain, a country dominated by large tenant-farmers, there was even less progress, but due to the perseverance of that valiant co-op promoter, Owen Greening, by 1909 there were 145 small agricultural societies in England and Wales, and 31 in Scotland. The Movement found its natural constituency among smallholders who had to co-operate to survive, but the larger farmers were able to buy and sell on their own account, and only much later, during the depression years of the 1930s, could they be persuaded to join in.

Worker Co-operation

Co-operation in France followed a similar development to that in Britain. It had its visionary, Charles Fourier, who was born a year after Robert Owen, and who also laid elaborate plans for a community in which poor people would find productive work and security: his idea of the 'phalanstery' also inspired model communities (at least 29 in the USA), which ended in failure.[20] France also had its more practical advocate (its William King) in Philippe Buchez, who in 1831 started an association of cabinet-makers, and formulated a body of rules for a worker co-op which included the principles of democracy (worker representation), a financial return proportional to work done, the indissolubility of capital (which protected the society from the temptation to sell and divide the assets), and automatic membership for all workers after a probationary year.[21] Buchez's work became known to the Christian Socialists (through the French-speaking J. M. Ludlow) and, in parallel with Louis Blanc who after the 1848 revolution secured state aid to set up worker co-ops, they set up the self-governing workshops which, as we have noted in an earlier chapter, all failed. The results in France were not quite as bad because the co-ops secured state loans and contracts, but by 1855 only about a dozen still survived.

The idea was revitalised when the owner of an iron foundry, J. B. Godin set up his business as a profit-sharing co-partnership, inspiring the second wave of Christian Socialist activity in Britain, which concentrated on the conversion of existing businesses to worker co-partnership rather than the more difficult task of setting up new ones. Critics pointed out that the lessons of Godin's foundry were limited, proving only that 'employees, under a carefully-defined and somewhat aristocratic constitution, are capable of carrying on a big business built up by another'.[22] Other examples – an old society of spectacle makers and a society of cab drivers – proved more hopeful, but by 1906 C. R. Fay found that these two, plus the iron foundry, were doing half the trade, while 340 small societies were doing the rest.

The worker co-op idea spread to Italy, where during the 1880s a new form emerged, the labour co-op. This was the peculiarly Italian contribution, a society of workmen (usually labourers, bricklayers or masons) which contracted out its services to local authorities, and was given preferential custom and some assistance from government, but was essentially a working class creation. A scattering of worker societies emerged in other countries (notably Bulgaria, where handicraft co-ops have always been strong) but it was a poor crop for all the seed sown by French and English promoters.

The founding of an International Co-operative Alliance

Given that of the four co-operative forms which emerged towards the end of the nineteenth century, worker co-operation was the weakest, it is ironic that it was the promoters of worker co-partnership in Britain who took the decisive step towards founding the International Co-operative Alliance (ICA). Having founded the Co-operative Union only to see it taken over by the Consumer Co-op Movement, they turned their efforts to an international body which, as they thought, would also help them to preach the gospel of worker participation, only to find that within a few years that too had become essentially a consumer-led federation. But we have to thank them for their efforts, nonetheless. This is how it happened.

The idea of an international alliance had been around since the mid-1860s, but it had to wait until the national movements had built up sufficiently to sustain it; all that the promoters of the idea could do was to exchange 'fraternal delegates' to each other's congresses, and wait for the

British postage stamp and first day cover issued to mark the 75th anniversary of the International Co-operative Alliance.

right moment. It came in 1893, when the first conference was held at Crystal Palace in London, with delegates from Belgium, France, Germany, Holland, Italy and Britain. It was conceived originally by E. V. Neale and his supporters as an alliance 'of the friends of production on the basis of the participation of the workers in profits'.[23] This would have excluded the only national body capable of sustaining such an alliance, the British Co-operative Union (and, strangely enough, would have allowed in capitalist firms which practised profit-sharing). In the event, Neale's death meant that a new chairman of the committee was elected, Henry Wolff, who was familiar with the German Movement and had written a book advocating people's banks. At the Conference, Horace Plunkett (who, as we have seen, had moved on from consumer to agricultural and credit co-ops) proposed that the Alliance include all accepted forms of Co-operation. This was agreed, on condition that members should accept the principle of co-partnership, which kept the Co-operative Union out for another year, but the idea was gaining ground and without the British Movement others were reluctant to join in.

By 1895, the Union had agreed to become the British section of an International Co-operative Alliance. The first ICA Congress was timed to coincide with the annual Co-operative Festival and Exhibition at Crystal Palace, and four days were set aside for discussion of each of the main types of co-op. It must have been a revelation to many of the delegates to find out just how varied the co-operative form had become, and how widely it had travelled: there were representatives from Belgium, Denmark, France, Holland, Hungary, Italy, Russia, Serbia, Australia, India, the Argentine Republic and the USA.[24] G. J. Holyoake, by now the grand old man of Co-operation, was up to his usual mischief, and managed to have one of the aims of co-partnership inserted into the final resolution of the Congress. It read that the ICA would 'promote co-operation and profit-sharing in all their forms'.[25] But it was a hollow victory, because the representatives of the consumer co-op movements of Europe would, by their sheer size and financial strength, come to dominate the ICA, and the growth of national movements would soon lead to the dropping of individual membership so that the supporters of co-partnership would have no platform at all.[26] The Alliance was bound to reflect the relative success of the different forms of Co-operation; as we shall see, the European Consumer Co-op Movement was in its turn to be overtaken by the fast-growing agricultural and credit movements of South East Asia, which in a democratic federation is how it should be.

Group of ICA delegates at its 1910 Congress in Hamburg, including representatives from Japan and India.

Between the wars

The ICA settled into a pattern of triennial congresses held in various European cities. It managed to promote mutual knowledge among co-operators, but had not really begun to initiate joint action on an international scale, and the decision of the German Schultze-Delitzsch movement to leave, and of the Raiffeisen movement not to join, were severe blows to its representativeness. Then the First World War forced it on to the defensive, and it was left to the British movement to hold it together. After the War, the underlying trends were all upwards. By 1930, 40 countries, with over 50 million households in membership were represented on the ICA. By 1934 this aggregate membership had passed the 100 million mark, mainly with the massive growth of the movement in the Soviet Union.[27] By 1937, the International Labour Office estimated that co-ops worldwide had 143 million members. The number of consumer co-ops had reached 50,000, with nearly 60 million members, but they were by now outnumbered by 672,000 agricultural co-ops which had nearly 64 million members.[28] Of all types of co-op, Europe now accounted for 300,000, the USSR for 287,000, Asia for 168,000, the Americas for 51,000, Africa for nearly 4,000, and Australasia for just over a thousand. If Holyoake had lived to see these figures he would have been delighted; for indeed Co-operation seemed to be going 'well in every land'.

Yet not in every land, because the enemies of the Movement had been gathering. Co-operation is an economic system in its own right, a 'third way' between capitalism and state planning, a system which puts the needs of people before the demands of capital, but which also demands freedom from state interference. As such it was bound to attract criticism both from private traders to whom its economic strength was beginning to be a threat, and from state functionaries to whom its political independence was also seen as a threat. These forces came together first in Italy in 1921. The Co-operative League of Italy had over 8,000 societies and around half a million people in membership, before the Fascists began to burn, plunder and wreck their property, assault and kill their leaders and close them down: by 1924 almost half the societies had disappeared, and by 1925 only a thousand were left. The League was dissolved and its property confiscated. Yet the members insisted on the continuation of the co-ops, and even the Fascists had to admit that they were needed. The survivors were grouped in a Fascist Union, and by 1936 membership had actually grown to three-quarters of a million.[29]

In Germany, there were in the early 1930s about 1,100 consumer societies with a membership of four and a half million.[30] In Saxony (the German equivalent of the textile areas of Lancashire and West Yorkshire) more than half the population were members. There were 21,000 banking societies, nearly 7,000 agricultural supply societies, and 4,000 home building societies.[31] The consumer co-ops suffered the worst; a private army of Nazis defaced and damaged co-op premises, assaulted employees and threatened customers, all with the connivance of the local police. Then when the Nazis came to power, they took over the entire Movement, appointed co-operative *führers* to run it and incorporated it into the German Labour Front. Many consumer societies were dissolved and their assets stolen. The People's Banks, worker and housing co-ops were all restricted and discouraged, and agricultural societies absorbed

into a Nazi food and agriculture organisation.

In Austria, over a third of the population were, by the early 1930s, served by consumer co-ops; Vienna alone had 144 stores with a membership of over 170,000, providing for more than half the city's population. Under Fascism, their leaders were arrested, they were compelled to join shopkeepers' trade associations and to submit to their control, and co-op managers were appointed by the private traders. The secretary of the ICA, Henry May, asked for and got an appointment with the Chancellor, Dr Dollfuss and he so convinced him of the worth of the co-ops that control was handed back to them. Of course, after the German takeover of Austria, the Movement was taken over in the same way as in Germany.

In Spain a small but growing consumer and worker co-op movement was destroyed when the Fascists finally won the civil war, but the co-op leaders who were driven into exile made notable contributions to the movements in the countries to which they had fled: Mexico, Colombia and Argentina. In Japan, by 1936 there were 15,000 agricultural co-ops, with 80 per cent of the farmers in membership, and a small consumer movement growing in the towns.[32] But the Movement was lost to the ICA when Japan invaded China.

Less dramatic but in the long-term just as threatening was the attitude of communist governments. In Russia, co-ops had grown dramatically during the First World War, so that by 1918 there were 26,000 societies distributing 65 per cent of all food supplies in Central Russia, with their own central bank and even a Co-operative University in Moscow. When the Bolsheviks came to power, the co-ops became the main instrument of distribution, but in return completely lost their autonomy; every consumer was now compelled to be a member, and all societies were consolidated into one nationwide Consumers' Commune. By 1920 all property had been confiscated, and the bank closed. As J. P. Warbasse describes it:

> The greatest voluntary co-operative movement in the world was completely absorbed by the political state. As a voluntary movement it disappeared.[33]

Yet the communists simply could not run the country without it, and in

The power of Co-operation – electricity supply in the USA achieved through Co-operatives.

1921 autonomy was restored to Centrosoyuz, the national federation, at least in theory. In practice it was still very much an arm of state planning, and in 1935 Stalin abolished all the co-ops in the towns, confiscating their assets without compensation to their ten million members. The rural societies, with 41 million members, survived.

On the other hand, there were some remarkable success stories, particularly in Scandinavia. This is what J. P. Warbasse found in 1936. In Finland, consumer, agricultural and credit Co-ops were handling a third of all goods distributed. In Sweden, they handled 40 per cent, electric current co-ops were providing most of the electricity, and a significant

The Luma Lamp factory in Sweden which broke a monopoly in electric lamp manufacturing; a subsidiary later opened a factory in Glasgow.

co-operative housing movement had begun, providing 15 per cent of housing in Stockholm. Iceland had become probably the most co-operative country in the world, with three quarters of its entire national business done through various kinds of co-op. In Britain, the Plunkett Foundation (set up in 1919 in honour of Horace Plunkett) was taking Co-operation to the colonies. In Canada, farmers had developed wheat pools to sell their grain to the rest of the world. In the USA, President Roosevelt had sent a commission of enquiry to tour Europe and bring back co-operative lessons in how to end the great depression. Anywhere where it was not repressed or taken over by the state, even through the depression years of the early 1930s, Co-operation prospered.

What it had not yet managed to do, despite the efforts of the ICA, was to turn national movements into a genuine international trading combine. At successive ICA Congresses, members had discussed setting up an International Co-operative Wholesale Society and an International Co-op Bank. They had passed high-sounding resolutions about peace and fair trade which to the historian now sound impossibly naive. Yet they had glimpsed the possibility that, if international trade had been organised co-operatively by the producers and consumers themselves, instead of by capitalist combines sheltering behind trade barriers, the awful depression of the 1930s might have been avoided, along with the Second World War which was its direct consequence.

Notes

[1] Mercer, T. W. (1947) p. 102

[2] Watkins, W. (1970) p. 4

[3] See Spaull, H. (1965)

[4] Fay, C. R. (1907)

[5] *Ibid* p. 273

[6] This was noted by C. R. Fay in his epic journey round Europe in 1906

[7] Fay, C. R. (1907) p. 307

[8] *Ibid* p. 291

[9] See Bjorn, C. (1977)

[10] See Sederak, E. and Danforth, A. (1980)

[11] Story told by Spaull, H. (1965)

[12] Figures from Fay, C. R. (1907)

[13] C. R. Fay notes that there were 200 rural credit co-ops in Ireland by 1905

[14] On the other hand, where fishermen club together to buy a boat and share out the profits a fishing co-op could be seen as a worker productive society

[15] See Bjorn, C. (1977)

[16] Statistics from Fay, C. R. (1907)

[17] But was their membership voluntary? Put this way (statistics by Bjorn, 1977) it looks as if the animals are the co-op members.

[18] See West, T. (1986) ch. 2 for interesting examples

[19] See Cole, G. D. H. (1944)

[20] See Mellor, M. *et al.* (1988)

[21] See Lambert, P. (1963). Note that these rules, if followed properly, would stop two of the deformations which Beatrice Webb complained of: closing down the society in order to share the assets, and refusing to admit new workers as members

[22] Fay, C. R. (1907) p. 240.

[23] Watkins, W. (1970) p. 24. Neale had retired as General Secretary of the

British Co-operative Union in 1891, having finally lost the battle in the Consumer Movement over profit-sharing

[24] See Watkins, W. (1970) p. 31

[25] *Ibid* p. 39

[26] In 1900, the British Co-operative Union was successful in ending individual membership of the ICA in all countries which had a national union

[27] Figures from Watkins, W. (1970)

[28] Figures quoted by Cole, G. D. H (1944) p. 353. Note that the figures for ICA membership, 71 million in 1938, are very much lower

[29] Figures from Warbasse, J. P. (1936), though he quotes 4,000 societies associated with the Lega Nazionale, and I have used Watkins' figure of 8,000, which is probably more accurate

[30] Figure from Bonner, A. (1970)

[31] Figures from Warbasse, J. P. (1936)

[32] *Ibid* (1936)

[33] Warbasse, J. P. (1936) p. 47

CHAPTER TEN

The international Movement today

Despite world wars and economic depressions, the collapse of empires and the redrawing of national boundaries, political repression and persecution, the Co-operative idea ... has survived to become more relevant than ever. (Will Watkins)

After the Second World War, the ICA grew into a powerful force, backed up by the development of strong national co-operative unions in several countries new to the Movement: during the War, the Co-operative Federation of Australia had joined, then after it the Co-operative League of China, a new Japanese Central Union of Agricultural Co-ops and so on. The Co-operative Leagues of USA and Canada became, in the words of the ICA's then general secretary, 'federations of truly national scope and

Feed plant of the United Co-operatives of Ontario at Guelph around 1950.

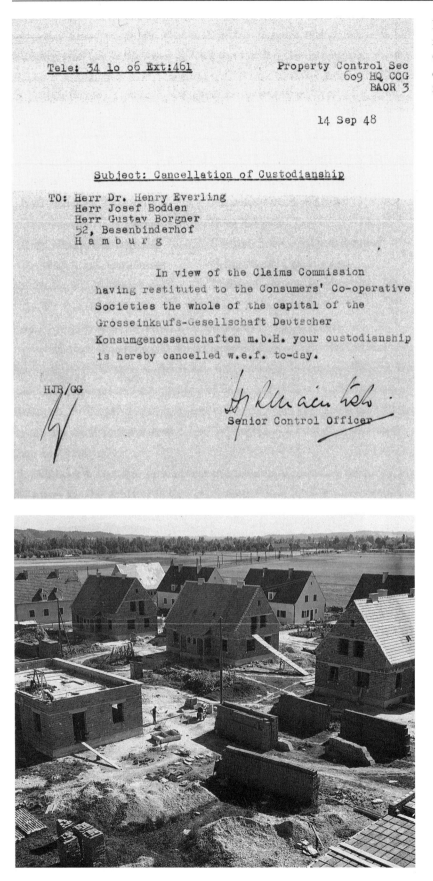

Tele: 34 lo o6 Ext:461

Property Control Sec
6o9 HQ CCG
BAOR 3

14 Sep 48

Subject: Cancellation of Custodianship

TO: Herr Dr. Henry Everling
Herr Josef Bodden
Herr Gustav Borgner
52, Besenbinderhof
H a m b u r g

In view of the Claims Commission
having restituted to the Consumers' Co-operative
Societies the whole of the capital of the
Grosseinkaufs-Gesellschaft Deutscher
Konsumgenossenschaften m.b.H. your custodianship
is hereby cancelled w.e.f. to-day.

HJB/GG

Senior Control Officer

Letter from the British Military Zone returning democratic control of the German Co-operative Wholesale organisation to the consumer societies in September 1948.

Post-war reconstruction – Co-operative housing estate set up by refugees near Linz, Austria, in 1953.

Celebrating International Co-operative Day in 1956 – Royal Arsenal Society's procession float.

importance'.[1] The first task of the ICA after the War was to provide emergency aid to refugees and then to help to rebuild the Co-operative Movements of Germany, Austria and Italy, whose reconstituted national unions then also rejoined the ICA. Consolidation of co-ops in Bulgaria, Rumania, Holland, Argentina and New Zealand resulted in ICA membership passing to their national federations. By 1946 membership had recovered to nearly 100 million members affiliated from 30 countries.

Yet almost from the start it was not easy to hold the Movement together. The Alliance had to defend Co-operative Principles against attacks from within its own membership, especially the principles of political neutrality and democratic autonomy. It was a difficult balanc-

Training in Co-operative management in Kenya.

Taking Co-operation to the Gold Coast (Ghana).

ing act, especially as the cold war began to intensify, but the ICA (with a British president and Russian and American vice-presidents) was almost alone in the world in being able to maintain links between the two world-powers. The trouble began when five republics within the USSR applied to join the ICA. The Russian Union, Centrosoyuz, had long been a member, but the ICA found that they were all far too dependent on Centrosoyuz to warrant membership in their own right. The Russians then retaliated by trying to block the membership of GEG, the West German wholesale society, on the grounds that German reunification should come first. Applications by five Hungarian organisations were then rejected, and that of seven regional unions of consumer societies in East Germany were adjourned. To their credit, the Executive Committee of the ICA stood firm, declaring that co-ops must be open to everyone, must be democratic at all levels, must be free and independent and insisting that 'In countries where the right of free association is denied, and where any divergent opinions are suppressed, free and independent co-operative organisations cannot exist.'[2] The Polish Central Union had by now become a compulsory union so its application was rejected, along with that of organisations in East Germany, Albania and Hungary; clearly the ICA was putting its principles before its own growth in size and influence.

Yet its influence did grow. As the oldest and largest of the international non-governmental organisations, it gained consultative status with the United Nations Economic and Social Council, and with other aid agencies, and was able to advocate the Co-operative solution to the problems of developing countries. A development fund was set up, supplemented by bilateral links between strong co-operative movements in the developed world and particular African and Asian countries.[3] By the late 1950s, co-op federations from the Gold Coast, Eastern Nigeria, Ceylon, Malaya and the Sudan had joined, with Mauritius, Mexico and British Guiana admitted as associate members.[4] Yet, as usual, it seemed that the Movement took two steps forward only to take a step backwards; the Peronists in Argentina had taken over a general meeting of the

Federation of Argentina Consumer Societies, expelling its president and electing their own officers. In Czechoslovakia the distributive functions of consumer co-ops were transferred to government agencies and, as in 1935 in Russia, the co-ops were left to serve only the rural areas. In Ghana, the government formed a National Co-operative Council but the Ghana Co-operative Alliance, wary of state control, refused to join it. Jack Bailey, the secretary of the British Co-operative Union, was sent on a conciliatory visit and was charged with spying, put under arrest and expelled from the country. The leading officials of the federation were dismissed and the government organisation took over their assets. Six years later, just as the Ghana Alliance had regained control and rejoined the ICA, a coup in Greece led to the Pan-Hellenic Confederation of Agricultural Co-operative Unions being put under the control of a military junta; the director and other leading officials were dismissed. It seems that dictatorships, whether of the right or the left, were still finding autonomous, democratic organisations of the people far too threatening.

By 1960, with the admission as members of Burma, Indonesia, Cyprus, Jordan, Iran, Chile and Western Nigeria, along with several specialised housing and fishery federations, the number of non-European countries represented exceeded those of the Europeans for the first time.[5] The ICA was able to set up its first regional office in India (covering South-East Asia), with funding for a Co-operative Education Centre coming from the Swedish Kooperativa Förbundet. A Caribbean Co-operative Confederation was formed with help from the Co-operative League of the USA, and an African Co-operative Alliance was formed among newly-independent states. With the expansion of agricultural and credit co-ops, the consumer co-operatives lost their majority on the ICA. The balance of power was shifting to South-East Asia, symbolised by the growth of the Japanese movement, and their willingness to take on a developmental role; in 1963 the Japanese International Co-operative Training Centre, IBACA, was set up. 1965 was declared by the United Nations to be International Co-operative Year, in recognition of the special role co-ops were playing in developing countries. The following

Swedish memorial to the Rochdale Pioneers at Vår Gård, the Swedish Co-operative College.

189

year, the number of countries in membership had climbed to 60 and the ICA had opened its second regional office for East and Central Africa.[6] International trading had always been an ambition of the ICA, but committees set up to explore it had nearly always ended up doing no more than exchanging information. However, there was one field in which the reality began to match the rhetoric, and this was in the oil business. National oil companies were by now doing very well; the Swedish oil co-op OK was handling 20 per cent of national consumption, and similar co-ops were doing 26 per cent of the business in Israel, and over 50 per cent in Egypt. An International Co-operative Petroleum Association had begun in 1946. By 1960 it had 34 member organisations in 22 countries, and it built an oil blending plant in Holland and began prospecting in Africa. Then in 1963 admission to membership of the ICA was granted to another supra-national body, the Scandinavian Wholesale Society (NAF). In 1966 the International Co-operative Bank at Basle was reconstituted as a commercial bank (INGEBA) and began to expand its business. Wholesale societies began seriously to engage in joint buying, and in the European Community, they started joint production of biscuits and then of chocolate. That tantalising vision which had haunted co-operators for years, of a movement which could meet the challenge of multi-national capitalism, had finally begun to take shape.

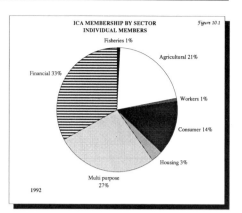

Figure 10.1

Crisis in the consumer co-ops

Consumer co-ops now make up only 14 per cent of the total individual membership of the ICA (see Figure 10.1). Though Europe still predominates, with 67 per cent of the societies in membership, Asia now has 25 per cent (Figure 10.2). In fact, throughout Europe consumer co-ops have had a hard time. Like the British Movement, they have had to adjust to a retailing revolution which has forced mergers between societies and drastic rationalisation, and sometimes threatened the very existence of national movements. In Sweden, for instance, just about all the problems experienced in Britain occurred, only around 15 years later. First there

Figure 10.2

A familar landmark on the Stockholm waterfront – the KF headquarters building.

190

An early picture of the headquarters of one of the two societies that now form the giant Co-op Kobe consumer society, the largest retail Co-operative in Japan.

was massive expansion, with the turnover of the national wholesaler (KF) growing in the 1970s to thirty times what it had been in 1950, but heavy investment in department stores proved to have been a costly blunder and there was a rivalry between the large regional societies and their wholesaler.[7] The number of shop outlets was heavily rationalised (down from 8,000 in 1950 to 2,000 in 1980), and from the late 1970s, mergers increased so that the top 25 societies were doing most of the business. The crisis came in the 1980s, when dividend had to be abandoned, KF was restructured (just as CWS had been) into a more market-led form, and some productive enterprises were floated on the stock exchange. Yet the Movement survived the turmoil to keep its 16 per cent share of the retail market.[8] Another co-operative sector which has kept its market share is that of Switzerland. It consists of a traditional co-op group which has pursued a successful policy of regionalisation (led by an authoritative

Modern development by the Kobe Co-operative Society in Japan.

national federation), and a new retail chain, Migros, which was a legacy from an entrepreneur who gave his business to his customers. Strangely enough, it may be that competition between these two has enabled them to prosper.[9]

Other movements have been less fortunate. In Germany, the parallels with the British history are uncanny; co-ops began to lose out to the multiples during the late 1950s, and they held a committee of inquiry into the need for restructuring which reported in 1967. But with weak central leadership, and directors of societies determined to retain a 'fossilised local autonomy', mergers were only obtained when a society was near bankruptcy. Regionalisation (with its target of 20 regional societies), the development of regional warehouses, the introduction of a standardised Co-op logo, all followed closely on the British experience. In one respect, though, the German solution was radically different: from 1973 onwards local societies which were in trouble began to be converted to limited companies. These were then taken into a national holding company, dominated not by the co-ops themselves but by their bankers (including the trade unions and the Swedish Co-op Movement which had generously lent its assistance).[10] By 1980, Co-op Zentrale AG was actually showing a profit, and was leading the way in supermarket development. By absorbing regional societies, and by bringing in new managers from the private sector, it eventually, in 1987, became the second biggest trading concern in Germany. However, it had expanded too fast, and the trade unions and Scandinavian co-ops withdrew. It had, of course, completely lost touch with its original consumer members, whose stake in the company was now reduced to around 10 per cent. Control transferred not to the bankers but to the managers, who had succeeded in buying up a majority of the shares (there also seems to have been outright fraud).[11] The firm was soon bankrupt, as one observer puts it 'ruined by managers who cared much less about the well-being of their company and its employees than about their own fortunes', and it has had to be completely restructured.[12] A few large societies have stayed both independent and successful (Co-op Dortmund being a fine example), but it remains to be seen whether a co-operative movement will survive.

In the Netherlands, in the face of intense competition, structural reform came too late, and the major part of the Movement, which had consolidated into one central organisation, was sold off in 1973 to a competitor.[13] Similar fates befell the consumer co-ops in Quebec and Belgium. In France, in 1985 the central organisations and the weaker retail societies collapsed, leaving only a few sound regional societies in existence. In Austria, though, amalgamation of 95 per cent of the entire movement into a Co-op Austria has not resulted in very encouraging trading results, and the benefits of amalgamation of the 'progressive wing' of the Movement in Finland are also uncertain. It seems that there has not, after all, been one prescription for restoring the health of the consumer co-op movement: regionalisation, amalgamation into one national co-op, the conversion to public limited companies, none have been a guarantee of survival.

If we look further afield, though, some interesting alternatives present themselves. For instance, in Canada, the movement has had to face the familiar dilemma of how to survive without losing local autonomy and democracy. As part of a new wave which has brought fresh ideas to the Movement, direct charge co-ops have been set up, working from depots

Replica of the Rochdale Pioneers' Toad Lane store on the campus of the Kobe Society Co-operative College, Japan.

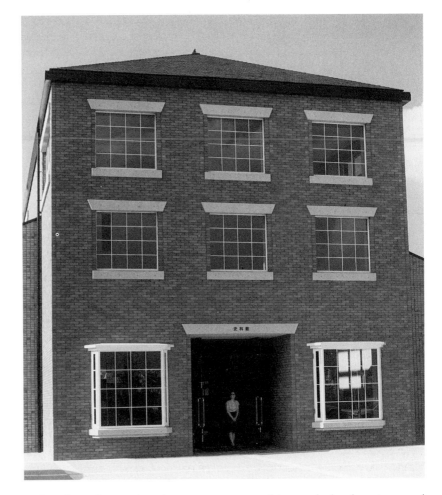

rather than shops, charging as near as possible to wholesale prices, and with operating costs covered by a weekly service fee. This has enabled some co-operative wholesalers to encourage these new independent co-ops, as an alternative to deeper structural changes, though problems for the traditional movement remain.[14]

Japan presents an even more interesting alternative. The early post-war history of the Movement sounds familiar: a boom in the 1950s led by a pioneering role in self-service gave way in the 1960s to stagnation and a policy of merger and regionalisation. But then the working class leadership was infused with new blood from the university co-ops, who improved the direction and management of the movement, competed aggressively with the competitors through new shop openings and launched a range of co-op own products which became known for their quality and reliability. Strong links were built up with the wider consumer movement, and products such as an environmentally-friendly washing powder and pure milk gave the co-op a good image and an enlarging share of the market. Underpinning all this was a real commitment to member involvement, especially in the testing and launching of these products. The campaign for pure milk also led to the most famous of the Japanese innovations – collective purchasing by members. It was realised that if products were ordered in advance by a group of members this would save the co-op in storage, administration and capital investment, savings which could be passed on to the members.[15] From 1964,

Routine medical checks at a Japanese 'han' meeting.

the first organising of members into 'han' groups began.

The han group consists of at least five (and usually around ten) people who agree to place an order every week on a printed order sheet. They elect a leader to organise a simple process; the orders are scanned by a computer, payment is debited automatically, and a personal delivery is made from the nearest distribution centre to the home of one of the members. A patronage refund is given six-monthly according to goods ordered. The groups are federated into regional committees which are represented on the co-op board, and han members are also integrated into the wider co-op by helping to test products, sampling goods at their own meetings, and holding study groups and social events. The typical member is a woman, younger, higher educated and with a higher income than average,[16] but generally tied to the home in the traditional role of the housewife; the han group seems to have played much the same role as the Co-operative Women's Guild has played in the British Movement in enhancing the status of women. The advantages for member participation are obvious, but the process also creates a great deal of loyalty among the employees who administer the joint-buying system, because they meet members regularly and can pass on their views. The Tokyo Society, Tomin Seikyo, has organised around 7 per cent of the city's citizens into han groups, and is aiming at 10 per cent.

These strengths allowed the Movement to remain, even by the mid-1980s, divided into over 1,200 mainly small societies, though 30 societies do nearly 60 per cent of the trade and Kobe, the biggest society, is also one of the biggest in the world.[17] Underpinned by the han system which contributes over 30 per cent of its sales and substantially lowers overall costs, it competes successfully against the private sector, and the productivity of its shops can only be matched by the very largest of superstores. Because the shops are also the distribution centres for han groups, the small shops have remained profitable. Together, the whole Movement has over 28 million members;[18] between 30–40 per cent of all households have at least one member, and in the Nada Kobe region the figure reaches 70 per cent. Surprisingly, these figures translate into a market share of only 1.5 per cent of all retail sales, 2.5 per cent of

New wave, USA – Members of the Davis Food Co-op in California pose for a 20th anniversary photograph in 1992. Begun as a bulk-buying club, the Davis Co-op has become the city's largest locally-owned business with two supermarkets and 6,000 members.

groceries, but in a market dominated by small 'open-all-hours' traders, this still makes the Co-op by far the biggest retail enterprise.[19] It is an open question as to how far the Japanese Movement can supply solutions for the very different setting of western Europe, but the emphasis on environmentally sound products, on joint buying and on member involvement must be worth adopting, and adapting to the urgent needs of these movements.

There is at least one sector where consumer co-ops have not had any of these problems of adaptation and survival, and that is in the provision of social services and medical care. For instance, there are significant medical co-op sectors in Japan, Sweden, Spain, the USA, India and Malaysia. Japan is unusual for a developed country in having little state provision for medical care, and so medical co-ops are growing rapidly: there are more than 100 of them, operating 88 hospitals and 207 clinics, looking after the health needs of about 3 per cent of the population, and financed by the members and 75 per cent government grants. The han group is such a popular form that it has been extended to deal with the health needs of citizens; more than 3,000 of them are attached to the Saitama Medical Co-op for instance, and they carry out routine medical checks and promote knowledge of healthy lifestyles which reinforces the interest of the mainstream consumer co-ops in providing pure food.[20]

The new wave co-ops

During the 1970s, a new wave of worker, housing and credit co-ops began in western Europe and the USA. One of the ironies of co-operative history is that while the consumer form was running into trouble, this new wave of activity renewed interest in the worker co-op, once dismissed by the consumer movement's leaders as an unworkable form. It still makes up only 1 per cent of the membership of the ICA (see Figure 10.1) but it is growing. The first new wave was based in the counter-culture of the late 1960s, and expressed in wholefood co-ops, radical bookshops, alternative technology companies and so on, and with a strong commitment to democratic working and equal pay. By the mid-

1980s there were 11,500 of them in West Germany (employing an estimated 80,000 people) and at least 3,300 in the USA.[21] Then, in response to the emergence of mass unemployment, the emphasis switched to job generation, and co-ops were set up in building, engineering, clothing and other more mainstream areas of industry. Worker takeovers began to be attempted, in one of three ways: as conversions of businesses going into a financial crisis; rescues of those which were about to collapse; and 'phoenixes', co-ops based on some of the residual assets after a firm has ceased trading.[22]

When these worker takeovers began, Italy already had the largest worker co-op sector in Europe, employing about 215,000 people mainly in building and engineering, and with a high concentration in the Emilia Romagna region.[23] Helped by this Movement, and the other co-operative sectors within the Lega Nazionale, worker takeovers have become the norm when a firm is in trouble; in the decade from the mid-70s there have been at least a thousand. In Spain, there have been more than 1,300 takeovers, aided by public funds and by an interesting new form of labour company known as SALa. In France, the home of worker co-operation, there were already over 500 co-ops in the mid-70s, but in a period of unprecedented expansion the number quickly rose to 1,269 in 1983, aided by government support.[24]

In Britain, this new worker co-op movement has been sponsored not by the old Co-operative Productive Federation but by the Industrial Common Ownership Movement (ICOM), founded by an industrialist who made-over 90 per cent of the shares in his company to a commonwealth made up of all the employees.[25] Along with around 60 local authority Co-operative Development Agencies, and a National CDA funded by central government, it has produced a small but very committed worker co-operative sector of around 1,400 co-ops.[26] In addition to these agencies, there has been intermittent action to save companies which were threatened with closure; the publicity surrounding three rescue attempts which eventually failed (the Scottish Daily News, Meriden and Kirkby Manufacturing) did not do the movement much good, but there have still been around 200 worker takeovers.

A key aspect of this renewed interest in the worker co-op form was the discovery of the Mondragon co-ops in the Basque region of Spain. Ever since the rise to power of Franco, Spain had been isolated from the ICA, and it was a surprise to learn that a large and thriving co-operative sector existed. In 1956 a Basque priest, José Mariá Arizmendiarrieta, who knew all about Robert Owen and the Rochdale Pioneers and was involved with a local technical college in the town of Mondragon, encouraged five graduates from the college to set up a worker co-op. The co-op, Ulgor, prospered, as did a savings bank, the Caja Laboral Popular, which became the financial foundation for a rapid development in co-ops manufacturing electrical goods, refrigerators and machine tools.[27] By 1975 there were 58 industrial enterprises spread over four provinces, with a combined turnover of £200 million and a labour force of 13,000, and several secondary level co-ops: schools, a college of technology, a research centre, along with consumer, agricultural and housing co-ops. Because under Spanish law the worker-members were classed as self-employed, they had to set up their own health care, pensions and unemployment insurance, and so became in microcosm virtually a complete co-operative economy.

Father José Mariá Arizmendiarrieta, who inspired the Mondragon Co-operative group.

Branch of the Caja Laboral Popular in the Basque capital, Vitoria.

The expansion of the movement was achieved without any bad debts and without a single redundancy, the key being the delegation of strong powers to the centre, in the Caja Laboral.[28] The structure linked the worker's financial interest to the company, because an initial interest in the firm grew over time (not as a shareholding but as a reward to labour) to become a lump-sum payment on retiring.[29] With a limit on inequalities in earnings based on a 3:1 ratio, and democratic control exercised through an elected board, the whole scheme was in conformity with Co-operative Principles, and it seemed to work. By 1985 there were 111 co-ops (plus housing and educational co-ops), with a workforce of 19,200. They had weathered the recession by increasing exports, with the more successful co-ops taking on workers displaced from those that had cut back. The group has restructured, with a new supervisory body and the co-ops organised in a matrix of sectoral and regional groups, so that they can retain strong central control and local ownership within a much expanded structure.[30]

Yet, exciting though the Mondragon achievement was, it proved difficult to transplant to other areas. It required a skilled workforce, with a tradition of small savings (each worker had to invest a substantial amount) and a strong sense of regional identity. It required a bank prepared to take on a proactive role as business developer and financial manager of each company. In Britain, the insistence of ICOM on common ownership was in direct contrast to Mondragon's substantial individual worker shareholdings of over half of all reinvestment, and attempts to develop a Mondragon in Wales have had little success.

The new wave of interest in co-ops also took the form of a search for ways of stabilising communities which were under threat. In rural areas, for instance in the west of Ireland and the Highlands of Scotland, this took the form of community co-ops, multi-purpose organisations owned by the residents, which began to undertake several different types of activity.[31] In the cities, it took the form of housing co-ops. These have until recently been very much a European model (71 per cent of housing societies in membership of the ICA are from Europe), though again Asia is catching up with 20 per cent (see Figure 10.3). The sheer size of some Asian countries makes it likely that they will eventually overtake the west even in this essentially urban form: in India, for instance, there are now around 70,000 societies with over a million members.[32]

Figure 10.3

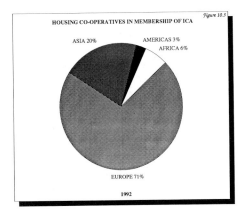

197

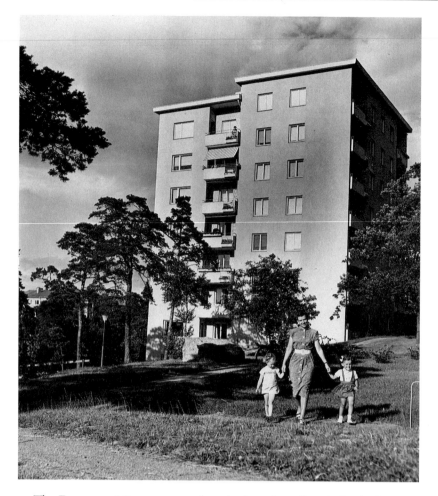

Post-war HSB Co-operative housing development at Årsta, Stockholm.

The European Movement tends to look to Scandinavia for its inspiration. Here the housing co-op has always been strong, with the classic mother – daughter structure of the Swedish HSB setting the pattern; this enabled a national and regional level savings-bank-cum-housing-developer to set up independent local co-ops run by the members but with the 'mother' retaining some powers of oversight. The movement has built a large slice of post-war housing and owns 17 per cent of the housing stock in Sweden and 19 per cent in Norway.[33] In Denmark a slightly different pattern emerged, based on housing associations which have about 18 per cent of the housing stock. Only 39 per cent of these are co-ops, but since 1972 all have had to give their tenants the right to supervise management and maintenance in sectional boards, and some seats on the supervisory board of the association. Tenant democracy exists on 90 per cent of estates.[34]

In Britain, the idea of co-operative housing had been almost forgotten, and enthusiasts had to look to Scandinavia to rediscover it. After much lobbying by Harold Campbell of the Co-operative Party, in 1961 the government introduced co-ownership housing on the Swedish model. It grew quickly, producing over 1,200 societies by 1977, but because it did not reproduce the mother-daughter relationship (relying instead on a Housing Corporation which was not really committed to co-ops), and because co-operative education was neglected, it never really developed into an autonomous co-operative form.[35] After being given the right to

sell their homes in 1980, the societies have gradually disappeared. A genuine form did emerge after 1974, when ownership co-ops were included in legislation supporting housing associations and then tenant management co-ops were allowed to take over local authority housing estates. New wave co-ops, inner city co-ops formed to rebuild declining communities and specialist co-ops catering for minority groups have all prospered, as they have done in Canada and some of the cities of the USA.[36] In the early 1990s, there are in Britain about 260 common ownership co-ops, about 150 management Co-ops and 200 short-life co-ops.[37] Since 1988, the emphasis in government policy has turned towards development through large housing associations, which disadvantages new ownership co-ops acutely. However, the development of tenant participation on local authority and housing association estates has encouraged a massive increase in tenant self-management; for the government, it is the Danish rather than the Swedish model which has proved most attractive.

Another co-operative sector which has received attention in this new wave of activity is the credit union. There are over 36,000 of them, with a membership of 77.5 million, most of them in the USA which has nearly 54 million of the members.[38] One in four Canadian and Irish adults belongs to one, yet in Britain there are relatively few: less than 300. The movement is growing quickly, though, with the number of co-ops in membership of the Association of British Credit Unions growing from 84 in 1988 to 204 in 1992, an annual average increase of 25 per cent.[39] One

Members of a small village credit union in the Fiji Islands.

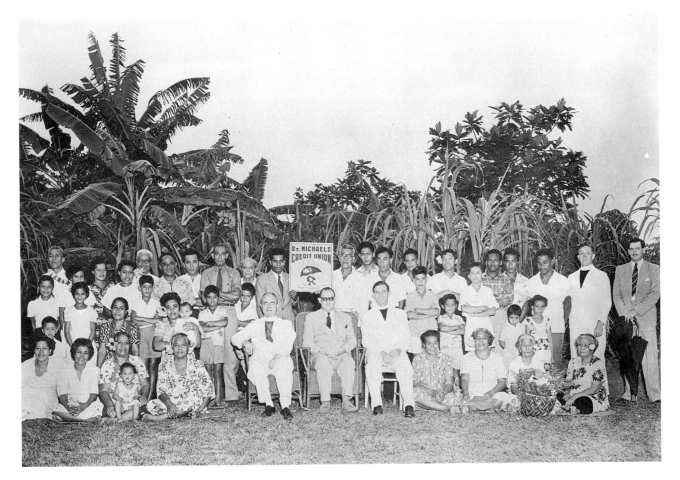

interesting development is the trend for tenants on council housing estates in some of the most deprived parts of Britain to discover one form of co-op and then another, starting from a tenant management co-op and moving on to form a credit union, or a worker co-op; in these cases a movement which started in the 1970s as a middle-class alternative to mainstream society has, in the 1990s, become a way for poor people to become part of it.

Co-operatives in a new world order

Since the late 1980s, the demise of communist regimes in the former Soviet Union and in east and central Europe has led to the co-operative movements in these countries facing dramatic changes, the outcome of which is still unclear. They are very old movements; an agricultural co-op was set up in Soboliste in Slovakia 'only 50 days after the Rochdale Pioneers set up theirs'.[40] Yet under communism they had been used as part of a centralised state-planning machine controlled by the Party, and so with the breakdown of the machine they have obviously been in great danger themselves. We can distinguish four phases through which they have gone since 1988. The first phase was in the USSR when, as part of Gorbachev's *perestroika*, a Co-operative Law was passed giving co-ops the leading role in the liberalisation of the regime; with little competition, they grew rapidly until there were 200,000 co-ops employing nearly five million people. Seen as an acceptable socialist alternative to privatisation, they were suspected by the old guard of being not real co-ops but capitalism in disguise.

Then, with the sudden collapse of communism, the second phase began, when all over Eastern Europe a reaction against the old order threatened to bring down the co-ops, because this time they were seen as too much a creation of the old regime. In Poland in early 1990 abolition of the co-ops was proposed, and all regional co-op unions and all but one of 14 national level organisations were nullified, their property liquidated and sold to the public.[41] The aim was eventually to convert all primary co-ops into private organisations. A similar attempt was made in

One of the 'old' movements – co-op store at a winter sports resort in North-East Bohemia, 1948.

Bulgaria to dissolve the consumer co-ops. In the states which resulted from the break-up of the old USSR, Centrosoyuz was dislocated and its assets distributed. Then the strenuous efforts of co-op leaders in these countries, backed up by the ICA and other international organisations, led to a realisation by politicians that co-ops were not just socialist creations but had been autonomous businesses and could be so again. They could, in fact, be one way of carrying out privatisation, because the members of co-ops could be identified and the assets returned to them which had been stolen by the state. They could also, as trading organisations, help to keep these countries' economies together while the privatisation of state assets was organised.

So the third phase was the rapid passing of co-operative laws so as to enable them to extricate themselves from the state and become truly autonomous.[42] In this process, there was a two-way restitution process, with the transfer of assets from the co-ops to individuals and to the co-ops from the state. The effect on the co-operative movements was mixed, depending on the kind of transfers that took place. Where individuals claimed the assets, real member shareholdings could be created, in a process not of privatisation but of 'personification', the restoring of co-ops to their members.[43] Alternatively, in the case of the break-up of collective farms owned by agricultural co-ops, the restitution of land to individuals has sometimes led to the co-ops themselves being broken up. Sometimes break-ups have occurred so that unscrupulous managers or politicians could get hold of the assets and form private companies, but generally the process has meant the return to the co-ops of real membership shareholdings. Transfer of assets back to the co-ops from the state has, of course, helped, but in some cases valuable real estate which used to belong to the co-ops has been sold off at auction.

The fourth phase, after real co-operative businesses have emerged, is the realisation that they now have to compete in a market economy. After decades of state interference they are not always in a fit state to do so, and need help with management training, loan capital and technology transfer.[44] Joint projects with western co-ops and private companies, and the founding of co-operative banks and insurance societies in each country, are beginning to create the conditions for their revival, but there is a long way to go; many co-ops will not survive, but new ones will be formed, simply because they are needed. The consumer co-ops should emerge strongest at first, though worker co-ops will also be significant, and perhaps the fastest growing will be credit unions, which have recently been reintroduced to all these countries. The agricultural co-ops will be the most problematic, because after the break-up of collective farms they will have to reconstitute themselves as supply and marketing co-ops to small farmers, who may at first not realise how much they are needed. In this process, the role of the ICA and of Western European co-operative development agencies will be crucial. It has been suggested that the ICA set up an auxiliary body for eastern and central Europe, to make sure that the momentum for reform can be channelled in the right direction.

Developing countries are also undergoing their own co-operative revolution. Asia and Africa between them have 84 per cent of the agricultural co-ops in membership of the ICA (Figure 10.4). Many of them, particularly in Africa, are in deep trouble: the need to service a growing debt burden due to huge loans which were taken out in the 1970s, the

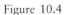
Figure 10.4

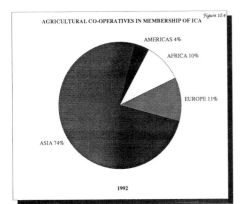

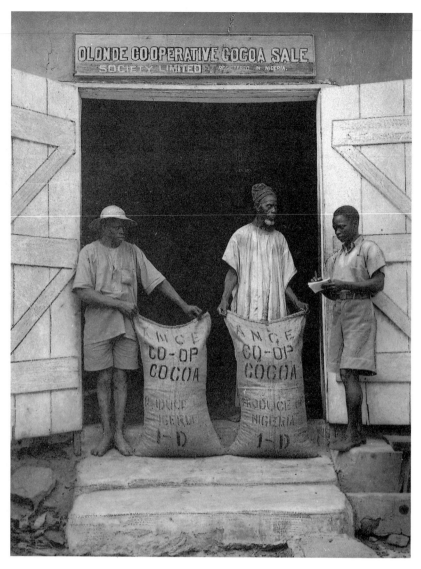

Nigerian village produce marketing
society in the 1950s.

decline in the price of agricultural produce which began in the mid-
1980s, and then finally the collapse of state-controlled economies in the
communist world, have all led to the countries of the Third World being
forced to begin a structural adjustment process. This involves economic
liberalisation, the devaluation of national currencies and a decrease in
the budget deficit.[45] It also involves a drastic restructuring of co-opera-
tive movements in these countries which is in some respects similar to
that going on in eastern Europe.

For a long time, agricultural co-ops in some countries have been little
more than parastatal agencies, granted monopolies over supply and mar-
keting, with their leaders imposed by the state, and with all major deci-
sions being decided elsewhere. Their economic weakness has been
disguised through inadequate auditing and liberal government subsidies
and price-fixing. Their lack of independence and real member involve-
ment is partly explained by a legacy of colonialism, partly by the use of
the co-op form by newly-independent states to consolidate state control
and extract surplus value from the people.[46] Now they are having to
learn to stand on their own feet, and in countries like Uganda and Tanza-

The organisation of fishermen in co-operatives is a feature of the African Co-operative Movement today.

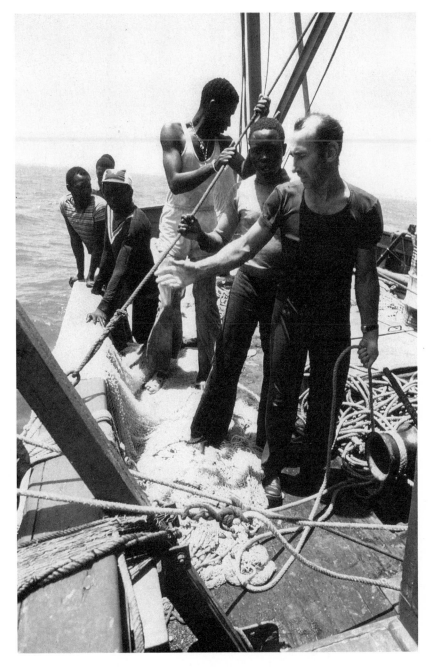

nia their market share has fallen from a protected 100 per cent to 20 per cent at most, with some co-ops going bankrupt.[47] Yet co-ops are still needed by small farmers to protect them against unscrupulous traders, and to organise marketing of crops from remote regions. So in time, and with help from development agencies who are clear about the need for training towards real autonomy, a genuine movement ought to appear. In fact, donor agencies are now insisting on radical restructuring as the precondition for future aid. The main question then concerns who takes charge of the new strategy; if co-ops themselves do so, perhaps led as in Uganda by an independent Co-operative College, then the pace of the change, and a stress on massive education and training of members, will ensure success.[48]

Campus of the Co-operative College, Moshi, Tanzania.

Women's involvement today in a co-operative produce marketing society raises their dignity and status as well as their general well-being.

In South-East Asia, the examination of co-operative values has led to a new emphasis on sustainable development and the protection of the environment. With over half the world's population and less than a third of its arable and permanently cropped land, and with the population expected to double between 1980 and the year 2000, it is no wonder. The question is an acute one for the co-operative movements in the region, because it is they, as agricultural, fishery and forestry co-ops, who have responsibility for much of the environment. Programmes are beginning. In India a farm forestry project has resulted in 33 primary co-ops being organised to plant 4,000 hectares of wasteland. In the Philippines the Co-operative Union is initiating programmes for water resource recovery, and a market vendors' co-op is promoting a biodegradable laundry soap. In Thailand, co-ops have planted three million trees, and in China a Shanghai co-op is a world leader in waste-material recovery and recycling. In Japan, agricultural co-ops have reduced the use of fertilisers and chemicals; forestry co-ops have begun to replant forests; fishing co-ops have established a monitoring system for fishing grounds; and fifty consumer co-ops have together set up an electric car development company.[49]

The key to all these projects is member education and involvement, because without genuine control by the members sustainable development in the long term is unlikely; governments and foreign investors have proved to be just too untrustworthy. But this leads to another issue which is gaining attention in the ICA, that of the role of women in the Co-operative Movement. Because most co-op managers and directors are men, as one leading woman co-operator puts it 'investments in education, training and production which directly benefit women are still like crumbs from men's richer table'.[50] Positive action has to be taken to ensure that women become involved in their co-ops, as managers and active members.

The Rochdale legacy reinterpreted

One of the original aims of an International Co-operative Alliance was to define and defend the true Co-operative Principles. It has done this through periodic re-examinations which seem, surprisingly enough after all this time, to have reaffirmed the relevance of the basic Rochdale principles. For instance, a special committee set up in 1933 identified four vital principles: open membership; democratic control; dividend paid according to business done; and limited interest on capital. It made the distinction between these and three others which were more optional: political and religious neutrality; cash trading; and the promotion of co-operative education. As we have seen, political neutrality had already been breached in several countries (though the ICA itself had always been a model of neutrality), and cash trading and investment in education were clearly sensible but not essential. The committee identified two other principles which the Pioneers had taken for granted: voluntary membership and trading only with members. Apart from this, they declared 'No modification of the Rochdale Principles is either necessary or desirable.'[51]

They tried again in 1966, and this time found six essential principles: voluntary membership, available without artificial restrictions or discrimination;[52] democracy, meaning in primary societies one person one

vote; a strictly limited interest on share capital; distribution of surplus so as to avoid one member gaining at the expense of others (the dividend principle updated); provision for education; and co-operation between co-ops. This last one was yet another principle which had been implicit from the beginning but never spelled out. Then in 1992, an exhaustive research project into co-operative values could recommend only three changes. Firstly, the principle regarding limited interest on capital should be made more flexible and reformulated within a more general principle that co-ops should rely on member capital rather than on capitalists who might demand a share of the assets. Secondly, a clause should be added on employee participation (something which has been scandalously neglected in consumer co-ops), and thirdly it strengthened the 'voluntary' principle by insisting on the autonomy and independence of co-ops.[53]

Yet in the end, months of research, hundreds of thousands of written words, whole days of debate at Congress, have only served to make the essential principles laid down a hundred and fifty years ago in Rochdale shine more brightly. Of course, the challenge is to find ways of making them live in practice. As Will Watkins put it: 'The real problem ... is to ensure that the more Co-operation changes, the more it must remain the same thing.'[54]

Logo for the ICA Centennial Congress in Manchester 1995.

Notes

[1] Watkins, W. (1970) p. 228

[2] Quoted by Watkins, W. (1970) p. 241

[3] Notable in this work have been the Swedish Centre for Co-operative Development, funded by the Swedish Co-operative Movement, and the Coady International Institute, attached to Antigonish in Canada, but several other national Co-operative Movements have also been active

[4] Associate membership of the ICA was given to new movements which had not yet proved their independence of the state or other promoters

[5] See Watkins, W. (1970) p. 299

[6] By now, most of the co-operative movements of eastern and central Europe had been admitted, but those of East Germany were still found to be too much under state control: see Bonner (1970) p. 453

[7] See Schediwy, R. 'The Consumer Co-operatives in Sweden' in Brazda, J. and Schediwy, R. (eds) (1989)

[8] See Böök, S-A. and Johansson, T. (1986)

[9] Setzer, J. 'The consumer co-operatives in Switzerland' in Brazda, J. and Schediwy, R. (1989)

[10] See Brazda, J. 'The Consumer Co-operatives in Germany', in Brazda, J. and Schediwy, R. (1989). The decision to turn co-ops into limited companies is explained by the fact that under German law no organisation could have a majority shareholding in a co-op, and by the need to keep retail societies from having a say in the national holding company

[11] The view of Brazda, J. and Schediwy, R. (1989) in their introduction

[12] Brazda, J. 'The consumer co-operatives in Germany' in Brazda, J. and Schediwy, R. (1989) p. 214

[13] See Reintjes, J. 'The Consumer Co-operatives in the Netherlands' in Brazda, J. and Schediwy, R. (1989)

[14] See Ketilson, L. H. (1988)

[15] See Vacek, G. 'The consumer co-operatives in Japan' in Brazda, J. and Schediwy, R. (eds) (1989)

[16] Sato, K. (1988) 'Joint buying groups of members' in *Journal of Co-operative Studies*, No 61, January

[17] The second largest being Konsum Stockholm, followed by Co-op Dortmund.

[18] Some confusion results from use of figures relating to those within the Union of Japanese Consumer Co-ops; e. g. just over 12 million members are within the union

[19] See Vacek, G. in Brazda, J. and Schediwy, R. (eds) (1989)

[20] See Williamson, I. (1992)

[21] Figures from Mellor *et al.* (1988)

[22] This typology is from the introduction to Paton, R. (1989)

[23] See Holmstrom, M. (1989)

[24] Figures from Paton, R. (1989)

[25] The Scott Bader Commonwealth became as influential in the 1970s as Godin's iron foundry had been in the 1870s, and for similar reasons. ICOM has both set up new co-ops and, in the co-partnership tradition, persuaded companies to convert to common ownerships

[26] For a history of the National CDA, see Murphy, B. (undated) Co-op development in Scotland has been co-ordinated by the Scottish Co-operative Development Committee (SCDC)

[27] See Mellor, M., Hannah, J., Stirling, J. (1988) ch. 2

[28] See Campbell, A. *et al.* (1977)

[29] These are not shareholdings in the capitalist sense, but are dividends based on work done, on which fixed interest is paid annually. So the scheme is in conformity with Co-operative Principles – see Campbell, A. *et al.* (1977)

[30] See Campbell, A. *et al.* (1987)

[31] See Stettner, L. (1981)

[32] See Khurana, M. L. (1989) – the figures are an update gained by personal communication with the author. There is a complication that the Indian Federation also acts as a building society, developing for owner occupation

[33] See Clapham, D. and Kintrea, K. (1992)

[34] See Crossley, R. (1992) Appendix C

[35] See Birchall (1988)

[36] See Heskin, A. (1991) for a history of several co-ops set up in Los Angeles among multi-ethnic working-class tenants

[37] Figures estimated by Birchall (1992)

[38] Quoted in Open University (1991). This reverses the impression given by the ICA, that there are far more credit co-ops in Asia than in the Americas – this may be because the ICA statistics only refer to co-ops in membership of the ICA

[39] Figures from Bussy, P. 'Credit unions in Britain' in Bayley, E. *et al.* (1992)

[40] See Spear, R. 'Changing trends in Eastern Europe' in Bayley *et al.* (1993), p. 17

[41] See Mavrogiannis, D. 'Role of Co-operatives in Central and Eastern Europe', in Bayley *et al.* (1993)

[42] For a survey of these see International Co-operative Alliance (1992c). New laws are already being drafted by co-operative movements in some countries, to improve on these

[43] See Balassopoulov, S. 'Privatisation of the Bulgarian Workers' Productive Societies' in ICA (1992c)

[44] See Central Co-operative Union of Bulgaria, 'Co-operative survival tactics in the market economy', ICA (1992c)

[45] See Schwettmann, J. 'Co-operatives in economies under reconstruction' in Bayley, E. *et al.* (1993)

[46] See Münkner, H-H (1992)

[47] See Schwettmann, J. in Bayley *et al.* (1993)

[48] The reaffirmation of the Co-operative value of self-help has been codified into a guide for a constructive development policy by AMSAC, Appropriate Management Systems for Agricultural Co-operatives – see Munkner, H-H (1993)

[49] See ICA (1992a) Section 5: 'Environment and Sustainable Development'

[50] Apelquist, K. (1992) p. 108

[51] Watkins, W. (1970) p. 188

[52] This allowed for the fact that in worker and housing co-ops membership could hardly be 'open' in the same way as for consumer co-ops – but selection of members had to be fair

[53] See Böök S-A. (1992) and the responses to it at the Tokyo Congress, 1993, in International Co-operative Alliance (1992)

[54] Watkins, W. (1986) p. ix

Bibliography

Alexander, D. (1970) *Retailing in England during the Industrial Revolution*, London: Athlone Press

Apelquist, K. (1992) 'Gender perspectives', in *Review of International Co-operation*, 85, no 4

Bailey, J. (1955) *The British Co-operative Movement*, London: Hutchinson

Bamfield, J. (1988) 'Co-operative Performance' in *Journal of Co-operative Studies*, 55, December

Birchall, J. (1987) *Save Our Shop: the Fall and Rise of the Small Co-operative Store*, Manchester: Holyoake Books

— (1988a) *What Makes People Co-operate?*, Oxford: Headington Press

— (1988b) *Building Communities, the Co-operative Way*, London: Routledge and Kegan Paul

— (1989) 'Time, habit and the fraternal impulse' in Young, M. (ed.) *The Rhythms of Society*, London: Routledge

— (1991) *The Hidden History of Housing Co-operatives in Britain*, Brunel University: Dept of Government Working Paper no 17 (also forthcoming in Heskin, A. (ed.) *The Hidden History of Housing Co-ops*, Los Angeles: UCLA)

— (1992) (ed.) *Housing Policy in the 1990s*, London: Routledge

— (1992b) *Housing Co-operatives in Britain*, Uxbridge: Brunel University, Dept of Government Working Paper no 21

Bjorn, C. (1977) 'The Co-operative Movement in Denmark: a historical sketch' in Bakgard, O. (ed.) *The Danish Co-operative Movement*, Copenhagen: Det Danske Selskab

Bonner, A. (1970 revised edition) *British Co-operation*, Manchester: Co-operative Union

Böök, S-A. and Johansson, T. (1988) *The Co-operative Movement in Sweden*, Stockholm: Swedish Society for Co-operative Studies

Böök, S-A (1992) *Co-operative Values in a Changing World*, Geneva: International Co-operative Alliance

Branton, N. (1992) 'Responding to change' in *Journal of Co-operative Studies*, Supplement to 74, June

Bunn, G. (1990) 'A Co-operative policy unit' in *Journal of Co-operative Studies*, 68, May

Burnett, J. (1986) *A Social History of Housing: 1815–1985*, London: Routledge

— (1989) *Plenty and Want: a Social History of Food in England from 1815 to the Present Day*, London: Routledge

Bayley, J. E., Parnell, E. and Hurp, W. (1992) *Yearbook of Co-operative Enterprise 1993*, Long Hanborough: Plunkett Foundation

Butler, J. (1986) *The Origins and Development of the Retail Co-operative Movement in Yorkshire during the 19th Century*, PhD thesis, University of York

— (1988) 'The Institute of Co-operative Directors', in *Journal of Co-operative Studies*, 62, May

— (1992) 'Safe for democracy?' in *Journal of Co-operative Studies*, 74, April

Butt, J. (ed.) (1971) *Robert Owen, Prince of Cotton Spinners*, Newton Abbot: David and Charles

Byrom, R. (1978) 'The consumer movement' in *Society for Co-operative Studies Bulletin*, 32, March

Campbell, A., Keen, C., Norman, G., Oakeshott, R. (1977) *Worker-owners: the Mondragon Achievement*, London: Anglo-German Foundation

Carbery, T. F. (1969) *Consumers in Politics: A History and General Review of the Co-operative Party*, Manchester: Manchester University Press

Carr-Saunders, A. M., Sargant Florence, P., and Peers, R. (1938) *Consumers Co-operation in Great Britain*, London: George Allen and Unwin

Clapham, D. and Kintrea, K. (1992) *Housing Co-operatives in Britain*, Harlow: Longman

Clayton, J. (1978) 'The experience of Shoefayre' in *Society for Co-operative Studies Bulletin*, 32, March

Cole, G. D. H. (1944) *A Century of Co-operation*, London: George Allen and Unwin

Cole, J. (1988) *Rochdale Revisited: a Town and its People*, Littleborough: Kelsall

Cole, M. (1953) *Robert Owen of New Lanark*, London: Batchworth Press

Co-operative Independent Commission (1958) *Report*, Manchester: Co-operative Union

Crossick, G. (1984) 'Shopkeepers and the state in Britain', in Crossick, G. and Haupt, H. G. (eds) *Shopkeepers and Master Artisans in 19th C Europe*, London: Methuen

Crossley, R. (1992) *The Right to Manage*, Manchester: Priority Estates Project

Davies, M. L. (1904) *The Women's Co-operative Guild*, London: Women's Co-operative Guild

— (1977) (ed.) *Life as We Have Known It: by Co-operative Women*, London, Virago

Davis, D. (1966) *A History of Shopping*, London: Routledge and Kegan Paul

Digby, M. (1960, revised ed.) *The World Co-operative Movement*, London, Hutchinson

Edmondson, T. R. (1978) 'Dry goods and wet blankets, part 2', in *Society for Co-operative Studies Bulletin*, 32, March

Elliott, S. R. (1937) *England Cradle of Co-operation*. London: Faber and Faber

Farrow, W. H. (1985) 'Co-operative Retail Services Ltd', in *Journal of Co-operative Studies*, 54, August

Fauquet, G. (1951) *The Co-operative Sector*, Manchester: Co-operative Union

Fay, C. R. (1908) *Co-operation at Home and Abroad*, London: PS King and Son

Flanagan, D. (1969) *A Centenary Story of the Co-operative Union of Great Britain and Ireland*, Manchester: Co-operative Union Ltd

Gaffin, J. and Thoms, D. (1983) *Caring and Sharing: the Centenary History of the Co-operative Women's Guild*, Manchester: Holyoake Books

Garnett, R. G. (1968) *A Century of Co-operative Insurance*, London: George Allen and Unwin

Garnett, R. G. (1972) *Co-operation and the Owenite Socialist Communities in Britain, 1825–45*, Manchester: Manchester University Press

Hall, F. and Watkins, W. P. (1937) *Co-operation: a Survey of the History, Principles, and Organisation of the Co-operative Movement in Great Britain and Ireland*, Manchester: Co-operative Union

Harrison, L. A. (1975) 'A single national federation?' in *Society for Co-operative Studies Bulletin*, 25, October

Heskin, A. D. (1991) *The Struggle for Community*, Oxford: Westview Press

Holmstrom, M. (1989) *Industrial Democracy in Italy*, Aldershot: Avebury

Holyoake, G. J. (1857) *Self-help By the People: the History of the Rochdale Pioneers*, London: George Allen and Unwin

— (1906, 3rd ed.) *Sixty Years of an Agitator's Life*, London: T Fisher Unwin

— (1912) *The Co-operative Movement Today*, London: Methuen

Houlton, R. (1987) 'Did the twins upset the professor?' in *Journal of Co-operative Studies*, 59, May

Hutton, D. (1986) 'Why did London fail?' in *Journal of Co-operative Studies*, 56, April

Jefferys, J. B. (1954) *Retail Trading in Britain 1850–1950*, Cambridge: Cambridge University Press

Kropotkin, P. (1972) *Mutual Aid: a Factor in Evolution*, Boston: Porter Sargent

International Co-operative Alliance (1992a) *Review of International Co-operation*, vol. 85, no 2/3, Geneva: ICA

— (1992b) vol. 85, no 4

— (1992c) *International Conference on Co-operative Property and Privatisation*

Ketilson, L. H. (1988) 'The marketing competitiveness of Canadian consumer co-operatives' in *Yearbook of Co-operative Enterprise*, Oxford: Plunkett Foundation for Co-operative Studies

Khurana, M. L. (1989) *Organisation and Management of Housing Co-operatives*, New Delhi: National Co-operative Housing Federation of India

Kinloch, J. and Butt, J. (1981) *History of the Scottish Co-operative Wholesale Society Ltd*, Manchester: Co-operative Wholesale Society Ltd

Lambert, P. (1963) *Studies in the Social Philosophy of Co-operation*, Manchester: Co-operative Union

McCabe, J. (1922) *George Jacob Holyoake*, London: Watts and Co

Mellor, M., Hannah, J., Stirling, J. (1988) *Worker Co-operatives in*

Theory and Practice, Milton Keynes: Open University Press

Mercer, T. W. (1936) *Towards the Co-operative Commonwealth*, Manchester: Co-operative Press

— (1947) *Co-operation's Prophet – Life and Letters of Dr William King*, Manchester: Co-operative Union

Munkner, H-H (1992) 'Co-operative values and development aid', in *Review of International Co-operation*, 85, nos 2/3

Murphy, B. (undated) *Co-operative Development Agency: History, 1978–1990*, CDA

Open University (1991) *An Introduction to Credit Unions*, Milton Keynes

Ostergaard, G. and Halsey, A. (1965) *Power in Co-operatives*, Oxford: Basil Blackwell

Owen, R. (1972) *A New View of Society*, London: Macmillan

Paton, R. (1989) *Reluctant Entrepreneurs*, Milton Keyes: Open University Press

Paxton, P. (1983) 'The impact on the Movement', in *Society for Co-operative Studies Bulletin*, 49, December

Pollard, S. and Salt, J. (1971) *Robert Owen: Prophet of the Poor*, Lewisberg: Bucknell University Press

Potter, B. (1899) *The Co-operative Movement in Great Britain*, London: Swan Sonnenschein

Redfern, P. (1938) *The New History of the CWS*, London, J. M. Dent

Richardson, W. (1977) *The CWS in War and Peace, 1938–1976*, Manchester: Co-operative Wholesale Society Ltd

Round, F. D. (1985) 'Colchester and East Essex' in *Journal of Co-operative Studies*, 54, August

Sato, K. (1988) 'Joint buying groups of members' in *Journal of Co-operative Studies*, 61, Jan

Sekerak, E. and Danforth, A. (1980) *Consumer Co-operation: the Heritage and the Dream*, Santa Clara, Consumers Co-operative Publishing Association

Sparks, L. (1992) 'Co-operative trade 1991: reflections and projections' in *Journal of Co-operative Studies*, supplement to 74, June

Spaull, H. (1965) *The Co-operative Movement in the World Today*, London: Barrie and Rockcliff

Stephenson, T. E. (1978) 'An analysis of the trade', in *Society for Co-operative Studies Bulletin*, 32, March

Stettner, L. (1981) *Community Co-operatives: Their potential for rural and urban development*, Oxford: Plunkett Foundation

Thompson, E. P. (1968) *The Making of the English Working Class*, Harmondsworth: Penguin

Treacy, M. and Varadi, L. (eds) (1986) *Co-operatives Today: Selected Essays*, Geneva, International Co-operative Alliance

Walker, G. (1988) Speech to the Society for Co-operative Studies Conference, 1987, reported in Birchall, J. 'Problems and Prospects', in *Co-operative Studies Journal*, 61, January

Warbasse, J. P. (1936) *Co-operative Democracy*, New York: Harper and Brothers

Watkins, W. P. (1970) *The International Co-operative Alliance, 1895–1970*, London: International Co-operative Alliance

— (1986) *Co-operative Principles, Today and Tomorrow*, Manchester: Holyoake Books

Webb, C. (1927) *The Woman With the Basket: The Story of the Women's Co-operative Guild*, London: Women's Co-operative Guild

Webb, S. and B. (1921) *The Consumers Co-operative Movement*, London: Longmans

West, T. (1986) *Horace Plunkett, Co-operation and Politics*, Gerrards Cross: Colin Smythe

Williamson, I. (1992) 'The Han way to health and happiness', in *Review of International Co-operation*, 85, no 4

Winstanley, M. J. (1983) *The Shopkeeper's World, 1830–1914*, Mancester: Manchester University Press

Wood, J. (1984) 'Some further comments' in *Society for Co-operative Studies Bulletin*, 50, April

Yeo, S. (ed.) (1988) *New Views of Co-operation*, London: Routledge and Kegan Paul

Index

Page numbers in **bold** refer to illustrations
Names of most Co-operative Societies have been abbreviated